Lifting the Shadow

Genocide, Political Violence, Human Rights Series

Edited by Alexander Laban Hinton, Nela Navarro, and Natasha Zaretsky

For a complete list of titles in the series, please see the last page of the book.

Lifting the Shadow

Reshaping Memory, Race, and Slavery in U.S. Museums

AMY SODARO

Rutgers University Press
New Brunswick, Camden, and Newark, New Jersey
London and Oxford

Rutgers University Press is a department of Rutgers, The State University of New Jersey, one of the leading public research universities in the nation. By publishing worldwide, it furthers the University's mission of dedication to excellence in teaching, scholarship, research, and clinical care.

Library of Congress Cataloging-in-Publication Data

Names: Sodaro, Amy, 1975– author.
Title: Lifting the shadow : reshaping memory, race, and slavery in U.S.
 museums / Amy Sodaro.
Description: New Brunswick : Rutgers University Press, [2025] | Series:
 Genocide, political violence, human rights | Includes bibliographical
 references and index.
Identifiers: LCCN 2024010906 | ISBN 9781978842632 (paperback) |
 ISBN 9781978842649 (hardcover) | ISBN 9781978842656 (epub) |
 ISBN 9781978842663 (pdf)
Subjects: LCSH: African Americans—Museums. | Slavery in museum exhibits—
 United States. | Collective memory—United States. | Racism—United States—
 History. | United States—Race relations—History.
Classification: LCC E185.53.A1 S64 2025 | DDC 305.800973—dc23/eng/20240403
LC record available at https://lccn.loc.gov/2024010906

A British Cataloging-in-Publication record for this book is available from the British Library.

Copyright © 2025 by Amy Sodaro
All rights reserved

No part of this book may be reproduced or utilized in any form or by any means, electronic or mechanical, or by any information storage and retrieval system, without written permission from the publisher. Please contact Rutgers University Press, 106 Somerset Street, New Brunswick, NJ 08901. The only exception to this prohibition is "fair use" as defined by U.S. copyright law.

References to internet websites (URLs) were accurate at the time of writing. Neither the author nor Rutgers University Press is responsible for URLs that may have expired or changed since the manuscript was prepared.

♾ The paper used in this publication meets the requirements of the American National Standard for Information Sciences—Permanence of Paper for Printed Library Materials, ANSI Z39.48-1992.

rutgersuniversitypress.org

Slavery is indeed gone, but its shadow still lingers over the country.
—Frederick Douglass, 1881

Contents

	Introduction: Memory in Post-Postracial America	1
1	Race and Memory in the United States: A Shifting Memorial Landscape	13
2	Telling "America's Story": The National Museum of African American History and Culture	37
3	"Shine the Light of Truth": The Legacy Museum	63
4	"After a Century of Silence": Greenwood Rising	89
5	America's New Memorial Museums	112
	Conclusion: Memory's Present and Future	135
	Acknowledgments	151
	Notes	153
	References	163
	Index	181

Lifting the Shadow

Introduction

• •

Memory in Post-Postracial America

On a hot August day in 2021, my husband, daughter, and I took a twenty-minute stroll from our tranquil, verdant neighborhood of Victorian mansions (mansions that we do not live in, but that surround our modest apartment building) up Brooklyn's vibrant and chaotic Flatbush Avenue to an overgrown empty lot in the heart of central Brooklyn. There we were scheduled to join a walking tour organized by GrowHouse NYC, a nonprofit organization fighting to preserve and commemorate the African Burial Ground located on this unkempt, seemingly abandoned corner of Brooklyn. Our tour guide, Shanna, led us through streets we thought we knew, telling us of the history of slavery in Brooklyn. Our streets, neighborhoods, and subway stations—Lefferts, Ditmas, Bergen, Nostrand—were in fact named for wealthy individuals (which we knew) who were major slave holders in the seventeenth and eighteenth centuries (which we did not). The First Dutch Reformed Church at the corner of Church and Flatbush Avenues, which was built in 1654, did not allow enslaved people to be buried there, and so the "Negro's burial ground" of Brooklyn was created a block away, used for much of the eighteenth century, and then fell into oblivion as the neighborhood developed around it. The history Shanna told us went back even further: the major streets that cut through the borough today as our primary thorough-fares had been paths used by the Lenape, who were the first inhabitants of what is today Brooklyn and who had complex relationships with both the

1

Europeans who colonized the land and the Africans and people of African descent that they enslaved.

The tour was eye-opening for a Brooklynite who had lived in the borough for twenty years and had never learned the history of slavery in their proverbial "backyard." While the struggle to preserve and commemorate Lower Manhattan's African Burial Ground is now well known to scholars of memory (e.g., Frohne 2015), this small corner of Brooklyn provided a reminder of how vulnerable these forgotten sites are, particularly when up against the economic and commercial interests of a place like New York City.[1] But while the information Shanna conveyed to us on the tour was no surprise, what was surprising to me—a scholar of commemoration—was that Brooklyn, a center of progressive politics with a majority BIPOC (Black, Indigenous, and other people of color) population, was so far behind in acknowledging this sinister past. While the momentum around memory of slavery is growing, it has taken a very long time to get to this point in the United States. In Brooklyn, for example, it is still largely up to small grassroots initiatives like GrowHouse NYC, with its walking tours, or Slavers of New York, a sticker campaign pointing out the many streets and other landmarks named for enslavers, to draw attention to the lingering memory of slavery.

This is somewhat surprising, considering that we have been in the midst of what scholars have described as a "memory boom" that has swept the globe in recent decades (Winter 2001). From popular culture to academia, civil society to national politics, memory of the past—in particular, past violence, atrocity, and oppression—weighs heavily on contemporary societies. Yet, while Holocaust museums are fixtures in most major U.S. cities, and in New York the 9/11 Memorial Museum is one of the city's most popular tourist attractions, commemoration of the United States' own violent past, including and especially slavery, is much less common. However, this has begun to slowly change in recent decades as established museums have introduced new or redesigned exhibits, historical sites have begun reckoning with slavery and other forms of oppression, and new museums and monuments have been created. Three of these new museums are the focus of this book: the Smithsonian National Museum of African American History and Culture (NMAAHC), which has extensive exhibits on slavery and segregation; the Legacy Museum: From Enslavement to Mass Incarceration, located in Montgomery, Alabama, which argues that slavery did not end, but evolved into today's system of mass incarceration; and Greenwood Rising, which commemorates the 1921 Tulsa Race Massacre and situates the massacre within the broader U.S. "systems of anti-Blackness," thus connecting past to present. These three museums represent a new intervention in America's memorial landscape and challenge the

dominant historical narrative that emphasizes a teleological tale of racial progress and belies ongoing injustices.

Race and Memory in "Post-Postracial" America

This tale of racial progress and concomitant silence around the history of slavery has been a centerpiece of American historical memory. In many ways, the election of Barack Obama to the presidency in 2008 seemed a fitting telos to this narrative and many hailed Obama's election as the beginning of a postracial America. For how could a racist nation elect a Black president? As Eduardo Bonilla-Silva writes, "The election of a black man as president [was] seen as prima facie evidence that race [was] no longer a central social force in the country" (2015, 59). However, as Bonilla-Silva and many others have demonstrated (e.g., Theoharis 2018; Wilkerson 2020), racism in the United States manifests much more often, and often more perniciously, in structural ways. It is woven into our institutions, practices, and processes. Thus, the idea of a postracial America was always deeply flawed; the roots of American racism run much deeper than many Americans want to believe.

Indeed, in many ways Obama's election helped usher in new waves of racism and slow whatever racial progress America's overarching historical narrative—and that of many museums and other institutions—hailed. Shortly after Obama took office, the Tea Party burst onto the political scene. While the movement's purported goal was to lower taxes and limit government, simmering beneath the surface was racial anxiety and animosity that erupted with Obama's election (Enck-Wanzer 2011; Zeskind 2012). As the Tea Party helped to embed populism into U.S. politics, it looked backward to a time when the United States' racial hierarchy was stable and white men were firmly on top. Today the movement has largely dissipated, but many of the Tea Party's ideals and symbols have been absorbed into the mainstream Republican Party, laying the groundwork for Donald J. Trump's racist political rise and his promise to "Make America Great Again." As this kind of populist politics raged on the ground, structural racism crept into the highest echelons of government, exemplified by the 2013 U.S. Supreme Court decision in *Shelby County v. Holder*, which essentially gutted the 1965 Voting Rights Act and allowed for an onslaught of new forms of voter suppression in eerie echoes of Jim Crow–era voting restrictions. This was followed in 2023 by the Court's decision to end affirmative action, halting decades of progress in diversifying institutions of higher education.

Against this turbulent political backdrop, any illusion of a postracial America was shattered in 2015 with the mass shootings of nine African Americans during a Bible study at the Emanuel African Methodist Episcopal Church in

Charleston, South Carolina, by white supremacist Dylann Roof. Not only did the violence of the attack horrify (most of) the nation, but investigators learned from his racist online rants that he had visited numerous historic sites associated with white supremacy, like plantations, and shared a multitude of symbols of white supremacy, including Confederate flags.[2] The direct connection between the shooting and these sites and symbols, which are often argued to represent southern heritage and pride, triggered heated debates and led to the removal of the Confederate flag from South Carolina's state capitol and other Confederate statues and symbols across the country. Passionate fights over Confederate symbols continue today, reminding us that "conflicts over how we understand, commemorate, and remember the past are not merely academic. . . . The fights over the nation's commemorative landscape mirror contemporaneous battles for control of the political landscape. These battles are ongoing, they are passionately fought, and they matter" (Domby 2020, 23).

As debates over race thus inserted themselves into politics and social life, Trump entered the 2016 presidential campaign. From the very beginning, his campaign relied heavily upon racist rhetoric—after all, he had launched his political career as a leader of the "birther" movement that claimed Obama was not born in the United States.[3] When he seemingly impossibly prevailed, his administration immediately ushered in a new ethos marked by xenophobia, exclusion, and often blatant racism. For anyone who had doubted the seriousness of Trump's racist rhetoric, the 2017 Unite the Right rally in Charlottesville, Virgina, put those doubts to rest. Hundreds of white nationalists marched on the city holding tiki torches and chanting racist slogans in protest of the removal of a prominent statue of Robert E. Lee, the leader of the Confederate Army in the U.S. Civil War, who has become one of the most prominent icons of the Confederacy. Met by anti-racist counterprotests, the rally turned deadly, with three people killed and dozens injured. Trump's response to the violence was to claim that there were "very fine people on both sides," which was viewed by most as a dog whistle comment condoning white supremacism. Thus, it is not surprising that white nationalist hate groups grew by 55 percent during Trump's presidency (Southern Poverty Law Center 2019). It was clear that the myth of a postracial America was only ever just a myth and that the United States had entered what cultural historian Alison Landsberg calls a "post-postracial" period marked by a "reemergence of race as a socially and politically significant discourse" (2018, 199).

A public and visual culmination of this surge in racism and white nationalism occurred on January 6, 2021, when an angry mob, incensed by what they believed to be a stolen 2020 presidential election and clinging to Trump's "Big Lie," stormed the U.S. Capitol with the goal of stopping Congress from certifying the election in order to overturn the results. The rioters gained access to the Capitol with relative ease and for several hours rampaged through the

building. Five people died that day, including a Capitol Police officer, another four Capitol Police officers committed suicide in the months after, and over 140 were injured; at this point, over 1,200 people have been charged with related crimes. Though they were a disparate group of insurrectionists—some with known ties to extremist groups, many with law enforcement or military ties, and many others seemingly just fervent Trump supporters—they were mostly male (85%), mostly white (95%), and broadly shared a set of grievances (Pape 2021). Research by the Chicago Project on Security and Threats found that most of the rioters were from counties with declining white non-Hispanic populations, suggesting that a primary motivation of the rioters was a fear of the "Great Replacement," a popular conspiracy theory among white nationalists that people of color are replacing white Americans in political and social life (Pape 2021). The symbols that adorned the mob reflected the racial animus underpinning the attack. There were the ubiquitous Confederate flags and other historical flags that have been adopted by white nationalist groups. There were nooses and gallows, alluding to racial terror under Jim Crow, and there were references to the Holocaust, such as the infamous Camp Auschwitz and 6MWE (6 Million Wasn't Enough) shirts. These sorts of symbols, like Confederate monuments, reference a past when white, Christian male dominance was unquestioned, and their use reminds us of just how central memory is to the negotiation of race in America today.

Thus, in the years since Trump's election—during which the museums that are the focus of this book have opened—race has firmly inserted itself into politics and culture in the United States and shows no sign of abating. While white nationalism surges, key cultural and political figures are openly embracing figures and ideologies that until recently would have been relegated the outermost fringes of U.S. society and discourse.[4] Even politicians that might pass for mainstream are falling over themselves to ban "critical race theory" and "wokeism" in K–12 schools and colleges and universities, arguing that any aspects of U.S. history and society that might make students uncomfortable—such as slavery or its legacies of structural racism—should not be taught.[5] A UCLA Law School project found that efforts to ban critical race theory have been proposed or adopted in forty-nine states and over five hundred districts (Sloan 2022). Anti-Black hate crimes have spiked in recent years, with high-profile cases like the Buffalo, New York, supermarket mass shooting in May 2022, numerous bomb threats to historically Black colleges and universities (HBCUs), and thousands of other daily acts of racial violence (Burch and Vander Ploeg 2022).

This racist turn in U.S. politics and culture reflects America's post-postracial era and comes in response to—and has been met by—a movement to more forcefully and critically address racial injustice, past and present. The emergence of new global norms vis-à-vis memory, such as the spread of a powerful human

rights discourse; the decentering of history to focus on marginalized and minoritized populations; and growing efforts to decolonize institutions, structures, and practices have inspired activists and other social actors to demand that nations, collectives, and institutions confront their racist pasts. Against a backdrop of shifting demographics in the United States and new emphases on diversity, inclusion, and pluralism, this movement to challenge hegemonic historical narratives and present practices vis-à-vis race in America has been fragmented and diverse, manifesting in a variety of forms; and it has accelerated in the post-postracial context.

Many of these efforts are happening at the local, grassroots level. Initiatives such as GrowHouse NYC's efforts to preserve and commemorate Brooklyn's African Burial Ground and the Slavers of New York movement, mentioned at the beginning of this introduction, are just two among many small, local organizations across the country that are working to confront the memory of slavery and its legacies. This kind of grassroots activism stretches all the way back to the time of slavery itself, when it manifested in the abolitionist movement and, following the abolition of slavery, efforts by African Americans to commemorate emancipation, preserve cemeteries and heritage sites associated with slavery, and celebrate African American history and experiences (Araujo 2023; Woodley 2023a). While the Jim Crow era drove many of these efforts underground, Black memory activism around slavery continues to shape U.S. historical memory of slavery up through today, manifesting perhaps most visibly and recently in the Black Lives Matter (BLM) movement, but echoed in smaller, yet similarly powerful grassroots efforts across the country (Araujo 2023).

While grassroots movements have been powerful forces for confronting this past, other social institutions have picked up this thread of activism and are doing their own work to challenge U.S. historical memory, often in even more widely visible ways. Colleges and universities are one set of institutions working to uncover and address their historical connections to slavery and its continuing legacies. Some were prompted by external influences; for example, the threat of a lawsuit for reparations in 2002 led Brown University's first African American president, Ruth Simmons, to establish a Committee on Slavery and Justice (see Harvard Radcliffe Institute 2022). At other institutions, such as Emory University and Yale, initiatives were led by students and faculty (Harris 2020). Today, universities across the United States (primarily in the Northeast and Southeast) have created research centers, hosted conferences, created memorials, and instituted reparations programs to address their connections to slavery. In 2014, Universities Studying Slavery, a consortium of over ninety institutions, was launched, evidencing the force of this movement to reckon with the legacy of slavery in U.S. institutions of higher education (von Daacke n.d.).

Other projects have similarly set out to research historical slavery in a way that will help make sense of ongoing racial injustice, such as the *New York Times'* 1619 Project led by journalist Nikole Hannah-Jones. Launched in August 2019, on the four hundredth anniversary of the arrival of the first enslaved Africans in the Virginia colonies, the project "aims to reframe the country's history by placing the consequences of slavery and the contributions of black Americans at the very center of our national narrative" (New York Times 2019). First published in the *New York Times Magazine* with ten articles, a photo essay and several poems and works of fiction, the project expanded to include a series of podcasts, a book and children's book, curriculums freely available to schools, and a six-part documentary. While the project has been widely praised—Hannah-Jones won a Pulitzer Prize for her lead essay—it has also been the subject of critique by both scholars, who argue that it misrepresents aspects of U.S. history (e.g., Wilentz 2020), and politicians who have sought to ban teaching the 1619 Project in schools (Schwartz 2021). The Trump administration even attempted to counter the 1619 Project and similar research into the central role of slavery in U.S. history with the creation of the 1776 Commission, which called for a new "pro-America" curriculum that avoided discussions of negative aspects of U.S. history (Crowley and Schuessler 2021).

This movement toward coming to terms with America's racist past has also slowly begun to make its way into debates on reparations. While reparations for slavery remain unpopular—a recent poll found two-thirds of Americans, and 90 percent of Republicans, oppose them (J. Sharpe 2021)—small steps have been taken. For example, in 2021, Evanston, Illinois, enacted what many have called the first reparations program in the United States. Aimed at addressing the "historical harm" done to Evanston residents through "discriminatory housing policies and practices and inaction by the City," the program will distribute $10 million in housing grants to families who experienced housing discrimination (C. Adams 2021). Similar initiatives have been launched in Amherst, Massachusetts, and San Francisco, California, and other cities like St. Louis, Missouri, Providence, Rhode Island, and Asheville, North Carolina, and states, like California, New York, and Vermont, are exploring reparations. These more localized movements also reflect small but significant shifts at the national level: for the first time in history, in 2021 the House Judiciary Committee voted to advance legislation on reparations for slavery that was first introduced in 1989. While the legislation will likely not progress any time soon with a Republican-led House and deeply divided government, merely advancing it out of committee points toward a growing acknowledgment of U.S. implication in past and ongoing impacts of slavery.

As these small steps have been taken toward advancing our understanding and acknowledgment of slavery and its legacies in a post-postracial context, George Floyd's murder in 2020 and the massive BLM protests that ensued have

given the movement momentum. While the promise of 2020 seems to be largely unfulfilled, BLM and the 2020 protests are one of the more visible parts of the larger shift in debates and discussions around race and the historical roots of racism in America. Both the force of the movement and the backlash against it underscore the high stakes of confronting historical and contemporary race in post-postracial America. This is a moment of dramatic racial reckoning—scholar Peniel E. Joseph (2022) refers to it as the "third Reconstruction"—and the landscape of historical memory of race is quickly shifting.

A New Wave of U.S. Museums

Against this backdrop of post-postracial America's dueling historical narratives, a small but significant set of new museums has opened that focus on past and ongoing racial injustice, beginning with the NMAAHC in 2016, which was followed by the Legacy Museum in 2018 and Greenwood Rising in 2021. As the first in what I believe is a new wave of U.S. museums more critically and truthfully confronting slavery and its ongoing legacies, these three museums fit into a much longer trajectory of African American museums, but also reflect what Marita Sturken describes as the growing belief that "the dominant US narrative—that slavery was an evil of a bygone past, that Confederate monuments are merely about heritage, that the civil rights movement ushered in legal equality for all, that an African American president signaled a largely postracial moment, and that white extremist violence today is an aberration rather than a norm—needed to be challenged, rejected, and revised with the histories of racial violence and terrorism that it masks" (2022, 224). These museums are not historic sites that are now reckoning with slavery or established museums creating new exhibitions, nor are they explicitly museums about slavery. However, they are challenging the national narrative on slavery and race by placing racial oppression at the center of American history and linking historical slavery to contemporary racial injustice. In doing so, they represent a new museological intervention into the historical memory of race and slavery in the United States.

I have selected these museums as the focus of this book for several reasons. The first is that they are relatively new and have been little theorized to date. While a number of scholars have analyzed the NMAAHC and the Legacy Museum, there are few scholarly analyses of Greenwood Rising and, to date, these three museums have not yet been analyzed against and next to each other.[6] For it is in putting them in conversation with each other, as I do in the following pages, that it becomes clear that they can and should be conceptualized as constituting a new form of U.S. memorial museum. While they differ tremendously in scale and scope, reflecting vast differences between the social, political, and economic contexts of their creation, there are important similarities in the

ways that they challenge hegemonic historical narratives. All three museums seek to demonstrate that slavery and racial inequality are central to both American history and to contemporary society. In this way they work to connect past racial violence to present forms of injustice. They also move beyond simple victim-perpetrator binaries, instead demonstrating that racial inequality is woven into our social institutions and structures. Thus, their narratives—to varying degrees, as we shall see—place white Americans in the position of what Michael Rothberg (2019) calls the "implicated subject"; while not perpetrators of racial oppression, implicated subjects benefit from systems of injustice and oppression and thus bear some degree of responsibility.

However, my analysis is particularly focused on identifying these three museums as new iterations of memorial museums that reflect global trends but emerge in the American context. In arguing that they are a new form of American memorial museum, I am distinguishing them from historical sites that address slavery, like the Whitney Plantation or the African Burial Ground, which have "one less layer of mediation" than museums (Autry 2017, 187). It is precisely this additional layer of mediation that interests me in their representation of race, slavery, and memory; their creators clearly perceived a gap in American historical memory and determined that a museum designed according to global commemorative practices was the best way to fill that gap. Thus, these museums address race, slavery, and memory in ways that challenge and critique dominant historical narratives in the United States using the particular combination of historical narrative combined with affective and experiential exhibitions common to global memorial museums. In analyzing how they revise hegemonic narratives using new museological tropes, these museums also help to illustrate the development of this new form of American memorial museum, from more traditional museological representations in the NMAAHC to more innovative strategies in the Legacy Museum, which are, in turn, developed in Greenwood Rising, though in ways that are somewhat more problematic.

Chapter Overview

Chapter 1 draws upon my broader research on memorial museums, tracing their emergence as part of a larger global memory boom in which museums have become an important tool used by societies around the world as they reckon with past violence and work to demonstrate their commitment to democratic ideals, tolerance, and nonviolence (David 2020; Sodaro 2018; Williams 2007). Against the backdrop of this global memory boom, the United States has slowly begun to reckon with its own past violence. The chapter thus sets the new museums against the broader historical memory of race and slavery in the United States, from the Lost Cause narrative that shaped post–Civil War memory

through the development of museums of African American history and culture and the commemoration of slavery in historic sites and museums. While earlier phases of African American museums have served as important spaces of community and empowerment (Burns 2013), they also worked to "segregate" the past from present in the effort to create "social consensus" around the past and its meaning (Autry 2017), demonstrating that museological representations of race and slavery have often remained "caught in the chains of white supremacy" (Araujo 2021, 2). This historical and conceptual backdrop lays the foundation for my analysis of these new museums as a third phase of museums that are influenced by global commemorative paradigms and that work to connect past racial violence to slavery's ongoing legacies—what Saidiya Hartman calls the "afterlife" of slavery.

The following three chapters present in-depth analyses of the case studies. Based on extensive fieldwork at each museum, each chapter analyzes the historical and political context in which the relevant museum was created and presents a "thick description" of its exhibitions and narratives. I examine them chronologically to situate the museums both within global museological practices and post-postracial U.S. society, but also to trace the development of this new form of American memorial museum. Chapter 2 thus examines the NMAAHC, which was heralded upon its opening in 2016 as symbol of national unity. However, the illusion of unity was quickly shattered as subsequent events ushered in the post-postracial era, revealing the promises and paradoxes of the NMAAHC. For it is a national museum that must tell the story of African American history, much of which is a story of oppression and injustice, as central to American history, which has long been dominated by patriarchal white supremacy and myths of freedom, equality, and democracy. Further, the museum must try to reconcile a fundamental contradiction at the heart of representing enslavement: the tension between a focus on slavery as an institution of supreme violence and one that celebrates African American resistance and agency (Gardullo and Bunch 2017). The chapter analyzes how the NMAAHC navigates these tensions in its exhibits and storytelling; while often caught between the genres of history and memorial museum—it is very much a transitional institution that straddles older museum models and the new iterations in the Legacy Museum and Greenwood Rising—it also lays the foundation for a new and critical mode of addressing this difficult past.

Chapter 3 examines the Legacy Museum: From Enslavement to Mass Incarceration, in Montgomery, Alabama, which is working to fundamentally shift U.S. historical memory of lynching, slavery, and racial oppression. Created by lawyer Bryan Stevenson's Equal Justice Initiative (EJI), the museum first opened in 2018 and is meant to extend the activist work of EJI to a national and international public. Built entirely with private donations, the Legacy Museum is free from the expectation to present a narrative of racial progress, like that in

other museums of African American history and culture (e.g., Autry 2013). Rather, the museum tells a story of the oppression of African Americans extending from slavery to racial terror and Jim Crow, through the Civil Rights Movement and right up to the present, contesting not just official histories, but also present systemic racial injustice, in particular today's system of mass incarceration. In doing so, the Legacy Museum unflinchingly forces visitors to confront this past and connect it to present racial inequalities, implicating white Americans in ongoing injustice and reflecting the potential of museums to engage in memory activism in the pursuit of social justice.

Chapter 4 analyzes Greenwood Rising, which opened in August 2021 to tell the long-silenced story of the Tulsa Race Massacre. The flagship project of the 1921 Tulsa Race Massacre Centennial Commission, a group of political, business, and religious leaders created to lead the centennial commemorations, Greenwood Rising (n.d.-b) is described as an "immersive journey" that "brings to life the memories of the past and the visions of success for the future and catalyzes important dialogue around racial reconciliation and restorative justice." Its narrative, which spans the history of Tulsa's Greenwood neighborhood from its booming days as Black Wall Street through the massacre and subsequent rebuilding and later decline, is experientially told using cutting-edge digital technology and, while centered on an immersive experience of the massacre, attempts to make connections between the past and ongoing systemic racism. However, despite Greenwood Rising's efforts to confront the past in a way that will help shape a better present and future, it has been controversial, and many members of Tulsa's African American community see the museum as a "symbolic gesture" intended to supersede monetary reparations and obscure ongoing racial injustice. Although Greenwood Rising works to challenge hegemonic narratives of racial progress in the United States, the controversies surrounding the museum raise questions about the limits of the ethics of remembering in the face of ongoing racial injustice and the challenges of transferring global commemorative forms to local contexts (e.g., David 2020).

Chapter 5 compares, synthesizes, and analyzes the three museums as representative of a new wave of American memorial museums focused on race and the legacies of slavery. One key point of comparison is what Robyn Autry (2013) describes as the "political economies" of the museums, and I examine the vast difference in the resources, power, and expertise that each of these museum projects has access to. The various institutional structures of these museums shape their storytelling; thus, my second point of comparison focuses on authenticity, affect, and experience in the museums' exhibitions. In their design choices and exhibitionary strategies, many of which are influenced by global memorial museum practices, the museums shape particular visitor experiences and understanding of the past, with varied degrees of affective impact. This impact and understanding is intended to challenge hegemonic historical

memory of race in the United States and convey moral messages and narratives of implication that radically depart from the dominant narratives of racial progress. Thus, not only do these museums reflect political and social changes in the United States, but they also point to an evolution in the memorial museum form from more traditional, twentieth-century memorial museum displays to innovative twenty-first-century digital media and interactive experiences and more radical and challenging historical narratives. However, they also help us to understand the limits of the work museums can do to right historical wrongs, shape societal attitudes and beliefs, and contribute to meaningful and lasting social change.

In the conclusion, I take some tentative steps toward a consideration of what impact these museums may be having and where this new form of memorial museum is heading. Though extensive visitor research is outside the scope of this project, my brief analysis of visitor reviews of the museums on TripAdvisor helps us to better understand the kinds of experiences visitors report having had at the museums. All museums are enthusiastically recommended as "must-see" institutions and going deeper into visitors' responses can help us understand what kinds of expectations they hold when visiting these museums and how they respond to the narratives, messages, and memory conveyed by the museums' exhibitions. In addition to considering their impacts on visitors, I also describe several new museums that have recently opened or are in development to consider how the three museums analyzed here have helped to contribute to larger shifts in American historical memory of race.

Erica Doss writes that "contemporary American memorials embody the feelings of particular publics at particular historical moments, and frame cultural narratives about self identity and national purpose . . . affect has agency" (2010, 59). A close examination of the NMAAHC, the Legacy Museum, and Greenwood Rising reveals much about our contemporary historical moment and the potential to more openly and truthfully address the United States' painful pasts. A national reckoning on race is urgently needed and already underway; this book captures the critical role of museums in this process. Contextualizing these important new museums within the contemporary American sociopolitical moment and national and global commemorative trends helps us understand how the violence of U.S. slavery and its lasting legacies are negotiated in public spaces and the potential of museums to contribute to the development of a new historical memory of race in the United States.

1

Race and Memory in the United States

• •

A Shifting Memorial Landscape

In Susan Neiman's (2019) book *Learning from the Germans: Race and the Memory of Evil*, which analyzes how Germany's efforts to "work off the past" might be instructive for American efforts to confront our own past violence, she recounts an anecdote told to her by the director of Buchenwald Memorial, Volkhard Knigge, concerning President Barack Obama's visit in 2009.[1] Standing in the concentration camp's crematorium, looking at a photo of corpses taken after liberation, Obama asked Knigge "What would that mean for a slavery museum in America?" While at that point, a slavery museum was still a somewhat distant proposition—ground was not broken for the NMAAHC until 2012—Knigge noted that Obama was asking the right question, that he "understood the core of Germany's work to create this self-critical look at our history" and how the United States could *and should* learn from this work (Neiman 2019, 288).

Clearly much has happened in the years since Obama visited Buchenwald and wondered about America's own working off the past. The existence of the three museums examined in this book is evidence of the tremendous progress that has been made in publicly confronting the evils of slavery and its ongoing legacies. But this progress has met with fierce resistance, reminding us of how fraught this past and its memory remain in the United States. Neiman began

writing her book in the wake of the Charleston shooting in 2015 and finished it just after the Charlottesville march of 2017, thus framing "America's failure to confront its own history" with these horrific examples of such resistance (2019, 26). Incorporating the full story of racial oppression and African American experience into America's dominant historical narrative would, as Fabre and O'Meally argue, following African American historian Nathan Huggins, "change the tone and meaning—the frame and substance—of the entire story" (1994, 4), much as Germany's reckoning changed the substance of German history and memory.

Germany's memory work is part of a larger, international "politics of regret" (Olick 2007) or "retrospective politics" (Berber 2015) that demands that societies and collectives work to come to terms with historical violence. To support this reckoning, new forms of memory, atonement, and commemoration have developed, including memorial museums, which are an extremely popular mechanism for societies wishing to publicly confront their own past violence. Yet while slavery and racial violence have been addressed in museums and exhibits in the United States, most American museums have tended to emphasize racial progress. It is only in the last several years that museums have begun to seriously grapple with this difficult past through a lens of regret and self-criticism in a way that echoes German efforts to work off the past. However, these new museums come at a volatile moment in the United States: white nationalism and right-wing extremism have flourished, even as events like the COVID-19 pandemic, which had a hugely disproportionate impact on communities of color, and police violence against African Americans, exemplified by the murder of George Floyd, have brought racial inequities into stark focus. Thus, this chapter situates these new museums within broader global commemorative trends, the rich history of African American museums and memory work, and the particular social and political context of post-postracial America. Recent years have shown how contentious the politics of the past are in the United States, and these new museums are excellent spaces for understanding both how the country is starting to come to terms with past racial violence as well as the resistance to that historical memory.

Memory, Museums, and the Politics of Regret

While the current era seems particularly fraught when it comes to memory of slavery and racial injustice, the United States has long grappled with this difficult past. Much of this struggle has been particular to the national and local context, but it also reflects global memory movements, practices, and normative demands. For much of modern history, commemoration of violence took the form of triumphant celebrations of national glory or sacrifice in the name of a righteous cause. Woven into the modern project was the effort to bolster

the nation-state through the creation of an "imagined community" unified around past triumphs and future glories (Anderson 1991), while forgetting difficult or controversial aspects of the past (Renan 1882/2018).

In the United States, this meant that wars the country won were commemorated in bombastic monuments like triumphal arches and equestrian statues; for more ambiguous conflicts, like the losing Confederacy in the Civil War, commemoration focused on the sacrifices made in the name of a "heroic" cause. Thus, in the wake of the Civil War, memory of slavery was largely forgotten, subsumed by the Lost Cause narrative that claimed slavery was a benevolent institution and that the Confederate cause was righteous.[2] Public memorial efforts, particularly in the South, and gaining momentum after the brief interlude of Reconstruction,[3] focused on honoring Confederate heroes and their sacrifices, helping to embed white supremacy into social institutions (Cox 2021; Domby 2020; King and Gatchet 2023). While the Lost Cause narrative did not comport with the Union experience of the war, the reunion of the nation was deemed far more important than setting the historical record straight (e.g., Blight 2002). Thus, this whitewashing of the past became the United States' de facto story not only of its foundation in democracy, but also its democratic reconciliation.

However, at the same time that the dominant American story was taking shape, African Americans were holding on to and shaping their own memories of slavery, the Civil War and emancipation. In the words of philosopher Cornel West, "African Americans have been the ones who could not forget: They have been the Americans 'who could not not know'" (qtd. in Fabre and O'Meally 1994, 3). Thus, African American communities across the nation, and especially in the South, kept the memory of the past alive in varied modes. Through books and art, through dance, music, and oral forms, and through freedom and emancipation celebrations that took the form of parades, church services, dances, and barbecues (Woodley 2023a),[4] African Americans created and maintained their own *lieux de mémoire* (Fabre and O'Meally 1994). These *lieux de mémoire* were powerful; as Kytle and Roberts note, in their study of memory of slavery in Charleston, South Carolina: "Black Charlestonians and their white Republican allies controlled the public memory of slavery in the city in the late 1860s and 1870s.... White remembrances, not black, existed on the sidelines in the wake of the Civil War" (2018, 8). Of course, Black memory in the wake of the Civil War was diverse and dynamic, changing over time and forming a foundation for a century of Black activism and a deep memory and history of slavery and emancipation that runs counter to the dominant American narrative. In fact, historian Thavolia Glymph (2003) argues that Black memory of the Civil War was so vibrant and powerful that the Lost Cause narrative emerged as a countermemory to African American memory work. However, while perhaps the Lost Cause was not initially the

dominant historical and mnemonic framework for remembering slavery and the Civil War, as the promises of Reconstruction slipped away, white elites wrested control of the narrative from African Americans, revising the past to serve as prologue to America's democratic union and glorious (white) future, reflecting the modern Western role of memory in the construction of the nation.

In the second half of the twentieth century, the temporal orientations of nation-states began to change. The modern focus on the future—with past celebrated as prologue to the present and future—began to give way to a new emphasis on the past, in particular past conflict and violence (e.g., Assmann 2020; Bevernage 2015; Huyssen 2011; Olick 2007; Torpey 2006). As Aleida Assmann writes, "The burden of the violent histories of the twentieth century weighs heavily on the present, demanding attention and recognition and forcing us to take responsibility and to develop new forms of remembrance and commemoration" (2020, 5). Thus, instead of embracing the future-oriented ideals of modern progress to "secure their cohesiveness by way of imagining the future" (Huyssen 2003, 94), states began to work at coming to terms with their negative pasts. Generally framed within a discourse of human rights and democratic culture, remembering and coming to terms with past violence is increasingly today a "prerequisite for state legitimacy" (Levy and Sznaider 2010, 5).

This "memory boom" arose in tandem with the global human rights regime, manifesting as one "expression" of a new human rights framework (Rothberg 2019, 57) and shaping societal norms around confronting human rights abuses. The new orientation to the past, variously referred to as a "politics of regret" (Olick 2007), "reparations politics" (Torpey 2006), or "retrospective politics" (Bevernage 2015), has led to the development of international norms regarding memory of historical justice. Lea David has termed these new norms "moral remembrance," which "prescribes standards for a 'proper way of remembrance' with which states are expected to comply when dealing with legacies of mass human rights abuses" (2020, 1). Thus, a constellation of new memory mechanisms, including truth commissions, political apologies, reparations programs, and memorials and museums, have emerged as requisite modes of addressing historical violence through a lens of political regret.

Memorial museums are an especially popular manifestation of moral remembrance and the memory boom's demand that collectives reckon with their past. Emerging from early efforts to commemorate the Holocaust (Sodaro 2018; Young 1993), memorial museums have spread across the globe and nearly any society with conflict in its recent (or not-so-recent) past has created one, from Germany, South Africa, and Rwanda to Armenia, Chile, and Cambodia (e.g., Jinks 2014; Sodaro 2018; Williams 2007). Memorial museums are new, hybrid forms of commemoration that seek to combine the authority and educative functions of history museums with the affect of memory in the effort to morally transform their visitors such that they embrace an ethic of "never

again." To impact visitors in this way, they not only use history to impart knowledge and understanding—incorporating archival photographs, videos, documents, and artifacts presented as evidence of what happened—but they also use experiential and affective exhibits to create encounters with the past that will help visitors empathize with victims, thus shaping their attitudes and behaviors (Micieli-Voutsinas 2021; Sodaro 2018; Williams 2007). Where they are built, memorial museums are also often extremely popular tourist destinations for visitors and locals alike, demonstrating that it is not just academics but the general public that is interested in memory of past violence.[5]

The creation of memorial museums reflects a widespread belief that there is an ethical duty ascribed to memory in the wake of mass violence. For example, moral philosopher Avishai Margalit argues that there is an "ethics of memory" that emerges in the case of crimes that "attack [our] very notion of shared humanity"; when such atrocities occur, even if they do not directly affect those whom we are closest to, we have a moral obligation to remember (2004, 9). Moral philosopher Jeffrey Blustein (2008) similarly argues that memory holds "moral demands" vis-à-vis our responsibility for the past. This responsibility is rooted not only in the utilitarian notion that memory of violence can help prevent future violence but also, from a deontological perspective, memory is the correct moral response to violence. Alison Landsberg echoes these arguments in her analysis of the affective experience of memory in mass culture: "With memory comes a sense of obligation and responsibility: remembering is a moral injunction" (2007, 628). The belief that memory is an ethical obligation has become embedded in today's culture of commemoration, manifesting in what Arleen Ionescu, in writing about the Jewish Museum Berlin, has termed a "memorial ethics" based on "bringing the invisible into visibility" (2017, 2) so that visitors can bear witness to historical violence. Memorial museums, with their broad public reach and powerful forms of storytelling, are an especially popular form of symbolic, communal reparation that enable visitors to bear witness, and that are now considered essential for coming to terms with historical violence vis-à-vis the politics of regret.

Yet even while many nations are being pushed to address past wrongs through the lens of regret as part of their moral obligation to memory, Aleida Assmann argues that a parallel "politics of self-assertion" has meant that powerful nations like the United States "have no reason to change their historical self-images of strength" (2020, 222). Thus, the "global rush to commemorate" using memorial museums (Williams 2007) has been very selective in the United States to date, with a couple of very prominent memorial museums and some striking silences, reflecting national politics and priorities. The U.S. Holocaust Memorial Museum (USHMM), which opened in 1993, was one of the first self-identified memorial museums and has become a global model for others, including dozens of other Holocaust museums in the United

States. Over twenty years later, the 9/11 Memorial Museum opened as another prominent American memorial museum, using cutting-edge museological design and technology to create a deeply moving and affective experience of 9/11. However, these museums adhere to hegemonic narratives of American innocence (Sturken 2016) in their efforts to promote American ideals of democracy and freedom (Sodaro 2018), providing visitors with what Edward Linenthal calls a "comfortable horrible memory" of atrocities for which the United States was not responsible (1995, 267). What has been missing from the memorial landscape in the United States are museums and memory sites focused on past atrocities that implicate the United States, such as the genocide of Indigenous peoples and slavery. However, in the last few years there appears to be space opening up in American historical memory to address and incorporate more contentious and difficult pasts, including—and especially—slavery and its legacies of racial violence.

This fits within larger movements in the museum world. In their early manifestations, museums were primarily elite, national institutions intended to enact a "ritual of citizenship" (Duncan 1991), teach visitors self-discipline in the "exhibitionary complex" (Bennett 1999), and "legislate" taste and social value to their audiences (Casey 2005). This gave museums a role in society as spaces of authority, objectivity, and legitimacy, which many retain today. However, over the course of the twentieth century, museum audiences expanded, and the role and function of the museum has shifted to an outward focus on "providing primarily education services to the public" (Weil, qtd. in Conn 2010, 23). As museums opened their doors to broader, more diverse audiences, they began to work harder to interpret the objects on display, adding text, explanatory panels, and descriptions to help visitors make sense of the objects in more interactive and innovative ways. The emphasis of museums has shifted from the objects themselves to the stories that objects and museums can tell—what M. Elizabeth Weiser refers to as museums' "narrative turn" (qtd. in King and Gatchet 2023, 166). In order to tell these stories, museums have embraced digital technology and other strategies to create interactive and experiential encounters with their collections and narratives, developing into what Valerie Casey (2005) has termed the "performing museum." These performing museums ask visitors to do more than passively absorb information and instead actively take part in learning and making sense of their exhibitions. This has greatly expanded their functions, as they "incorporate dimensions such as entertainment, empowerment, experience, ethics, and narrative endeavor" (Andermann and Arnold-de Simine 2012, 5–6).

As museums have become more inclusive and democratic institutions, they have begun to challenge the idea that museums are "objective" and "neutral" institutions and are increasingly taking on an activist role as institutions "committed to individual and social well being" (Janes and Sandell 2019, 7).

Together with museums' movements into more socially engaged and activist stances, there are also new demands being placed on contemporary museums. There is growing pressure to decolonize museums and prioritize diversity, equity, access, and inclusion in both their exhibitions and narratives and their personnel and leadership. The very museum form is implicated in the historical mass violence of colonialism, and in response to this growing awareness, museums are reevaluating their collections and missions, as well as working to dismantle the white supremacy that is often structured into museums as institutions (Shoenberger 2023). Against this backdrop of growing demands, expectations, and efforts of museums to be more inclusive, representative, and responsive, the museological landscape in the United States is expanding in important ways, in particular regarding slavery and its legacies.

Race and Memory in U.S. Museums

The best way to put your bad images to rest is to declare them history and put them in a museum.

—David Vann, former mayor of Birmingham, Alabama (qtd. in Theoharis 2018, xii)

While African Americans have practiced significant forms of what Pierre Nora (1989) referred to as "commemorative vigilance" around slavery, the Civil War, and emancipation (Fabre and O'Meally 1994, 7), this memory work has mostly remained on the peripheries of American public history and memory. In fact, African American history, and that of other minoritized groups, is woefully underrepresented in U.S. historic and heritage sites (Linn-Tynen 2020). For example, fewer than 8 percent of the almost one hundred thousand sites listed on the National Register of Historic Places are focused on African Americans, women, Latinos, and other minoritized groups (Bronin 2020). Nevertheless, museums of African American history and culture are not new. Since the founding of the first African American–focused museum, at Hampton University in 1868, African American museums have proliferated; by 1978 there was enough momentum for the formation of the Association of African American Museums, which currently has over two hundred members (Burns 2013, 8–10). Thus, to some degree, race has always had a place in U.S. museology.

In their respective work on African American museums, sociologist Robyn Autry and historian Andrea Burns have noted that African American museums developed in phases, emerging in varied social, political, and economic contexts that shaped their roles within their communities and the larger nation. The first phase consisted of the establishment of "neighborhood" (Burns 2013) or "regional" (Carbonell 2023) museums, primarily in northern or midwestern cities during the 1960s and 1970s civil rights era, at the height of

the Black Power movement (Ruffins 1992). These museums, such as Chicago's DuSable Museum of African American History, the International Afro-American Museum of Detroit (today the Charles H. Wright Museum of African American History), and the Anacostia Neighborhood Museum (today the Anacostia Community Museum) in Washington, DC, were created as alternatives to and disruptions of hegemonic narratives in mainstream museums.[6] Their creators, who were mostly local activists with little museum experience (Autry 2017, 57), "believ[ed] their institutions communicated a radical new agenda about power, memory and identity" and as such could "serve as conduits for the needs of the black community" (Burns 2013, 4). They were intended to be a corrective to mainstream museums' lack of diversity in personnel, exhibits, and narratives, and to serve as "instruments of empowerment for the Black community" (Ruffins 1992, 565). They thus were, and continue to be, very much aimed at the African American communities that created them; in the words of Dina A. Bailey (2019), they were spaces "*of* community, *in* community, and *for* community" (296; emphasis in original). As Autry argues, they represented the "grassroots appropriation and reinvention of museums as vehicles to awaken and deepen collective black consciousness and self-pride" (Autry 2013, 70).

While these museums served their communities and challenged mainstream museology, interest in African American history grew over the second half of the twentieth century both within academia and among the public. This was driven in part by books like Alex Haley's *Roots* (1976) and Dorothy Spruill Redford's *Somerset Homecoming* (1989) and closely corresponded to the global memory boom and its growing demands to amplify marginalized voices in the historical record. This interest in African American history helped to usher in a second, post–civil rights phase in which museums and historic sites were developed and created to focus on recent African American history, primarily the Civil Rights Movement. This second phase corresponded with a growing public interest in heritage sites, and these museums were often part of urban renewal projects based on the assumption that African American heritage could help drive tourism and economic development (King and Gatchet 2023). As Autry notes, this second phase was also linked to the global politics of regret: "Part of the public atonement for histories of slavery and state-sanctioned segregation has been the investment of public funds into black heritage sites" (2013, 73).

Thus, museums like the National Underground Railroad Freedom Center in Cincinnati, Ohio, the Museum of the African Diaspora in San Francisco, and the National Afro-American Museum in Wilberforce, Ohio, were created, often through public-private partnerships that were "less participatory" than the older neighborhood museums (Autry 2013, 74) but often resulted in more prominent tourist attractions. Similar public-private partnerships

drove the redevelopment of African American historic sites, as well, such as the Birmingham Civil Rights Institute, across the street from the 16th Street Baptist Church where four young girls were killed in a racial terror attack in 1963; the National Civil Rights Museum at the Lorraine Motel in Memphis, Tennessee, where Martin Luther King Jr. was assassinated in 1968; and the King National Historic Site in Atlanta, which encompasses the house that King grew up in and Ebenezer Baptist Church, and which opened just before the 1996 Olympics in Atlanta. Many of these initiatives were driven by the desire to attract tourist dollars and spur economic growth. But the preservation of the historic sites of tragedy, in particular, were also intended to help rehabilitate the cities' images vis-à-vis their racist pasts, again indicating the nod toward the political regret underpinning these projects (Dwyer and Alderman 2008).[7]

However, the creation of these museums and their orientation toward the African American communities in which many of them are located also demonstrate that in the United States, at least until recently, "interrogation of the society's racist past is the purview of so-called ethnic or black museums" (Autry 2017, 23). Just as it was Black memory work that kept memory of slavery alive in the face of the Lost Cause narrative, so it was largely up to African American museums to represent and educate about this past. Slavery and other forms of historical racial injustice have been primarily treated as part of African American history as opposed to part of the broader American history presented in mainstream museums, which tends to focus on myths of a nation built on ideals of democracy, equality, and freedom. This differential treatment of U.S. history has produced a memorial landscape "bifurcated along racial lines" (Autry 2017, 7) and, by relegating racism and racial injustice to African American institutions instead of integrating this history into mainstream museums, has largely absolved white Americans from responsibility for past racial injustice and its structural legacies.

Nevertheless, and despite this bifurcation, Autry notes that acknowledging past racism in museums and historic sites like the African American museums of the first two phases, while critical work vis-à-vis historical memory, has generally fallen short of addressing ongoing systemic injustices and the lasting legacies of historical racism (2013, 72). Christina Sharpe, in her analysis of "wake work" as a mode of wrestling with the ongoing legacies of slavery, points toward this tension in museums, asking, "If museums and memorials materialize a kind of reparation (repair) and enact their own pedagogies as they position visitors to have a particular experience or set of experiences about an event that is seen to be past, how does one memorialize chattel slavery and its afterlives, which are unfolding still?" (2016, 22). This is a pressing question for museums, in particular those focused on history; many African American museums, like most history museums, have tended to avoid confrontation with the "ongoingness"

of racial trauma and instead contain and historicize past racial injustice, suggesting that racism is a remnant of a past that is easily differentiated from the (less racist, more enlightened) present. This tendency of museums to relegate the negative past to history and safely contain it within the museum walls is common to memorial and other museums and is an important tension within the "retrospective politics" that drives much remembrance today (Sodaro 2018). As Berber Bevernage writes, by "historicizing contemporary injustice and treating it in terms of historical discourse, a distance is created between one's own present-day activities and these allegedly past or anachronistic crimes" (2015, 344). The very existence of a museum—a place "that we visit to gaze at the past as if it were indeed a foreign country distinct from our everyday practices" (Autry 2017, 188)—is often taken as evidence that past violence and injustice is truly in the past. Thus, while many of the first and second phases of African American museums address racism in ways that differ radically from mainstream museums, they have tended to focus on the historical experience of racism without explicitly connecting it to present injustices.

There are good reasons behind this effort to contain racial animus to the past. For while museums of African American history and culture have been actively engaged in efforts to "raise awareness of racial inequities" (Hayward and Larouche 2018, 169), they have also been aimed at empowering Black communities. Burns argues that the first and second phases of African American history and culture museums represented crucial "free spaces" for their communities where African Americans could "develop a strong sense of identity and self-affirmation" (2013, 5). To provide this affirmation, these museums have worked to avoid narratives focused on victimization, instead presenting what Autry (2017) refers to as a "vindicationist" approach that celebrates Black achievement and accomplishment and the full integration of African Americans in American society. As Autry explains, in these museums "some of the darkest chapters in American history are converted into the substance of a metanarrative that tells the story of blacks' transformation from racial subjects to citizens" (Autry 2013, 63). After all, the absence of Black histories and experiences in mainstream museums and other public spaces can be seen as an erasure of African American identity, memory, and history (Linn-Tynen 2020, 259). African American museums thus worked to insert Black history into the United States' memorial landscape while bolstering Black identity by "explaining the triumph of an oppressed group over extreme odds" (Autry 2017, 92–93).

This vindicationist approach of African American museums, and their effort to avoid focusing on narratives of victimization, is also reflective of global practices in memorial museums and others that focus on oppression and atrocity. Most Holocaust museums, for example, balance their stories of the victimization of Jewish communities with stories of resistance, resilience,

and agency. However, in America's racialized memorial landscape, where histories of oppression are primarily restricted to museums that must also serve as institutions of community empowerment, this has attenuated broader historical understanding of racial injustice in the United States. Autry, following Ira Berlin, argues that the creation of the first phase of African American museums as alternatives to the dominant national museology has contributed to a "thinning of public knowledge about the centrality of slavery and racial oppression in the formation and transformation of American society" (2013, 64). The second phase, in their celebration—and (often) simplification—of the successes of the Civil Rights Movement, has helped to shape the dominant civil rights narrative into a way for America to celebrate racial progress. As political scientist Jeanne Theoharis writes, "A story that should have reflected the immense injustices at the nation's core and the enormous lengths people had gone to attack them had become a flattering mirror . . . a testament to the power of American democracy" (2018, x).

Thus, despite the proliferation of African American museums across the United States, the hegemonic narrative of racial progress that fits so neatly alongside the Lost Cause narrative absolving white Americans of the racist crimes of the past has remained largely intact. Though the goals of African American museums vary—from highlighting resistance and resilience to working to "vindicate the race" vis-à-vis white America (Burns 2013, 9) to accommodating (white) visitors in order to bring in tourist dollars and burnish a city's image (Dwyer and Alderman 2008)—African American museums have often avoided in-depth confrontation with the violence and injustice of slavery and its ongoing legacies. The overarching suggestion in these museums is thus that violence can be left in the past (e.g., Apsel 2019; Autry 2017; Theoharis 2018), reminding us that generally "the cost of achieving a moral consensus that the past was evil is to reach a political consensus that the evil is past" (Meister 2012, 25).

Perhaps nowhere is this more clear than in one of the more prominent recent initiatives that sits on the cusp of the second and third phases of African American museums: Atlanta's National Center for Civil and Human Rights (NCCHR), which opened in 2014. Part of a cultural complex in downtown Atlanta that includes the Georgia Aquarium and World of Coca-Cola, the NCCHR was the brainchild of a group of civil rights activists who won political support as public officials sought to revitalize Atlanta's downtown.[8] The museum was created through a public-private partnership in a complicated process shaped by both internal politics and external factors like the 2008 Great Recession (e.g., Apsel 2019; Ostow 2024). Plans for the museum were significantly scaled back and its opening delayed by several years, but the smaller yet sophisticated museum finally opened in 2014 in a striking new building designed by Philip Freelon, who we shall encounter in chapter 2 as a lead designer for the NMAAHC.

While the museum's name and mission to "inspire people to tap their own power to change the world around them," as stated on its website, suggests a connection to contemporary human rights concerns, the core of the museum is the historical civil rights exhibition *Rolls Down Like Water: U.S. Civil Rights Movement* (NCCHR n.d.). With an emphasis on Atlanta as the "city too busy to hate," the exhibition covers the highlights of the movement, beginning with the death throes of Jim Crow in an exhibit called "Crossroads of Change," and moving through major events, such as school desegregation, the Montgomery Bus Boycott, lunch counter sit-ins, and the Freedom Rides. A large, bright room focuses on the hope inspired by the March on Washington, but the exhibit turns dark and ominous with the violence that followed—the 16th Street Baptist Church bombing, the murder of civil rights activists in Mississippi, the Selma-Montgomery March, and Bloody Sunday. The exhibition celebrates the Civil Rights Act and Voting Rights Act and culminates with King's assassination and the accompanying grief and rage. Neatly tying up this past, it ends with a solemn but hopeful memorial to those killed in the movement. Throughout there are the now-requisite interactive elements, such as the entrance lined with "White" photographs on one side and "Colored" on the other, calling to mind Johannesburg's Apartheid Museum; the period televisions, where visitors can spin the dial to choose the "channel" they wish to watch; and, especially, the lunch counter, where visitors don headphones through which they hear threats and racial slurs hurled at them while their stool shakes menacingly. With these kinds of interactive and immersive elements, the exhibition is a beautifully designed mix of archival film, photographs, documents, and artifacts that conveys the struggles and triumphs of the movement. In this story of redemption, the NCCHR "reinforces popular narratives about sacrifice and achievement" (Apsel 2019, 92), echoing the stories of racial progress that have dominated in museums of African American history and culture.

However, reflecting global memorial museum trends and marking what could be viewed as the beginning of a third phase of African American museums, the museum is intended to frame the Civil Rights Movement within the more universal movement for human rights. Thus, there is also an exhibition focused on global human rights called *Spark of Conviction*. Here visitors learn of human rights abuses around the globe. There are life-size photos of some of the worst human rights abusers in history, such as Hitler and Pol Pot, who stand next to present dictators. There are panels on contemporary human rights abuses in the mines, factories, and industries that create the things that we use in our everyday lives, and there are testimonies of individuals who have fought for human rights. There is a section on human rights abuses in the United States called "Toward a More Perfect Union." It is here that one finds the museum's only mention of slavery. But the diminutive size of this section and the detached tone—a radical departure from the museum's affective

telling of the Civil Rights Movement story—suggest an "othering" of the very concept of human rights: in this museum, human rights are only an issue long ago or far away.[9] Considering the topic of the museum—civil and human rights—it is shocking that slavery is given only historicized and cursory mention in the secondary comparative exhibit and nowhere is lynching mentioned (see also Apsel 2019, 110). Rather, the violent legacy of slavery is smoothed over into a tale of triumph.

In many ways, the NCCHR's design and universalistic aspirations suggest adherence to the politics of regret and a meaningful effort to engage with the United States' racist past, and some have linked the museum to a new wave of African American museums (e.g., Severson 2012). However, in actuality, the museum's decontextualized civil rights exhibits and othering of the concept of human rights serves to frame Jim Crow "as a horrible Southern relic, and the movement to unseat it [as] a powerful tale of courageous Americans defeating a long-ago evil," thus "wash[ing] away the sins of the nation" (Theoharis 2018, x). The museum's chief creative officer, renowned theatrical director George C. Wolfe, conceived of it as a space that would hew to memorial museum practices by combining "the visceral intimacy of theatre, the intellectual rigor of a museum, and the intimacy of a documentary" (Kompanek 2014) to "connect the triumphs and losses of the fight for racial justice in this country to contemporary human rights issues" (Atlanta Downtown 2009). Despite this lofty vision, the NCCHR ultimately reiterates the triumphant narrative of racial progress that has become the foundation for America's historical memory of race.[10]

Museums and the Memory of Slavery

> There is no place you or I can go, to think about, or not think about, to summon the presences of, or recollect the absences of slaves; nothing that reminds us of the ones who made the journey and of those who did not make it. There is no suitable memorial or plaque or wreath or wall or park or skyscraper lobby. There's no 300-foot tower. There's no small bench by the road. There is not even a tree scored, an initial I can visit, or you can visit in Charleston or Savannah or New York or Providence, or better still on the banks of the Mississippi.
>
> —Toni Morrison (1989 [2008])

In 1989 Toni Morrison piercingly noted the absence of the memory of slavery and the enslaved in U.S. historical memory and public space. Although this is beginning to change, her observation, particularly in tandem with the above example of the NCCHR, is a sharp reminder that despite the proliferation of African American museums and their nod to political regret, the triumphalist narratives

of many of them have helped to keep memory of slavery and its lasting legacies largely outside of mainstream public memory and discourse. This is not just the case in the United States, but around the world. As the politics of regret drove memorialization of twentieth-century atrocities, such as the Holocaust, genocides like those in Cambodia, Rwanda, and Bosnia-Herzegovina, and oppressive, dictatorial regimes such as those in Latin America and communist East and Central Europe, the more distant violence of colonialism and imperialism has been generally obscured behind remembrance of these more recent atrocities. Nevertheless, over the second half of the twentieth century, the growing emphasis on human rights and burgeoning political power of minoritized and marginalized groups has meant a deepening public validation for victims of historical injustice and new demands for perpetrators of those injustices to confront their implication. Thus, memory of past violence has begun to extend beyond the atrocities of the twentieth century and a slow but steady stream of efforts to commemorate slavery has emerged in recent decades.

Some of the earliest efforts began in West Africa, starting in the 1960s with decolonization and intensifying in later decades, when historic sites associated with the transatlantic slave trade were turned into museums. These include sites like Senegal's Maison des Esclaves (House of Slaves), which opened as a museum telling the history of the transatlantic slave trade in 1966 (Ostow 2019), and Ghana's Cape Coast Castle Museum, which was established in 1974 and incorporated a permanent exhibit on the slave trade in 1994 (Araujo 2021, 5). These were joined by other historic sites and museums in Angola, Benin, Gambia, and Nigeria, among others, which were primarily aimed at developing heritage sites to boost tourism (Araujo 2018, 2021). Across the globe, slavery was also working its way into public memory, in part through anniversary celebrations. Brazil celebrated the centennial of the end of slavery in 1988, which coincided with the transition from military dictatorship to democracy and a new constitution that expanded citizenship and marked a watershed moment in confronting its historical memory (de Almeida and Viana 2018). In 1992, Europe and the United States celebrated the five hundredth anniversary of Columbus's arrival in the Americas; two years later, and within this context of heightened historical awareness, UNESCO (n.d.) established the Routes of Enslaved Peoples: Resistance, Liberty and Heritage project, a multifaceted international research, education, and commemoration initiative intended to "break the silence" around the transatlantic slave trade. France observed the 150th anniversary of its abolition of slavery in 1998, a commemoration marked by a silent protest of forty thousand people from former French colonies demanding that the French government recognize slavery and the slave trade as crimes against humanity. The French government did this in 2001, while also establishing a National Committee for the Memory and History of Slavery (Foundation for the Remembrance of Slavery n.d.).

Meanwhile, the United Kingdom was preparing for its own bicentennial commemoration of the abolition of slavery in 2007. A central part of the commemorations was the creation and redesign of museums and exhibits. For example, the William Wilberforce House in Hull, a house museum dedicated to the British abolitionist, was renovated and reopened for the anniversary with a new emphasis on the transatlantic slave trade (Arnold-de Simine 2012). And what had started as the Transatlantic Slave Gallery, established in 1994 in the Merseyside Maritime Museum in Liverpool, was developed into the International Slavery Museum, which opened in 2007 for the commemoration as the world's first museum (here distinguished from a historic site or a museum exhibition) dedicated to slavery (Araujo 2021, 6).[11] With the detailed history of slavery that it presents, its affective exhibits (Arnold de-Simine 2012), and its emphasis on human rights and activism (Araujo 2020; Ostow 2020), the International Slavery Museum in many ways laid the groundwork for other exhibits and museums throughout Europe and the Americas that were beginning to be developed to tell the story of slavery.

Historian Ana Lucia Araujo, who has conducted the most comprehensive research on museums of slavery in the Americas, Europe, and West Africa, concluded in her monograph on the topic that most museums addressing slavery tend to emphasize the wealth created by slavery, the victimization of the enslaved, and their rebellion (and punishment), thus historicizing slavery and framing it within a familiar (white) hegemonic historical discourse. To a far lesser degree they address the ongoing legacies of slavery and contemporary racial injustice. In their particular emphases, Araujo argues that many museums focused on slavery fail to critically engage with this past and instead reproduce racial hierarchies: "Museum exhibitions exploring the problem of slavery remain caught in the chains of white supremacy. . . . Most exhibitions fail to fully discuss the legacies of slavery such as anti-black racism and persisting racial inequalities" (2021, 2). That is, they struggle with memorializing slavery's afterlives (Hartman 2008; C. Sharpe 2016).

Within this context of growing, if flawed, international attention to slavery—and despite the still-dominant politics of self-assertion shaping American public memory—U.S. museums and exhibits slowly began to incorporate stories of slavery as well. While silence has dominated American memory, the silence itself is highly revealing and helpful in tracing the emergence of the memory of slavery in U.S. museums and its entanglement in the "chains of white supremacy." Perhaps nowhere is this more evident than in the approximately 375 plantations (often called plantation house museums) sprinkled throughout the southeastern United States, which have been described as "ground zero for understanding how we have come to remember or forget the history of enslavement" (Potter et al. 2022, 4). Until the last few decades, these popular heritage tourism sites primarily played the role of whitewashing

American history (e.g., Alderman, Butler, and Hanna 2016; D. Butler 2001; Eichstedt and Small 2002; Modlin 2008). Through their focus on the wealth and luxury of the "big house" and the refined and genteel southern lifestyle à la *Gone with the Wind*, they have "symbolically annihilate[d]" the history and memory of the enslaved as they present a sanitized and romanticized moonlight and magnolia view of America's past (Eichstedt and Small 2002). Any reference to the work done on the plantation referred to "servants" and spaces of work, like the kitchen, were often not included on the tour.[12]

This began to change in the early 2000s, when a number of plantations began to incorporate slavery into their history-telling, adding slave cabins to their landscapes and beginning to tell stories about life under slavery, responding to broader historiographical shifts and global trends. Efforts to incorporate slavery into tours and exhibits have been uneven, ranging from framing slavery as a benevolent institution (Butler 2001) to relegating it to the edges of the landscape and narrative in a way that maintains the emphasis on rich, white plantation owners. Nevertheless, motivated either by the desire for social justice or by public pressure (or both), more and more plantation museums are undergoing this "reparative turn" toward incorporating the history of slavery. But the interpretation of slavery is still often preoccupied with the comfort of white visitors (the vast majority of visitors to plantations) and works to create an "affective inequality" that encourages visitors to empathize with the slave holders rather than the enslaved (Potter et al. 2022, 13).

One exception is the Whitney Plantation, which opened in late 2014 and was hailed by some as the first slavery museum in the United States (Amsden 2015).[13] Potter et al. call the Whitney a counternarrative site "where the lives of the enslaved are interwoven and centered in the plantation assemblage" (2022, 218) and unlike other plantations throughout the South, the Whitney focuses on the stories of the enslaved. It is a private operation, which was purchased and developed into a historic site by a wealthy, white New Orleans lawyer and real estate developer, John Cummings. Upon buying the land, which he had intended as just another real estate investment, Cummings received a detailed study of the site from its former owner, the petrochemical company Formosa, and quickly began to educate himself about slavery at the Whitney and in the region.[14] He brought in Senegalese historian Ibrahima Seck to be the museum's director of research and put $8 million of his own money into developing it, declaring, "America cannot rewrite its history, but that doesn't mean we should ignore it" (Cummings 2015).

To center the enslaved at the site, Cummings and Seck scoured the region, purchasing and restoring a Baptist church built by formerly enslaved individuals, four slave cabins from a nearby plantation, and a slave jail to be the centerpieces of the Whitney's tours, as well as artifacts associated with slavery like sugarcane cauldrons. Perhaps most affectively, the Whitney is infused with

memorials and commemorative art. Dotted throughout the landscape are forty terracotta sculptures by Woodrow Nash of enslaved children that people the site, attempting to fill in the absence of the enslaved so common at other plantations. There are also memorial walls honoring the individuals enslaved at the Whitney, in Louisiana, and the over two thousand enslaved children who died in St. John's parish. Whenever possible, the voices and experiences of the enslaved are evoked—in the excerpts from the WPA Slave Narrative collection,[15] in descriptions of their everyday lives with an emphasis on the horrors of slavery, and in stories told by the guides (Potter et al. 2022). In contrast to most plantations, here the "big house" is the last, and brief, stop on the tour, which visitors enter from the back, just as the enslaved would have done. The goal of the Whitney is to transform visitors through affective encounters with the history of slavery and stories of individuals; this is further evident in the lanyards that visitors receive before their tours that have illustrations of enslaved individuals (most from the plantation) and quotes or stories about them.[16] In its efforts at combining affect and history with the goal of transformation, the site reflects global commemorative norms. In its centering of slavery, it also challenges hegemonic American histories in radical ways, and both reflects and contributes to the "the rise of broader institutional efforts in advocating for more inclusive historical interpretation of slavery . . . across a wide array of historic sites, museums, and public spaces" (Potter et al. 2022, 17).

While plantations have been a central site of debates and developments in the representation of slavery in the United States, parallel shifts were occurring at other historic sites. Colonial Williamsburg began to interpret slavery in 1979, hiring six African American interpreters to play the role of the town's enslaved population.[17] George Washington's estate, Mount Vernon, opened a slave quarters to the public in 1962, though for several more decades slavery was "persistently concealed" until a slavery tour was introduced in 1995 (Araujo 2020, 136). Monticello, Thomas Jefferson's Virginia plantation, similarly began to offer slavery tours in the 1990s, pressured by what Araujo describes as the growing international push "to make slavery and the slave trade visible in the public space" (2020, 146). Over the next few decades the site began to incorporate more of this history, launching the oral history project Getting Word, which collects oral histories of descendants of the enslaved, commemorating the slave burial ground, and, in 2018, opening a new exhibit, "The Life of Sally Hemings," in Monticello's slave quarters (Araujo 2020, 150).

Museums have also been carefully wading into the struggle to represent slavery. Arguably, the Old Slave Mart Museum in Charleston, South Carolina, is the oldest and was the first slavery museum in the United States (a claim that the museum makes). It was opened in 1938 by Miriam B. Wilson who used it as a platform for advancing the Lost Cause argument that slavery was benevolent and necessary (Kytle and Roberts 2018, 246–256). After her

death, it was passed on to relatives who maintained this narrative. When her relatives passed away, the museum was almost shut down, but was ultimately acquired by the City of Charleston and reopened in 2007 with a focus on the domestic slave trade (Kytle and Roberts 2018, 327–328). However, as the museum's narrative throughout most of its existence attests to, musealizing slavery in the United States has never been a straightforward matter.

There were also early exhibitions addressing slavery, such as the Anacostia Neighborhood Museum's *Out of Africa* (1979) and the Smithsonian National Museum of American History's *After the Revolution: Everyday Life in America, 1780–1800* (1985), which included the experiences of enslaved families (Brooms 2012). However, as with plantations and other historic sites, in the 1990s and early 2000s momentum around the representation of slavery in U.S. museums grew. African American museums began to incorporate exhibits on slavery, such as Detroit's Charles D. Wright Museum of African American History (MAAH) that has a replica of slave ship as part of its exhibits on slavery, but, as Autry argues, in the MAAH and other African American museums the violence of slavery (and segregation) is "framed as ultimately surmountable obstacles toward Black emancipation" (2017, 86).

If representing slavery is controversial and complex in African American museums, at mainstream institutions it has been even more so.[18] An exemplar is the Library of Congress's (LOC) exhibition *Back of the Big House: The Cultural Landscape of the Plantation* (1995), which used quotes and photographs to show the experiences of those enslaved on U.S. plantations. However, hours before its opening, the exhibition was canceled and dismantled after African American LOC employees complained that it was offensive (Fischer 1995).[19] Tensions over employment discrimination and "long-standing grievances" against the LOC made the exhibit feel, to many Black employees, like "one more of the library's racist insults" (Vlach 2006, 63). The fact that an exhibition meant to counter efforts to silence and erase the experience of the enslaved and instead tell these often forgotten stories was so hurtful to the LOC's African American employees demonstrates just how thorny the memory of slavery can be. It is also a reminder that it is not just white Americans who are resistant to telling the history of slavery in museums: "The stance against the construction of a slavery museum in the United States has been historically related to the resistance of white public authorities and the population they represent in recognizing these atrocities as part of the country's official history and also associated with African Americans' rightful refusal to make slavery the central place of their historical experience" (Araujo 2020, 120).

Despite these ongoing tensions, the momentum around telling the history of slavery has not slowed. In the early 1990s, the African Burial Ground was uncovered in Lower Manhattan. Though a controversy ensued over what to do with what turned out to be the nation's largest and oldest burial ground for

enslaved and free Africans and people of African descent, community activism forced the U.S. government to open a memorial, in 2007, and small museum, in 2010, on the site to tell the story of the burial ground and slavery in New York City (Frohne 2015). The establishment of the African Burial Ground as a National Historic Landmark in 1993, and extensive research conducted at the site, helped to pave the way for the New-York Historical Society's 2005 groundbreaking exhibition *Slavery in New York*, which highlighted the centrality of slavery to the North and pointed toward a shift in mainstream museum practices toward a more critical and open confrontation with the difficult knowledge of slavery (Hulser 2012).

While many considered the African Burial Ground to be a site of national importance, and continue to today, plans were already underway for a national museum that would firmly usher in the third phase of African American museums in the United States: the Smithsonian National Museum of African American History and Culture (NMAAHC).[20] Yet as this brief recounting of race, memory, and slavery in U.S. museums shows, while global commemorative movements within the politics of regret have helped to shape memory of race and slavery in the United States, such memory has also been greatly influenced by persistent racial inequalities and the lasting legacies of slavery. As Araujo writes, "The construction of racial hierarchies in a modern world . . . largely impacted the ways slavery is remembered and memorialized in various Atlantic societies" (2020, 6). Race has always been a factor in shaping American historical memory, though it has taken a more central role in mainstream U.S. political and social life in the last two decades as the United States shifted into Landsberg's (2018) post-postracial era.

A New Form of American Memorial Museum

The three new museums that I am examining in this book, the Smithsonian NMAAHC, Montgomery's Legacy Museum, and Tulsa's Greenwood Rising, mark a shift into what we can see as a third phase of African American museums. But, going further, I argue that they also represent the emergence of a new type of American memorial museum. While the United States has several world-class memorial museums, in particular the USHMM, which serves as a global model, and the 9/11 Memorial Museum, until recently, there have not been any prominent national (or nationally prominent) museums that commemorate violence perpetrated by the United States. That has begun to change with these new museums that draw from both the long history of African American museums and the global memorial museums movement to represent a new iteration of American memorial museum—one that presents a more critical historical memory of slavery and its legacies, departing from narratives of racial progress in its efforts to convey morally transformative messages to its visitors.

These new museums differ from their predecessors in several important ways that link them to the global memorial museum movement and point to an important shift in American historical memory of race, slavery, and its legacies. One important difference is in their intended audiences and narrative orientations. While museums of African American history and culture have typically been created and framed as what we might call "ethnic," "culturally-specific," or "identity-driven" museums, the three museums examined in this book depart from that model. Though their focus is on African American history and experiences, unlike their predecessors in the United States they are not intended primarily for African American communities and are meant to attract audiences well beyond. Rather than presenting African American history as a "counter" history to that presented in mainstream institutions, these museums work to center African American history within mainstream American historical memory. In this way, they teach more universal lessons about the centrality of slavery and inequality to all of American society, and they are aimed as much at white visitors as they are at African American visitors.

This is exemplified by NMAAHC founding director Lonnie Bunch's claim that the museum was "not being built as a museum by African Americans for African Americans. . . . [Rather,] African American culture is used as a lens to understand what it means to be American" (qtd. in Burns 2013, 159). The Legacy Museum and Greenwood Rising similarly work to tell their histories as American history. The Equal Justice Initiative (2022) makes the point that the Legacy Museum is intended to tell a "comprehensive history of the United States with a focus on the legacy of slavery" via its "immersive experience with cutting-edge technology, world-class art, and critically important scholarship about American history." Greenwood Rising (n.d.-b) is intended to educate Oklahomans and all Americans, and to frame the massacre through a "lens of a centuries-long period of anti-Blackness in America and systemic oppression grounded in laws and customs, and rooted in social, political, and economic systems."

In their attempts to tell a more inclusive history that conveys universal moral messages, these museums reflect the goals of many memorial museums around the world that are working to insert the memory of genocide, exclusion, oppression, and suffering into the broader historical memory of their societies. Just as Holocaust museums vow to ensure that their societies never forget so that "never again" can such violence occur, these museums are meant to insert the memory of the painful past of racial injustice into dominant American historical memory in a way that can spark change. But in order to do this in a meaningful way, they must reach white visitors, in particular. Thus, while they serve (to varying degrees, as we shall see) as vital Black spaces for their communities, they are also aimed at presenting this difficult history to white Americans.

In order to center this difficult history in the larger American historical memory, the NMAAHC, the Legacy Museum, and Greenwood Rising also mark an evolution in museum form, in particular when analyzed next to each other. Their exhibits indicate a movement from more traditional displays in earlier African American history museums, with a focus on objects and their interpretation, toward the new exhibitionary strategies of memorial museums that combine the educative functions of history with the affect of memory. Memorial museums are hybrid commemorative forms that infuse their historical exhibits with memory, from incorporating testimony and interactive digital media to providing experiential encounters that attempt to take the visitor "back in time" to experience the past. They are driven by narrative; even the NMAAHC, which has amassed an enormous collection of objects and is the most traditional of the museums examined here, is focused primarily on the story it tells. The Legacy Museum and Greenwood Rising go further and display hardly any objects, instead using innovative digital technologies to advance their narratives. They are thus what we would call narrative, conceptual, or experiential museums that depart from more traditional museological practices of collection, display, and interpretation of objects and instead focus on telling stories in ways that impact visitors emotionally.

A key part of how these museums work to convey their morally transformative messages is by connecting past to present. Autry notes that most African American museums (and in fact most memorial museums) have worked to clearly separate past from present in the service of constructing national consensus: "By displaying coherent narratives that locate social disintegration and fragmentation as artifacts of a bygone era distinct from the present, the collective as a unifying force is restored" (2017, 188). In the Legacy Museum and Greenwood Rising, and to a lesser degree in the NMAAHC, the trauma of slavery and its ongoing legacies is not allowed to remain in the past. Rather, they work to connect past to present to demonstrate the ongoing impacts of the past. Memorial museums, with their goals of moral transformation of their visitors and societies to embrace an ethic of "never again," are intended to highlight this connection between past and present—to show their visitors that what happened in the past can plausibly happen again in the present and future without their vigilance. The museums I focus on here, to varying degrees, go further and attempt to show their visitors that the violence, injustice, and inequality of the past continues today and that they must actively work to change this.

But it is not just the ways in which they present history and connect past to present and the audiences that they are created for that differentiates them from other African American and memorial museums in the United States. It is, especially, the history that they tell that represents a critical shift in the commemorative and historical landscape of the United States. While the

sweeping story of slavery and segregation that the NMAAHC tells is one that is increasingly well known, telling this story in a Smithsonian museum on the National Mall is a radical intervention into the official history that has, until recently, defined national museums of history. The Legacy Museum and Greenwood Rising go even further. The Legacy Museum does not just tell the story of slavery, it makes the argument that slavery did not end but evolved into mass incarceration—an argument that has gained traction in academia and some circles of public discourse but is unprecedented in museological form. It makes this argument with a deep and sustained discussion of lynching, one of the most shameful and silent chapters in America's history. Greenwood Rising not only tells the detailed story of the Tulsa Race Massacre, which until just a few years ago was almost completely unknown to the American public except by those who minimized it as a race riot, but also situates the massacre within the United States' larger systems of anti-Blackness, refusing to allow the elasticity of the concept of racism to obscure or make abstract what was a brutal attack on Black agency and accomplishment. Just a decade ago, these museums would have been unthinkable in the critical and challenging histories that they tell, pointing to the newness of what it is that they are doing.

However, just as musealizing the past in memorial museums may serve the unintended purpose of distinguishing past from present and allowing the past to remain past, so too in the NMAAHC, the Legacy Museum, and Greenwood Rising the effort to tell this difficult history in a way that unflinchingly connects past and present is often uneven, revealing the limits of memorial museums in their efforts to morally transform individuals, collectives, and societies. Silke Arnold-de Simine has written that the memorial museum has been viewed as something of a "panacea" that "promises to offer democratic and inclusive approaches to difficult pasts, to preserve the collective memory of a generation of . . . witnesses, to channel public debates and to regenerate urban and rural areas" (2013, 8). Some of these impulses and hopes are clearly built into this new set of museums that seek to address past and ongoing racial injustice in the United States in a way that can contribute to societal transformation. However, as studies of memorial museums demonstrate, museums themselves are not a panacea and can be at best one part of larger social efforts at change (e.g., Autry 2017; David 2020; Jinks 2014; Sodaro 2018). Thus, the museums examined in this book are part of a shifting public debate and discourse about the ongoing legacies of slavery, but they are limited in just how much social change they can spark. And yet, societies around the globe cling to the hope that remembering past violence and injustice will help to prevent them in the present and future. Thus, these museums are likely the beginning of a phase that will include many more efforts to publicly and critically examine the United States' history of racial violence, injustice, and inequality.

Conclusion

In 1881, Frederick Douglass wrote, "Slavery is indeed gone, but its shadow still lingers over the country," an observation that remains particularly salient today (and which I have used as the epigraph for this book), as debates over Confederate symbols, critical race theory, reparations, and Black Lives Matter remind us that the past is hardly past. While the United States has been extremely slow to acknowledge the atrocities of its own past, in the context of the global politics of regret and shifting national narratives, histories, and dynamics, discursive space appears to have opened up to more critically and openly address this dark side of U.S. history. Amidst a range of initiatives aimed at confronting the history and legacies of slavery, museums have emerged as one critical social forum for this new reckoning, in particular the three museums examined in this book. In their critical engagement with the "difficult knowledge" of slavery and its legacies, these museums reflect an adherence to the normative expectations around historical memory of violence that have spread around the globe today. The United States appears to be finally catching up with the "global rush to commemorate" within a politics of regret (Williams 2007).

However, within the American context, in which racism is often misunderstood to be an individual phenomenon, these museums also do something more radical: they move beyond simple victim-perpetrator binaries, instead demonstrating that racial inequality is structured into our institutions. They thus take us into the ethically complicated but potentially progressive and productive territory of implication. Michael Rothberg introduces the concept of the implicated subject to describe a relationship to historical and present injustice, oppression, and violence that doesn't fit the usual, clear-cut categories of victim, perpetrator, and bystander: "Implicated subjects occupy positions aligned with power and privilege without being themselves direct agents of harm; they contribute to, inhabit, inherit, or benefit from regimes of domination but do not originate or control such regimes" (2019, 1). In the United States, implicated subjects are the beneficiaries and participants in a deeply entrenched system of racist injustice, violence, and oppression. Rothberg argues that accepting this position can "open up a space for new coalitions across identities and groups" because it "draws attention to responsibilities for violence and injustice greater than most of us want to embrace and shifts questions of accountability from a discourse of guilt to a less legally and emotionally charged terrain of historical and political responsibility" (2019, 20). Accepting this implication demands that individuals, as well as groups and institutions, take responsibility for the burdens of the past.

In their exhibits, narratives, and public programming, the NMAAHC, the Legacy Museum, and Greenwood Rising—to varying degrees—tell a story of the implication of white American individuals and institutions in past and

present racial injustices. In this they have the potential to radically alter the historical memory of slavery, as well as shape contemporary responses to racial injustice. However, as this chapter has shown, reckoning with the United States' racist past is a complex endeavor, and these museums help us to understand the broader societal movement toward addressing past and present racial injustice and the virulent resistance to this movement in the effort to maintain the status quo. But a closer examination shows that these museums navigate their particular political, social, and cultural contexts in ways that are often uneven, revealing their potential to contribute to the development of a new and critical historical memory of race in the United States but also the perils they face within today's post-postracial context.

2

Telling "America's Story"

●●●●●●●●●●●●●●●●●●●●●●

The National Museum of
African American History
and Culture

> What stories are we prepared to tell,
> and what stories are we willing to hear,
> without transforming them into preferred
> narratives that make no demands on our
> comforting illusions about the relation-
> ship between slavery and freedom in the
> life of the nation?
> —Edward Linenthal, "Epilogue:
> Reflections" (2006, 216)

The Smithsonian National Museum of African American History and Cul-
ture (NMAAHC) was chartered by George W. Bush in 2003 and opened in
September 2016. It had been a hundred years in the making, its creation pro-
ceeding in fits and starts that mirrored national political, cultural, and eco-
nomic shifts over the course of the twentieth century. Its opening, in the
waning days of Barack Obama's presidency, celebrated the museum as a symbol
of national unity—if not by putting past racial violence and injustice behind
us entirely, by understanding it as central to the teleological tale of progress that
is America. In his lofty speech, Obama posited that "the American story

that this museum tells [is] one of suffering and delight; one of fear but also of hope; of wandering in the wilderness and then seeing out on the horizon a glimmer of the Promised Land" (The White House 2016). Congressman and civil rights hero John Lewis called it a "great monument to our pain, our suffering, and our victory" (Yahr 2016a). From its opening, the expectations of what this museum would mean in the struggle for racial justice were high; in the words of former president George W. Bush, "Even today, the journey towards justice is not compete. But this museum will inspire us to go farther and get there faster" (Yahr 2016b).

While the opening of the museum reflected Obama's "hope" and "Promised Land," the subsequent election of Trump and surge in white nationalism and exclusionary politics reminds us that the past is not as neatly packaged and put away as it is in the museum. In many ways, the NMAAHC embodies larger, national tensions around historical memory of race and slavery—it is an institution filled with promise, but also paradox. As a federal museum located on the National Mall, the symbolic recognition of African American history that the NMAAHC bestows is unparalleled. However, while the museum's representation of this essential history plays an important role in moving the nation closer toward justice, the fact that it is a national museum in many ways compromises its ability to truly break from the triumphalist narrative of race in the United States. For the NMAAHC is straddling two historical narratives that are viewed by many as incompatible. It must tell the story of African American history, much of which is a story of oppression and injustice, as central to American history, which is rooted in patriarchal white supremacy and myths of freedom, equality, and democracy. Further, it must try to reconcile the tension between a focus on the inhumanity and supreme violence of slavery versus one that celebrates African American resistance and agency. These paradoxes and tensions have very much shaped the ways that this federal museum, in the heart of the nation's capital, tells the difficult story of "America's original sin" (Wilkens 2016, 58).

"Making a Way Out of No Way"

The creation of the NMAAHC has been well documented, and today feels somewhat inevitable (Bunch 2019; Wilkens 2016; Wilson 2016).[1] Spanning the course of a century, the museum's development was interwoven with and shaped by major twentieth century events like the world wars, the Great Depression, and the Civil Rights Movement, as well as by shifting social and cultural norms related to race in the United States. But from the very start, the demands for a memorial, and later museum, were tied to recognition and social justice, putting the project at the avant-garde of memory work in the twentieth century.

In 1915, the Committee of Colored Citizens was formed to support Black veterans who were excluded from the national commemoration of the fiftieth anniversary of the Civil War in Washington, DC. Frustrated by the lack of recognition of their sacrifices and patriotism—and looking to celebrate and commemorate African American self-emancipation through fighting and dying in the Civil War (Woodley 2023a, 198)—the committee decided to use money it had raised to build a monument to Black soldiers in Washington. At this time, support for the Ku Klux Klan (KKK), Jim Crow laws, and lynching was surging. The racist film *The Birth of a Nation* had just been released and was taking the country by storm—it was even screened at the White House—reinforcing stereotypes and caricatures of African Americans, glorifying the KKK, and helping to set off waves of violence that would spur the Great Migration. Although African American memory work was an important form of resistance to the anti-Black sentiment surging through the United States at this time (Woodley 2023a), much of that memory work was being driven into the shadows by Jim Crow, segregation, and the KKK (Kytle and Roberts 2018, 9). Within this context, the initial efforts to create a monument to Black soldiers were linked to "humanizing" Black Americans and celebrating their contributions to American society (Wilkens 2016, 36). The first bill to create a monument was introduced in Congress in 1916, but World War I intervened, putting the controversial project off even while Black soldiers fought for the United States in segregated ranks.

After the war, momentum to build the monument returned and became linked to growing anti-lynching campaigns. A memorial was no longer deemed enough to "recognize the Negro as a fellow human being" and the scope of the project expanded to a "memorial building" that would not just commemorate but also celebrate Black achievements (Wilkens 2016, 36). Advocates for the project argued that such a space would not only help to show (white) Americans the many contributions Black Americans had made to society— from "distinguish[ing themselves] on almost every battlefield of the Republic" to "lay[ing] the economic foundations of our society" through unpaid slave labor—but also change attitudes of those who believed in the "insignificance of the negro" (U.S. Congress 1928, 7). In this sense, plans for a public, national African American monument reflected the goals of many African American museums in the United States with their "vindicationist" narratives (e.g., Autry 2017; Burns 2013). But these plans also reflect the goals of many contemporary memorial museums, to both educate and commemorate in a way that will change individual attitudes and shape societies to be more tolerant and inclusive. These arguments were effective enough that a bill to create a National Memorial Building to Negro Achievement and Contributions to America was signed into law by President Coolidge in 1929. However, history again intervened and plans languished as America clawed its way out of the Great Depression and into World War II, in which Black soldiers again fought

in segregated ranks abroad and continued to be treated as second-class citizens at home.

It was not until the 1960s that the project found renewed energy in the successes of the Civil Rights Movement and broader societal shifts as previously marginalized groups began to demand rights and recognition. The first wave of African American neighborhood museums had begun to emerge across the country, but when James Scheuer, a white senator from New York, introduced a bill to create a "Negro History Museum Commission," debates around the project shifted (Wilkens 2016, 47). Many in the Black community were skeptical about a project spearheaded by white Americans, or its being a federal museum at all, believing that knowledge about Black history would be better disseminated in textbooks or other forms within African American communities (Wilkens 2016, 50). Meanwhile, violent riots in cities across the United States led President Johnson to commission the 1968 Kerner Report on racial violence, which concluded that "our nation is moving toward two societies, one Black, one White—separate and unequal." In a 1968 hearing before Congress, James Baldwin summed up much of the turmoil and indecision around the project: "My history . . . contains the truth about America. It is going to be hard to teach it" (qtd. in Wilkens 2016, 51). Just days after Baldwin's testimony, Martin Luther King Jr. was assassinated and the nation descended into anguish and riots, at once a reminder for detractors of the challenges posed by the project and, for advocates, of its pressing necessity.

As debates over a national museum continued in the 1970s and 1980s, African American history and culture museums moved into the second phase of larger, more prominent museums and historic sites, many of them celebrating the Civil Rights Movement, which gave new force to calls for a national museum. When officials in Ohio began to explore the creation of an African American history museum in Wilberforce, an important stop on the Underground Railroad and the site of historically Black Wilberforce University, some in DC hoped this initiative could become the national museum. However, when Congress passed a federal charter for the creation of the National Afro-American Museum in Wilberforce in 1981, rather than satisfying those calling for a national museum, it renewed demands for a museum in Washington (Yiin 2016). In order for the museum to be truly national and bestow the desired recognition of African American history and culture, the Smithsonian was considered by many the best home for such an institution, despite its poor record of telling Black history and promoting a diverse workforce (Wilkens 2016, 59).

When the Smithsonian National Museum of the American Indian (NMAI) was approved by Congress in 1989, arguments against a similar African American institution had even less traction. This diminished further with the opening of the USHMM just off of the National Mall in 1993, which caused many to question why the nation's capital would have a museum commemorating the

Holocaust and no memorial or museum remembering "America's original sin" (Wilkens 2016, 58). In this context, the National African American Museum Project was established at the Smithsonian, advancing John Lewis's bill to create a "National African American Heritage Museum and Memorial" closer to realization, despite detractors like Senator Jesse Helms, who worried that such a museum would "demonize America" (qtd. in Wilkens 2016, 65). An unlikely bipartisan congressional coalition—John Lewis and Max Cleland, both Democrats from Georgia, and Republicans Samuel Brownback of Kansas and J. C. Watts of Oklahoma—gave the project the final push it needed, and, by the time George W. Bush took office in 2001, there was broad bipartisan support. A bill for the creation of the museum was passed by Congress in 2001 and Bush chartered the museum in 2003. But there still remained details of its location and design, and a new Presidential Commission was formed to hammer out the final plans.

"A Fool's Errand"

In 2005, Smithsonian leadership made a decision that would play a tremendous role in shaping the institution into what it is today: they selected Lonnie Bunch to be its founding director.[2] Bunch, who would go on to serve as the first African American secretary of the Smithsonian, started his career as a curator at the National Museum of American History and was intimately acquainted with the inner workings of the institution. Initially reluctant to take the helm of a "museum of no: no staff, no site, no architect, no building, no collections, and no money," Bunch ultimately decided he could not resist being part of a project that would "nurture the souls" of his ancestors (Bunch 2019, 8–9). His professional background as a Smithsonian insider combined with his personal attachment to the project meant that he well understood the challenges that the museum faced, such as how to balance the suffering and pain of slavery and segregation with an uplifting celebration of African American culture, and how to carefully tell this fraught history in a way that makes it an American story.

Bunch saw in these challenges a potential that reflects the expectations of what Lea David terms "moral remembrance" (2020) and the global proliferation of memorial museums that are intended to fulfill a particular set of functions. Bunch writes:

> The museum would be a laboratory for me to test and implement my hopes for
> what a museum could be in the 21st century. I wanted a museum that was a
> tool to help people find a useful and useable history that would enable them to
> become better citizens; a museum that would explore and wrestle with issues
> of today and tomorrow as well as yesterday . . . an institution that was of value
> both in the traditional . . . and in nontraditional ways, such as being a safe

space where issues of social justice, fairness and racial reconciliation are central to the soul of the museum. (2019, 9–10)

From the beginning he saw that the museum must do more than just display artifacts and teach history; it must also work to change visitors to become better citizens and work toward social justice and racial reconciliation. In other words, he planned to make it a transformative institution.

To do this, Bunch had to get the Museum Council on board with his vision and ultimately answer to the Smithsonian's Board of Regents. One of the thorniest questions was that of the location and building the museum would be housed in, in particular whether it would be located on the National Mall. The Mall is commonly viewed as America's front lawn—the most richly symbolic cultural location in the nation; for this reason, real estate on the Mall is extremely valuable. Many, including members of Congress and civil society actors like the National Coalition to Save the Mall, believed that the Mall was already "full" and that the NMAI and the USHMM had gone too far down the slippery slope into calls from various ethnic and racial groups to have their stories told on the Mall (Wilkens 2016).[3] The decision was ultimately up to the Board of Regents, with input from the Museum Council, who reviewed four locations: two removed from the Mall, one in the old Smithsonian Arts and Industries building, and the present "Monument" site. Proponents of the spaces off the Mall argued that the museum could help "expand" the Mall and develop parts of Washington in need of revitalization, while supporters of the Arts and Industries building believed that this was an excellent compromise that would get the museum on the Mall without overbuilding. But others, including Bunch, worried that a site far from DC's tourist center or in a "second-hand building" would be an "insult to Black America" (Bunch 2019, 39–40). In contrast to many of the African American museums in the first and second phases (see chapter 1), which were created in and for African American neighborhoods and communities, Bunch and many of the staunchest supporters of the NMAAHC wanted this museum to have a central place in Washington, DC, and, accordingly, American historical memory. The regents agreed and selected the Monument site.

Because the site was empty, a new building would have to be constructed and two architecture firms with extensive museum experience were hired to guide the plans: Davis Brody Bond in New York City, which had designed the New York Public Library's Schomburg Center for Research in Black Culture, the Birmingham Civil Rights Institute, and would soon design the 9/11 Memorial Museum; and Freelon Group Associates in Durham, North Carolina, which had designed Baltimore's Reginald F. Lewis Museum, San Francisco's Museum of the African Diaspora, and eventually Atlanta's National Center for Civil and Human Rights. To see how other museums told difficult histories and "ran against the grain of mainstream cultural narratives" (Wilson 2016, 53),

and reflecting the transnational ways that memory travels today (e.g., de Cesari and Rigney 2014; Erll 2011), the Davis Brody Bond and Freelon Group teams visited museums around the world, including Ottawa's Canadian Museum of History, Yad Vashem in Israel, the Museum of New Zealand Te Papa Tongarewa, and the nearby USHMM. They also interviewed hundreds of visitors to the Mall and held public forums across the country to find out what the public wanted to see in the museum. The responses were many and varied; there was great interest in the museum and people hoped the museum would "tell the truth" (Wilson 2016, 51) about African American history in a museum that was "inclusive and relevant" and not "watered down" (Bunch 2019, 47). Exactly what this meant was not always clear: as Bunch put it, slavery was the number-one issue that people wanted to see represented in the museum and the number-one thing they did not want to see (Gardullo and Bunch 2017, 252).

From this research a conceptual plan for the museum was developed, sketching out the galleries and main topics of the permanent exhibition. This was clearly a team well acquainted with best practices for the creation of a museum like this, from the museum experience of the architectural firms to the inclusive, public nature of their information gathering to their visits to other museums around the world. Adhering to these best practices and principles of inclusiveness and transparency, an international architectural competition was called, with an emphasis on ensuring that minority architects and firms were among those chosen. Six finalists, all with minority principals, were selected to submit concept designs, which were displayed at the Smithsonian for the public to weigh in on. After presentations by the teams and several weeks of deliberation, the jury selected London-based Ghanaian-British architect David Adjaye, who had teamed up with Bond and Freelon.[4] Their design—a tiered building sheathed by a bronze "corona" inspired by Yoruba design and African American ironwork, with a welcoming porch referencing African American and Caribbean culture—was, as the architects put it, deemed to best "embody the African American spirit. Majestic yet exuberant. Dignified yet triumphant. Of the African Diaspora yet distinctly African American" (qtd. in Wilson 2016, 59).[5]

As the project progressed, Bunch and his growing staff worked to keep the museum visible in the public eye, which was essential to maintaining momentum, particularly in fundraising. The museum teamed up with the popular StoryCorps project to create StoryCorps Griot to collect African American stories. They held a monthly program on NPR in which Bunch and Michele Gates Moresi, supervisory curator of collections, would discuss objects from the expanding collection. Bunch traveled the world to lecture and present on the museum, including a trip to Ghana's Cape Coast, which influenced his ideas about the emotional impact the museum should have when telling about slavery. The museum also created ten temporary exhibits, some of which traveled

the country and some of which were displayed in a dedicated gallery in the National Museum of American History, further seeking to cement the museum and its history into mainstream American historical memory.

Another way Bunch maintained public visibility was through building the museum's collection. Earlier in his career, Bunch himself had subscribed to a common assumption that there exists a "paucity of objects that illustrate African American history and culture" (Bunch 2019, 90). Just as traditional historical narratives are written by the victors, so museum professionals and the general public have long assumed that there is little extant material culture associated with minoritized groups who have been largely left out of public history. In the early days of the museum's conception, Bunch and his team wondered whether a collection was even necessary, or whether technology could replace artifacts in telling the museum's story, particularly in light of the changing roles of museums (Bunch 2019, 92). But Bunch's experience curating other African American exhibits for the Smithsonian suggested that one just had to find creative ways to uncover the material remains of African American history.

In addition to reaching out to collectors, museums, archives, and other historic institutions to mine their collections, Bunch—inspired by the popular PBS program *Antiques Roadshow*—initiated a program called Save Our African American Treasures. Over several years, this program traveled the country, inviting people to bring their family heirlooms in for consultations with curators with the goal of helping families preserve these objects and understand their symbolic and monetary value. For while the dominant, white American historical memory had ignored and marginalized Black memory work since the Civil War, African Americans had maintained and cared for their *lieux de mémoire* (O'Meally and Fabre 1994). Not only did this program help the museum acquire objects, but it also provided ways to connect with communities: in helping people see the value of their family heirlooms, the museum team built trust with communities and interest in the museum (Bunch 2019, 95). These were also media events that drew attention to the museum's creation and the stories that it would tell. The museum also partnered with local African American museums at these events, working to assuage fears that the NMAAHC would siphon attention, interest, and resources from the local institutions that had worked so hard to establish themselves in their communities. Thus, although it would be a national museum, erected in the heart of the nation's capital and meant to appeal to all Americans, from its conception through its realization the NMAAHC worked hard to include African American communities in its creation. As Ana Lucia Araujo writes, the NMAAHC's historical exhibition "is the only exhibition in an official national institution in the world to recount the history of slavery from the point of view of the African American community whose ancestors were enslaved" (2020, 129).

In addition to grassroots efforts to build a collection out of nothing, the museum had some high-profile acquisitions enabled by its status as a national institution. Historian Charles Blockson donated a collection of items belonging to Harriet Tubman—her handkerchief and hymnal are on display—and Joyce Bailey donated a collection of objects related to Black fashion owned by her mother, Lois K. Alexander Lane, including the dress sewn by Rosa Parks that she was carrying when she was arrested (Bunch 2019, 99). For Bunch, the most meaningful but also in some ways the most fraught object is the casket that Emmett Till was buried in.[6] Early in his tenure as the new museum director, his friend Mamie Till Mobley had asked him to carry on the memory of Emmett. Though he and his team worried about the ethics of collecting and displaying a casket, ultimately they decided that accepting the donation would be an essential part of carrying Emmett's memory, and it would become a central memorial complement to the museum's historical narrative (Bunch 2019, 113).

Because the project began with nothing, a team of designers, curators, scholars, and educators was working to design the ninety-thousand-square-foot exhibition even as they were assembling the collection and the building was being constructed. As Bunch composed a museum staff, he also created a Scholarly Advisory Committee, chaired by John Hope Franklin until his death in 2009 and made up of some of the foremost historians, art historians, anthropologists and archaeologists, and educators to provide "intellectual guidance" to the process (Bunch 2019, 162).[7] His team also visited universities across the country to meet with scholars who would help develop the exhibitions. Ultimately, each exhibition had its own scholarly advisory body (Bunch 2019, 166) and over sixty historians were involved in the process, helping to shape the museum's rigorous historical narrative and, as we shall see, providing a sharp contrast to the Legacy Museum and Greenwood Rising, which were both largely created by individuals who were not museum professionals or historians.

The NMAAHC was ultimately able to collect thirty-five thousand objects to house and display in the stunning building by Freelon Adjaye Bond / SmithGroup that is unlike anything else on the Mall.[8] Though the tiered corona has a low profile from the distance, appearing to fit into the bland, neoclassical style of the Mall, when one gets close its metallic skin shines and the intricate latticework plays with the light, reflecting the museum's desire to open dialogue about race and racism that can contribute to healing; the upward thrust of the corona is meant to symbolize the inspiration and aspirations of the museum's stories (NMAAHC n.d.-b.). The museum is dramatically flanked by the Washington Monument and, from both outside the building and from strategic vantage points within, visitors can see the White House and Capitol—a symbolic location indeed for the nineteenth Smithsonian museum that took a hundred years and $500 million to create.

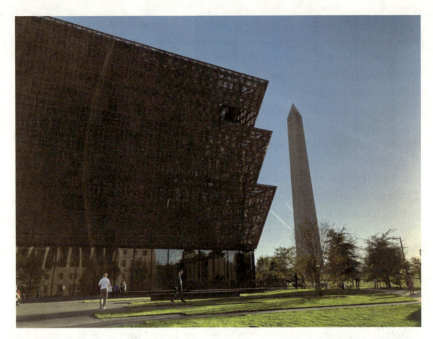

FIGURE 1 National Museum of African American History and Culture with view of Washington Monument. Photo: Amy Sodaro.

The symbolism of the location is both important to and reflective of the story the museum tells. As the long, winding road to its creation suggests, many Americans along the way thought that such a museum should not exist or at least should not be located on the National Mall. Many others disagreed about what kind of story the museum should tell, in particular the question of how to balance the horror of slavery with stories of uplift, resistance and "making a way out of no way." These issues with which all African American museums have had to contend are particularly fraught in the NMAAHC, which had as its mandate to make this most heinous part of America's history central to the overarching American experience.

The Journey toward Freedom: The NMAAHC Historical Exhibition

The NMAAHC's centerpiece is the historical exhibition, which covers three subterranean floors and was designed by the preeminent exhibit design firm Ralph Appelbaum Associates (RAA), known for their work in similar institutions such as the USHMM and the Canadian Museum of Human Rights. The historical exhibition is complemented by two upper floors of permanent galleries celebrating African American culture and achievement, as well as

temporary exhibits, but visitors are meant to start their tour of the museum deep underground and in a distant past. Before beginning *The Journey toward Freedom: 15th–21st Centuries*, visitors are ushered into a holding area that explains that they are about to embark upon the "uneven history" of African Americans, who came to the United States as "forced labor" but through their struggles "forced the nation to rethink the meaning of freedom and equality." As visitors wait to descend, they are given a visual overview of this "uneven history" on a massive wall of photographs and images that span the African American experience, from etchings of enslaved Africans in the colonies to a photograph of Barack Obama's 2009 "Beer Summit" with Henry Louis Gates Jr.

The historical exhibition begins four stories underground with "Slavery and Freedom 1400–1877." In this section, the development of chattel slavery is laid out chronologically, beginning with a brief display on Europe and Africa before they collided in the transatlantic slave trade. Using dim lighting and close, claustrophobic space (e.g., Gruenewald 2021), the exhibition moves visitors into a display on the Middle Passage and it is here that visitors have one of their first immersive encounters with the past. While panels, statistics, and images give an overview of the workings of the transatlantic slave trade, visitors are invited to enter a cramped, dark room with the sound of waves crashing in the background, evoking a slave ship. Visitors walk along a creaky wooden plank catwalk listening to haunting testimony of individuals who endured the terrifying journey. A few objects are displayed in dramatic lighting—shackles to fit an adult and child together with a tiny shackle-shaped amulet, and large ballasts that were used to steady the ship and its human cargo. The room, which its creators acknowledged was "almost designed as a memorial space" (Catlin 2015), exemplifies the kinds of affective encounters that are mediated through lighting, sound, and "affective architecture" (Jinks 2014), and which are commonly used in memorial museums to evoke an emotional response in visitors that will help impart the museum's moral message.

From this moving experience, the exhibition goes on to discuss slavery's different forms in the varied regions of colonial America and the contradictions of the Revolutionary War as a fight for liberty even while slavery became the foundation for this new land. From the very beginning, the fundamental paradox, but also the American-ness, of the museum's story is explicit: "The US was . . . forged by slavery as well as a radical new concept, freedom. This is a shared story, a shared past told through the lives of African Americans who helped form the nation." For visitors, it has also become clear at this point the methods the museum employs for its storytelling: the exhibition is packed with artifacts, images, and documents, which are arranged in chronological display cases and explicated by text panels, with video and audio filling in the museum experience. For visitors to other memorial museums, such as

the USHMM, it is a very familiar mode of storytelling, dense with information and with affective and experiential elements integrated throughout.

As the exhibition progresses through the Revolutionary War, it opens to the visual representation of one of the central arguments of the museum: the "Paradox of Liberty." This is one of the most widely photographed parts of the museum and provides what cultural studies scholar Tim Gruenewald calls "a visceral experience of freedom" that helps to shape the story of slavery into America's teleological tale of progress (2021, 122). A bronze sculpture of Thomas Jefferson stands atop a platform with the Declaration of Independence spelled out behind him on the towering wall. At first glance, this looks like any other celebration of the founding of America, but, on closer examination, the story begins to crumble. Behind Jefferson is a stack of boxes each with the name of one of the over six hundred individuals that he enslaved whose names have been retrieved. Though the stacked boxes can be likened to efforts to name victims as a form of memorial and mourning, a common trope in Holocaust and other memorial museums, Araujo argues that with Jefferson standing at its center, this exhibit "utilizes the wall of names device to reinstate racialization and reinforce white supremacy" (2020, 62). Artifacts from Monticello—Jefferson's eyeglasses, a pen holder—however, are reframed as tools that helped him create the fundamental paradox of the nation's dual foundations of freedom and bondage. Surrounding Jefferson are four other bronze sculptures. In another museum these might be other white, elite founding fathers, but here they are individuals who challenge Jefferson's notions that Blacks are "inferior to the whites in the endowments both of body and mind".[9] Toussaint Louverture, the Haitian revolutionary; Elizabeth Freeman, who successfully sued for her freedom in Massachusetts in 1781; the poet Phillis Wheatley; and the self-taught scholar Benjamin Banneker.

This paradox continues to frame the rest of this exhibit on how slavery shaped America, as the exhibition traces the expansion of both the United States and the domestic slave trade, after the international slave trade was banned in 1808. Here, as in much of the museum, data and dispassionate historical analysis are complemented by affective, individual stories. A timeline of maps of the expansion of the United States, detailing each treaty and compromise, is balanced by moving audio testimonies taken from the WPA Slave Narrative collection about the horrors of family separations and a wall subtly lined with details of sales of enslaved individuals, including "For the sum of $5.00 ONE NEGRO BOY named Sharpen aged eight years (1825)." In the middle of the room, yet another theme in the museum's history telling emerges: African American resistance and resilience framed throughout the museum as "Making a Way Out of No Way." Here some of the draconian laws that governed the lives of the enslaved—such as prohibitions against marriage or gathering in groups—are set against the creative ways that African Americans

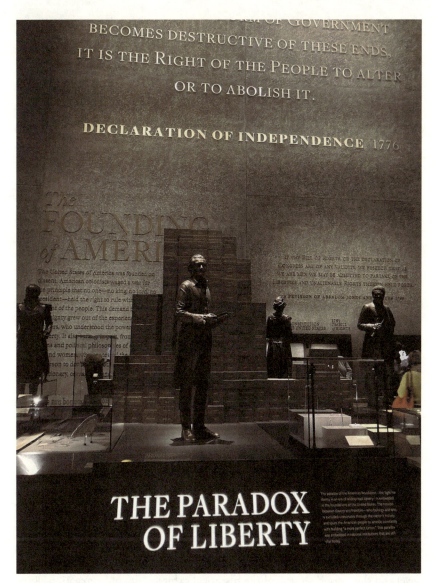

FIGURE 2 *The Paradox of Liberty* exhibit. Photo: Amy Sodaro.

circumvented these rules: a wedding ring is displayed that was used in over four hundred illegal marriages; musical instruments and artifacts from Black churches inform visitors that despite gatherings being forbidden, Black institutions and culture were not only developed and sustained, they also thrived. Even the actual slave cabin from Point of Pines, North Carolina, is displayed to show the inhumanity of slavery as an institution—the point is made that the cabin gave some shelter, but no safety—balanced with the humanity and

50 • Lifting the Shadow

agency of those who resided in such cabins and still found ways to "nurture," "cultivate," and sustain "community."

This first floor of the historical exhibition ends with the Civil War. Somewhat dry historical analysis succinctly explains the lead-up to the war—the abolitionist movement and moral arguments against slavery clashing with the economic benefits of the institution. But subtly woven in are more provocative statements about how institutions like banks, insurance companies, and even the post office were implicated in the perpetuation of slavery. The exhibit points out that "the lives and labor of enslaved African Americans transformed the United States into a world power. Yet they received no recognition or payment for what they created." This statement at once seems to be a basis for arguments for reparations—which could be read as dangerous in a national institution[10]—but also as justification of the museum's existence as a prominent, Smithsonian institution located in the heart of the National Mall. But the statement's placement in an awkward corner of the dense historical exhibition perhaps renders it somewhat toothless, with many visitors passing it by.

The first level of the historical exhibition ends on a note of triumph: the brief "Emancipation and Transformation of America" highlighting immediate changes after the war was won and Reconstruction began. On the wall are reproductions of the Emancipation Proclamation, and the Thirteenth, Fourteenth, and Fifteenth Amendments.[11] The Point of Pines cabin takes on new meaning as the exhibit describes how African Americans were newly able to acquire land. Many went on to live in former slave cabins, which they could now fashion to be their own, as well as reunite with family and establish churches and schools, in particular the historically Black colleges and universities. As with each level of the historical exhibition, there is an alcove where one can sit with their thoughts, surrounded by images and quotes from prominent individuals in the fight for racial equality, as well as a Reflection Booth where, in pre-COVID times, visitors could record their experiences and thoughts before soldiering on to the next section.

The promise of Reconstruction is quickly broken by the Compromise of 1877, which is briefly explained in a video on the ramp up to the next subterranean level and the second section of the historical exhibit: "Era of Segregation 1877–1968." This section is perhaps the most familiar, as a fairly traditional exhibit on the lead-up to and ultimate triumph of the Civil Rights Movement. Packed into the rooms on this level are discussions of the development of Jim Crow segregation through the Black Codes and later segregation laws; enforcement of segregation through lynching, violence, and the rise of the KKK; and celebrations of the heroes of the Civil Rights Movement. This familiar historical narrative is interwoven with cultural responses—from a display of a staggering number of African American stereotypes in popular culture, to Black American achievements in music, art, literature, education, and community engagement.

The displays on racial violence, oppression, and terror are generally presented in red: a red wall lists dozens of segregation laws across the country; white displays with red writing describe lynchings, riots, massacres, and convict leasing. The museum's most disturbing images are outlined in red. This effort to tag graphic images with a warning reflects developing best practices in memorial museums that are aware that their sensitive subject matter and graphic images may cause trauma and trigger visitors (as we shall see, Greenwood Rising even includes an "emotional exit" for visitors who wish to avoid the violence). But in the NMAAHC, the red outlines ironically draw attention to the images, suggesting that perhaps this fraught issue was not yet fully thought through. Similarly, the exhibit addresses race massacres that are just now gaining popular and historical attention, such as those in Tulsa, Oklahoma, and Elaine, Arkansas, with brief descriptions and photographs, but they are referred to as riots, not massacres, reflecting an already dated use of terminology in the NMAAHC. There are the expected water fountains, Jim Crow signs, and KKK hoods on display, underlining the injustice and suffering of segregation, but these are balanced by markers for all-Black towns that sprang up in the postbellum period and displays on African American churches, schools, and clubs. This balance between upset and uplift frames the Great Migration as driven mostly by job opportunities, not an escape from violence, and links it to the vibrant Harlem Renaissance and activism that paved the way for the Civil Rights Movement.

The movement itself is explained in a somewhat chaotic room with the now-requisite recordings of empowering speeches playing in the background and a multitude of panels in black, white, and orange giving overviews of important figures, groups, and moments: Rosa Parks, the Southern Christian Leadership Conference, the Student Nonviolent Coordinating Committee, Ruby Bridges, Sit-Ins, Freedom Rides, the March on Washington, the bombing of the 16th Street Baptist Church, Freedom Summer, Malcolm X and Black Power, the Selma March, and so on. Some of the museum's most prominent artifacts are displayed here: Rosa Parks's dress, the dolls used by Kenneth and Mamie Clark in their groundbreaking doll experiments, a stool from the Greensboro, North Carolina, Woolworths' lunch counter. The layers of photographs, video, audio and text convey an onslaught of information—so much so that it can be difficult to see that some stories are left out of even this vast a museum, such as a detailed discussion of the arrest of Claudette Colvin (and several other women) before Rosa Parks or the almost complete silence on the Black Panthers (Wood 2022, 428).[12] Displays on the Civil Rights Act and Voting Rights Act give a sense of victory as visitors leave the main part of the exhibit.

The concourse outside the main exhibit displays a somewhat jumbled set of artifacts that temper this triumph and infuse the museum with further experiential and affective elements. Perhaps the most moving display is that of

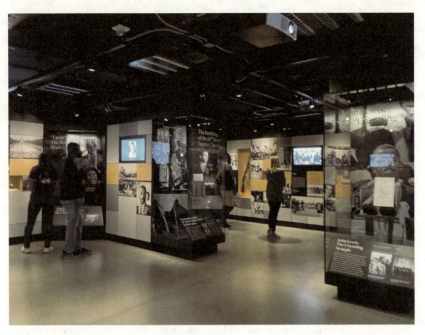

FIGURE 3 *Defending Freedom, Defining Freedom: The Era of Segregation 1876–1968* exhibit. Photo: Amy Sodaro.

Emmett Till's coffin, which is exhibited in a dedicated memorial room. Visitors often must queue to enter the memorial almost as if they were lining up to pay their respects at the funeral; while waiting they can read panels explaining his visit to Mississippi and his brutal murder and hear from Mamie Till herself why she decided to hold an open-casket funeral. Inside the memorial room, with gospel music playing in the background, the casket is the focus, displayed in front of a life-size photograph from the funeral and surrounded by panels celebrating the bravery of Mamie Till. It's an extremely powerful and affective exhibit that moves many visitors to tears. Outside, visitors can see a copy of the magazine *Jet*, which showed the original photographs of Till's brutalized face. While the entire historical exhibition is emotionally moving, this room with its heartbreaking reminder of the individual impacts of racial violence and its framing as a memorial space is particularly affective and complements the museum's rigorous historical narrative with memory and emotion. The violence that has been somewhat abstract until now begins to feel more tangible and real, reflecting the ways in which memorial museums seek to give the visitors firsthand, affective experiences that will change the ways that they view the past and, ultimately, the present and future.

Beyond the memorial are other very large artifacts and displays. There is a segregated train car that visitors can walk through to experience the difference

between the "colored" and white cars, which also evokes the USHMM's rail-car that serves as a mode of experiential understanding of the past. There is also a long, re-created lunch counter with touchscreens that provide an interactive, panoramic experience of highlights of the Civil Rights Movement. While not unlike the lunch counter at the National Center for Civil and Human Rights, this one does not put visitors in the place of the victims of segregation's violence and rhetoric. Rather, at this counter, visitors are asked to "step into the shoes" of civil rights activists and leaders, asking themselves what they would do if they were faced with situations and choices related to historic events like the Selma March, the Woolworth's Sit-In, and the Montgomery Bus Boycott (SEGD 2017). While most often memorial museums work especially to help visitors identify and empathize with the victims of violence and atrocity, in this particular exhibit, visitors are encouraged to engage in what is perhaps the more difficult work of standing up to injustice. At the lunch counter, visitors are faced with difficult choices and can compare their responses to those of other visitors, helping them to understand not just the experiences of victims of injustice, but also—and especially—what it means to fight against it, reflecting the museum's efforts to engage not just the past, but also the present and future.

These interactive elements again draw upon tropes common to memorial museums to help visitors encounter the past in a way that will impart understanding, identification, and transformation. Also displayed is a guard tower from the infamous Angola prison in Louisiana, which had once been a plantation that enslaved people.[13] But while the museum notes the continuation of slavery at Angola through convict labor in the twentieth century, it misses the opportunity to more rigorously connect historical slavery to contemporary mass incarceration, watering down its impact. However, tucked into a corner is *Struggle for the Soul of America*, a powerful film that is one of the most important exhibits in the whole museum in that it makes the argument that the racial injustice that began in this country with slavery continues today. The film is the only place in the permanent exhibit where past racial injustice is explicitly connected to the present and not allowed to be "segregated" from the present in the name of national consensus (Autry 2017). However, on my visits almost no one took the time to seek out this film in its hidden corner, and it seems most visitors instead begin the ascent to the next historical period with the tragedies and triumphs of the era of segregation echoing in their minds.

The final floor of the historical exhibition is "A Changing America 1968–2008." The historical narrative that started out plodding and meticulous in the slavery exhibit and became slightly disjointed in the segregation exhibit now becomes downright fragmented. The exhibit starts with the assassination of Rev. Martin Luther King Jr, with video and photographs showing the news media announcing his death and the subsequent funeral and riots. The rest of the exhibit mostly focuses on a celebration of Black achievement,

with panels on Black Power, Black Liberation, and the Black Panthers; the Black Arts Movement and Black Theater, Black Is Beautiful, and Black Feminism; the Black Caucus and Electoral Politics; and Black Popular Culture. These displays are vibrant and cacophonous in the layers of description, photographs, and videos they display, and they depart from the more traditional and chronological history telling in much of the rest of the exhibit. The end of the exhibit is similarly disjointed and lively, but it almost feels like the designers ran out of space and energy to continue a systematic historical narrative. Visitors are ushered out past the set of *The Oprah Winfrey Show*, which is opposite a wall of busy, cursory displays on how each of the last few decades evoked the continuing promise and paradoxes of Black life in America. For the 1980s, the emergence of hip-hop is celebrated against a Reagan-era backdrop of cheap drugs and violence, but the war on drugs is never mentioned. For the 2000s, photographs of Colin Powell, Condoleezza Rice, and Halle Berry receiving her best actress Oscar are next to images of Hurricane Katrina, a Black Lives Matter (BLM) T-shirt, and a Trayvon Martin protest sign, with no contextualization for any of it, producing a kind of whiplash. What feels like a rush to the finish of "history" is solidified with the abrupt end to the historical exhibit with a set of displays on Obama's 2008 election. A display case is lined with pro-Obama buttons and signs, magazine covers celebrating his historic

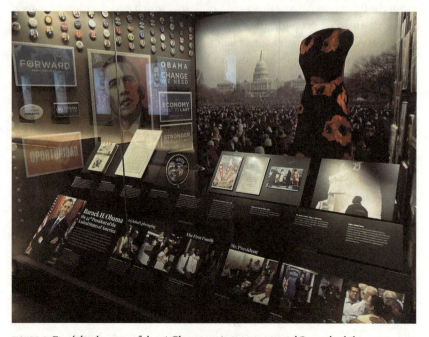

FIGURE 4 Final display case of the *A Changing America: 1968 and Beyond* exhibit. Photo: Amy Sodaro.

win, images of his days in office, and one of Michelle Obama's dresses against a backdrop photograph of his inauguration, which shattered crowd records. The ramp up to daylight has another massive image of his inauguration and the message is clear: while the horrors of slavery and injustices of segregation have been clearly laid out as central to American history and experience, they are just that—history. The museum ultimately tells a tale of progress, constructing "consensus" out of a difficult history (Teeger and Vinitzky-Seroussi 2007).

Culture, Community, and More

Though the core of the NMAAHC is the historical exhibition, that's not all there is to see. If visitors need a place to sit quietly and process what they have seen, there is the stunning—though unfortunately often empty— Contemplative Court on the top level of the underground galleries. A skylight floods the room with natural light—a welcome lifting of the shadows of the underground exhibits—and a fountain rains into a pool below, the rush of water a calming trope common to memorials. Benches line the room, inviting contemplation, and the room evokes the USHMM's Hall of Remembrance and the spaces for reflection built into many other memorial museums.

Once one has recovered from the "past," there are galleries on the third and fourth floors that celebrate Black community, culture, and achievements. There is a set of "Community Galleries," where a core exhibit on "Making a Way Out of No Way" repeats many of the themes of the historical exhibition, and complementary exhibits on sports and the military underline African American contributions to American society. Woven into these exhibits is also some additional historical storytelling—an exhibit on "The Power of Place" displays ten "place studies," including places that have been touched on in the historical exhibition, such as Tulsa and Angola prison. Here the Tulsa "riot" receives further attention and, in the case of Angola, the link is more explicitly made between past racial injustice and contemporary mass incarceration. But these examples are framed as places "that reflect the resiliency of African Americans in making places for themselves and overcoming the challenges they faced," and are somewhat subsumed by the more sweeping—and slightly more ahistorical— focus on community. Another set of "Culture Galleries" highlight African American achievements in everything from cuisine and fashion to music, theater, and film.[14] One could easily spend a day without even visiting the historical exhibition, these exhibits are so rich. Even the museum's Sweet Home Café is part of the experience, offering a menu that "showcases the rich culture and history of the African American people" (NMAAHC n.d.-c).

For Araujo, the balance between the in-depth, thorough historical exhibit and the culture galleries is what sets the NMAAHC apart from the numerous other museums of Atlantic slavery that she has researched. The museum

"is the only initiative to fully explore individual and collective cultural and intellectual contributions by enslaved and freed black Americans while greatly emphasizing the multiple pervasive forms through which racism and white supremacy operated and continue to do so in the United States" (2021, 106). However, within the permanent exhibition space there is not much rigorous connection made between past and present injustice.

There are several spaces in the NMAAHC for temporary exhibitions, which, at least recently, have been better able to extend the temporal framework of the museum, taking its exhibits and messages into the contemporary social and political context. For example, a recent temporary exhibit on visual arts, "Reckoning: Protest. Defiance. Resilience," drawn from the museum's permanent collection and inspired by the "twin pandemics of COVID-19 and systemic racism," displayed important contemporary artworks like Amy Sherald's posthumous portrait of Breonna Taylor that graced the cover of *Vanity Fair*; David Hammon's *The Man Nobody Killed*, commemorating Michael Stewart, a Brooklyn artist killed by New York City transit police following his arrest for writing graffiti on a subway station wall; and Bisa Butler's quilted portrait of Harriet Tubman. Another exhibit, "Make Good the Promises," which closed in 2022, focused on the unfulfilled promises of Reconstruction. Though most of the exhibit was historical and again reiterated themes of African American resilience and agency, the very end of the exhibit looked at the legacies of Reconstruction in contemporary forms of racial injustice, such as the murder of Trayvon Martin, mass incarceration, voter suppression, the persistence of the Lost Cause narrative, and the question of reparations. Echoing other memorial museums, the exhibit had an interactive component and invited visitors to post responses to the exhibit, some of which suggested that visitors were making connections between what is exhibited in the museum and contemporary racial injustice in the United States.

The museum also hosts many events. From visits for K–12 school groups, to scholarly talks, to film screenings, the museum offers regular, free programming to its community. The NMAAHC has hosted commemorations, such as for the one hundredth anniversary of the Tulsa Race Massacre in June 2021, and special celebrations for events like Juneteenth. It also strives to respond in real time to current events. In the wake of the murder of George Floyd in 2020 and the BLM protests, the museum opened an online portal called "Talking about Race" to provide multimedia resources to educators, parents, and all Americans to facilitate difficult conversations about race. To document the protests and the outrage behind them, the museum sent curators and historians to Lafayette Square in Washington, DC, to collect artifacts and interview protestors. These are but a few of the hundreds of events, interventions, and activities that the museum has engaged in since its opening. And like most history and memorial museums, much of the work to connect the past to contemporary

events happens in these more nimble and flexible, but temporary, spaces, such as events, online resources, and temporary exhibits. While these can arguably reach more people than are able to visit the museum, they provide a different experience and perhaps attract an even more self-selecting audience than those who visit the museum. Thus, while they complement and can fill in gaps in the history told in the museum, the permanent historical exhibition is likely that which leaves the greatest impression.

"A Failure and a Success"

As the long history of its creation and the varied paradoxes and tensions within its exhibits suggest, the NMAAHC is a complex institution that is balancing myriad narratives, ideals, and expectations. From the beginning the museum was conceived to be more than simply an institution that would collect and display objects; it would also commemorate African American loss and suffering and celebrate African American achievement in a way that would demonstrate and ensure African Americans' position as equal in American society. As the project developed and was influenced by global commemorative trends, Bunch and his team envisioned it as a transformative place "for truth-telling, for healing, for reckoning and for transformation" (Gardullo and Bunch 2017, 256); a place in which African American history and experience could be woven into the American story, facilitating racial reconciliation, justice, and equity. When the NMAAHC opened in 2016, it appeared to provide evidence—laid out for all to see on the nation's front lawn—that the United States was at last meaningfully confronting the problem of race. Trump's election and subsequent events have been a sharp reminder that solving the enduring problems of racial injustice will never be as simple as presenting them in a museum.

One of the key contradictions that the museum had to navigate was that between the "upset" and "uplift" (Cotter 2016), between the "beautiful" and the "terrible" (Gardullo and Bunch 2017) in the "uneven" African American story. This is a dilemma that has been at the heart of historiography of American slavery, with scholars debating whether their focus should be on the utter and complete violence of slavery as a form of "social death" (Patterson 2018) or on the lived experience and resistance of African Americans to bondage. As chapter 1 outlines, for the many African American museums that came before the NMAAHC, the terrible was underemphasized to make way for an empowering focus on the beautiful (e.g., Autry 2017), a narrative attractive to both white and Black visitors. However, this struggle between the terrible and the beautiful is not simply a scholarly or museological debate; it has also been influential in shaping perceptions of race in the United States. For much of the twentieth century, scholarly and public attention to slavery focused on the extreme violence and subjugation of the system, underpinning an assumption that "the

'pathological condition' of twentieth century African American life could be seen as an outcome of the damage that black people had suffered under slavery" (Brown 2009, 1234). This approach dominated social sciences, becoming a way to further degrade African Americans by claiming that the institution of slavery had robbed them of their humanity. On the other side of the debate were those who emphasized African American resilience and cultural retention, such as W.E.B. Du Bois and Carter G. Woodson. These approaches carved out space for an understanding of African American agency and celebration of contemporary African American culture, though some have argued that these approaches downplay the horrors of slavery. Thus, this balance between the upset and uplift is complex, as slavery was a deeply inhumane system, but one that did not extinguish the humanity of those subjugated to it.

Throughout the NMAAHC's historical exhibition, it is evident how these two approaches are carefully negotiated. Its focus is the foundational paradox of the United States between slavery and freedom and for nearly every story of subjugation there is one of resistance; for every artifact associated with violence, there is one of beauty. Throughout these juxtapositions, the museum again and again demonstrates that "making a way out of no way was...the mantra and the practice of a people" (Bunch 2019, 164). The museum presents its overarching history "in such a way as to convince the onlooker of black worth and value by stressing blacks' involvement in various national events... replicat[ing] the systems of recognition and social values of dominant society (Autry 2017, 62). Gruenewald likens the museum's presentation of "a teleological cause-and-effect narrative of progress that provides closure through celebration of African American achievement" (2021, 1) to Ibram X. Kendi's (2017) concept of "uplift suasion," through which African Americans can persuade white Americans away from racist ideas by uplifting themselves to a higher position in American society. In some ways the museum itself is intended to serve as a powerful form of uplift suasion. Thus, countering the dark, sobering violence of the subterranean historical levels is the bright, exuberant celebration of the upper floors. And in some ways the museum itself, rising as a shining bronze corona on the National Mall amidst the markers of white supremacy, is a light lifting the long shadow that slavery has cast over the nation.

The museum walks this fine line carefully, mostly avoiding the clichés of uplift that are so common in many African American museums. Rather, its narrative and exhibitions center slavery and race in American history. In order to convince the public that it deserved a place on the Mall, and to raise the staggering amount of money needed to build it, the NMAAHC couldn't be a museum for African Americans only, but had "to demonstrate through its interpretive frameworks that issues of race shaped all aspects of American life: from political discourse to foreign affairs to western expansion to cultural production" (Bunch 2019, 160). The museum, particularly its exhaustive and

demanding historical exhibition, was intended to demonstrate to visitors that race has always been central to American history and the American experience. Thus, one cannot leave the museum without understanding the centrality of racial inequality to the foundations of the United States. Araujo describes the historical exhibition as "the largest, the richest and the most authoritative permanent exhibition surveying this history and memory of the Atlantic slave trade and slavery ever held in a museum in the world" (2020, 127). Memory scholar Alison Landsberg writes that in centering slavery this way, "the museum creates the occasion for white people to confront the violence that whites, and white supremacy, have inflicted on blacks" and to "*own* uncomfortable memories of American whiteness" (2018, 209; emphasis in original). For Landsberg, this discomfort comes specifically from the public nature of the museum experience. Because the museum is intended to be for *all* Americans, Black and white visitors together traverse this difficult history. For Black visitors, visiting the NMAAHC may be something of a "pilgrimage"; white visitors, meanwhile, are forced "to accept their own complicity, to feel the shame of their own white privilege, while in the company of African Americans" (2018, 212).

This suggests that the NMAAHC presents a new narrative of racial oppression that gets closer to putting white Americans in the position of Michael Rothberg's implicated subject. Rothberg's concept of the implicated subject moves beyond the more typical victims-perpetrators-bystanders paradigm, instead considering those who "occupy positions aligned with power and privilege without being themselves direct agents of harm; [implicated subjects] contribute to, inhabit, inherit, or benefit from regimes of domination but do not originate or control such regimes" (2019, 1). Through the concept of implication, Rothberg highlights the "grey zone" surrounding not only instances of past violence, but also the forms racial violence takes today. For while guilt, with its attendant legal and ethical associations, may lie only with the perpetrators of historical violence, implication—and the responsibility that accompanies it—persists in the "structural injustices" such violence perpetuates (Rothberg 2019). The concept of implication, then, provides us a new vocabulary through which to think about the responsibility and moral position of individuals and groups, like white Americans, who may not have directly participated in the oppression, enslavement, or exploitation of African Americans but who have nonetheless benefited from past and ongoing American systems of racial oppression.

Just as the common (mis)perception of racism is that it primarily operates at the level of the individual, rather than permeating society's structures, so too a common white response to the heavy history of U.S. slavery is something along the lines of "my family never owned slaves"; the suggestion being that others are responsible for, or implicated in, racism and slavery. In the NMAAHC, these illusions are dashed by the historical exhibition, which so

painstakingly demonstrates the centrality of the institution of slavery to the founding of American society; one cannot help but see the pervasiveness of racial inequality, which goes beyond individual actors and family histories and is structured into American society. Rather, the "privilege of unknowing" (Sedgwick 1988) is shattered and white visitors must confront their own position within a society founded on the unfreedom of slavery. As historian James Oliver Horton writes, "For a nation steeped in this self-image, it is embarrassing, guilt-producing, and disillusioning to consider the role that race and slavery played in shaping the national narrative" (2006, 36). And it is this disillusion and embarrassment that takes visitors into the realm of implication. According to Rothberg, "Implication does not require the continuities of genealogy or the intimacies of the family. [It derives from] a structural position in relation to groups, classes, and modes of production that makes some people the beneficiaries of histories 'not their own' and disadvantages others regardless of their genealogical connection to the past" (2019, 80). As we shall see, the NMAAHC does not go as far as the Legacy Museum and Greenwood Rising in its efforts to implicate white visitors, but by demonstrating to white visitors the pervasive reach of slavery in American society, it does suggest their implication in this difficult past and its legacies.

And yet, almost as a reminder that this is a national museum located in the heart of the nation's capital, the difficult history told in the museum ends on a note of triumph, with the election of America's first Black president. This culmination belies the realities of racism in the United States that were already seeping into public life during Obama's presidency and reveals the museum's take on contemporary U.S. race relations. Thus, in tempering her praise of the museum, Araujo writes that "the ghost of white supremacy insists to haunt the exhibition space" (2020, 129). In Bunch's words, "The exhibitions convey a sense of rising from the depths of the past to a changed present and a future of undefined possibilities" (2019, 171), though in the post-postracial period these "undefined possibilities" have often seemed very bleak.

Because it had to navigate numerous tensions related to its stature as a national museum, the NMAAHC feels in some ways caught between genres and varying notions of temporality. In many ways it is a traditional history museum; it was created by a team of historians and much of its narrative and exhibition design follow conventional, diachronic modes and temporal frameworks of history telling. The museum's story of African American history adheres to traditional Western temporalities, described by Michel de Certeau as "essentially begin[ning] with differentiation between the *present* and the *past*" (1988, 2). In ending the historical exhibit in 2008 with the election of Obama, the museum is drawing a line between past and present, and presenting a fairly typical historical narrative of progress (e.g., Berlin 2004; Bevernage 2015). At the same time, it is a memorial museum, with exhibits

and experiences like Emmett Till's casket, the immersive Middle Passage room, or the interactive train car or lunch counter that are imbued with memory, which has its own temporality: memory exists in the present and is "immediate, emotive, and highly selective," "attending to aspects of the past that shaped current circumstances" (Berlin 2004, 1265). Memorial museums have the kind of activist agenda of transformation that Bunch envisioned for the NMAAHC, but the political and social realities of the museum somewhat constrain its ability to draw a line of continuity between America's racist past and the present. As Maya Phillips (2019) wrote in the *New Yorker*, the museum will always be "a failure and a success."

The simultaneous failure and success of the museum can be traced to the above paradoxes that it must contend with, but also and perhaps especially to the fact that it is caught between eras. It was created and opened in what many saw as a postracial America, where racial injustice could begin to fade into historical memory. While the idea of postracial America was an empty myth to begin with, the narrative of progress the historical exhibition ends with has been belied again and again by events in the eight years after the museum's opening, particularly in 2020 with the murder of George Floyd and the BLM protests. And while the museum has deftly responded to these shifts in U.S. society with temporary exhibits and events, the permanent exhibit is in some ways already itself a historical artifact.

This sense is borne out by the traditional exhibit designs of RAA. Though one of the most prominent exhibit design firms, in particular for memorial museums, even Bunch wondered if RAA might be a bit anachronistic for the twenty-first-century museum he envisioned: "I knew that RAA had mastered the creation of twentieth-century exhibitions, but I was unsure if the firm could help the museum identify and address the challenges of audience and technology that would be at the heart of the twenty-first-century exhibition development" (2019, 169). While the NMAAHC exhibits are much lauded, they are also more conventional and rooted in a different experience of temporality than the next two museums I will be examining, both of which were created primarily by individuals who are not museum professionals and were designed with input from newer "experience design" firms like Local Projects and tech companies like Google. The Legacy Museum and Greenwood Rising, with their innovative use of digital media and more radical temporal frameworks, appear to be pointing toward a new form of twenty-first-century memorial museum.

Conclusion

The tensions and paradoxes of the NMAAHC are reflected in the mixed responses to it in popular media. Holland Cotter (2016) of the *New York Times* refers to it as a "data-packed, engrossing, mood-swinging must-see" but also

notes that it's "confusing" and "complicated" and that its curators have thrown "more topics and words in our direction than you can possibly hope to catch, never mind absorb, in one visit." Phillip Kennecott (2016), writing in the *Washington Post*, acknowledges the "powerful stories" and "robust, rich, fascinating history" that it tells but also refers to that history as feeling "disconnected and episodic" in the museum, and observes that the emphasis on resilience and agency "threatens to become generic, a 'happy ending' motif in the feel-good vein of Hollywood." Edward Rothstein (2016) of the *Wall Street Journal* writes that the museum is "illuminating, disturbing, moving" but ultimately "flawed" because of its "self-celebratory" approach as an "Identity" museum, which strips history of its complications. Many refer to it as "overwhelming" both in content and design, pointing to the many ways that the museum may indeed always be a "failure and a success."

Other reviewers laud the museum as "a welcome rebuke to dead white men" (Wainwright 2016) and praise its exhibits for demonstrating to visitors "how deeply the grand conspiracy of white supremacy runs" (Newkirk 2016). Christopher Hawthorne (2016) of the *Los Angeles Times* writes that it is "a place less to celebrate America and its place in a Western lineage—the central ambition of the Mall as a whole—than to put the fundamental contradictions of the national experiment under glass and give them a hard look." The NMAAHC is also an extremely popular institution among the general public. On TripAdvisor (n.d.), it's rated as the number-two museum in Washington, DC—a city replete with excellent museums. In 2022, it was the third-most visited Smithsonian museum and the required free timed-entry passes are frequently sold out weeks in advance (Smithsonian n.d.).

As these reviews, statistics, and my own analysis demonstrate, museums can never be everything to everyone. In many ways, the long, arduous process of the NMAAHC's creation, demonstrates the importance of its existence. That importance, I think, is encapsulated in an anecdote from a recent visit. As I waited in a long line of ticket holders for the museum to open, two groups of African Americans in front of me began to chat with each other. They quickly realized that one of the women in each group was celebrating her birthday with a visit to the museum. The women laughed together as they talked about how they always visit the museum on their birthday—it provided a chance, as one of them said, to be surrounded by her people and history. As the line started moving, they wished each other happy birthday and joyously set off to celebrate their birthdays and their history—with its upset and uplift, its beauty and terror. It is because of the contradictions and paradoxes woven into it that the NMAAHC is such an important institution in the American memorial landscape, and this museum that is "like no other" has helped to pave the way for other new and challenging museums to finally tell this "American story."

3

"Shine the Light of Truth"

• •

The Legacy Museum

On April 26, 2018, just over eighteen months after the NMAAHC opened to celebration and fanfare in Washington, DC, the Legacy Museum: From Enslavement to Mass Incarceration opened in Montgomery, Alabama, in what had become a very different United States. Donald Trump's 2016 election to the presidency unleashed a dizzying backlash to racial progress and revealed the fallacy of such narratives, which have predominated in many African American museums and shaped the triumphant ending of the NMAAHC's story of African American history. Though the Legacy Museum opened in an America rife with racial tension and newly overt racism, it was prepared to address these challenges head on in its efforts to fundamentally shift U.S. historical memory of slavery, lynching, and racial oppression by arguing that slavery did not end but evolved into today's system of mass incarceration.

The Legacy Museum, together with the National Memorial for Peace and Justice, which commemorates the victims of "racial terror lynching," was created by lawyer/activist Bryan Stevenson's Equal Justice Initiative (EJI n.d.-c) as "part of EJI's work to advance truth and reconciliation around race in America." Coming out of EJI's work in legal activism, the museum and memorial are intended to impart a critical and honest history of race in the United States to a broad national and international audience—a history that can support EJI's work in the criminal legal system, but also one intended to reshape the national narrative. And unlike the NMAAHC, the Legacy Museum was created entirely with private funding, meaning it is free from expectations to present a

63

vindicationist narrative of African American history. Rather, the museum tells a story of the oppression of African Americans extending from slavery right up to the present, contesting not just official histories, but also ongoing systems of oppression, in particular mass incarceration. In the way the Legacy Museum forces visitors to confront this past and links it to present racial inequalities embedded in American institutions and systems, it places white Americans in the position of implicated subjects, while presenting Black visitors with an unvarnished historical narrative that many already know too well—a history they were "born knowing" in the words of Fabre and O'Meally (1994, 3)—and providing a space for acknowledging and mourning racial violence in the United States (Woodley 2023b; see also Woodley 2024). This chapter analyzes the Legacy Museum in the context of post-postracial America, examining how the museum's implicatory narrative indicates an important shift in how past and present racial injustice are reckoned with in U.S. public spaces. Though they opened only a year and a half apart, because of their very different political-economic positions within the commemorative landscape in the United States, the Legacy Museum goes much further than the NMAAHC to challenge narratives of racial progress and connect the history of slavery to today's injustices.

The Equal Justice Initiative and Historical Memory

The EJI was founded in 1989 by lawyer and activist Bryan Stevenson, with the goal of providing legal representation to individuals who had been wrongly convicted or unfairly sentenced. What started as a tiny, barely funded organization, as described by Stevenson (2014) in his best-selling memoir *Just Mercy*, grew to include dozens of staff and lawyers who have saved 115 men from execution and successfully petitioned the Supreme Court to end life sentences without parole for children. With the growth of the organization, its mission also expanded, and today it is "committed to ending mass incarceration and excessive punishment in the United States, to challenging racial and economic injustice, and to protecting basic human rights for the most vulnerable people in American society" (EJI n.d.-a).

A central part of this effort at sweeping social change has been confronting the long history of racial injustice in the United States, which has been largely forgotten by communities clinging to the Lost Cause narrative or subsumed by triumphalist stories of racial progress. In many ways, Montgomery was the ideal place to witness the long American silence around slavery: when Stevenson, who grew up in segregated Delaware, moved to Montgomery after attending Harvard Law School, there were historical markers all over the city commemorating the Confederacy—fifty-nine to be precise (T. Adams 2015)—and not a single marker telling the history of Montgomery's central role in the

slave trade. As the capitol of Alabama, Montgomery is a city of imposing, neo-classical white government buildings; for a deep-red state that believes in small government, the government appears to be massive and ubiquitous. Among the gleaming government buildings are numerous courts, police stations, sheriff's offices, jails, and parole offices, suggesting an omnipresent criminal justice system—part of the reason that EJI is based here. But this present Montgomery is also steeped in history and riddled with the "sometimes deadly paradoxes that hold the country in a constant state of suspended racial tension" (Pierce and Heitz 2020, 963). All over the city are reminders of Montgomery's fame as both the "cradle of the Confederacy" and the "birthplace of the Civil Rights Movement." Just a short walk from the place where Rosa Parks boarded a bus and refused to give up her seat in 1955 sits the First White House of the Confederacy, where Jefferson Davis resided until 1861. Dueling monuments flanking the now run-down but once grand Dexter Avenue, which runs from the river to the capitol, commemorate the Selma to Montgomery march of 1965 and the inaugural parade of Jefferson Davis in 1861. Even the striking Artesian Basin and Court Square Fountain, gracefully poised between the riverfront and the capitol, was the long-forgotten site of slave auctions. But for Stevenson, the silence around Montgomery's deep implication in the institution of slavery was a glaring absence that had to be filled.

Stevenson has frequently invoked the experiences of other countries' memory work around past atrocity, arguing that such silence would be unthinkable in places like Germany, South Africa, or Rwanda, where genocide and apartheid are widely and visibly commemorated. Firmly believing that "a more informed understanding of America's racial history and the challenges it creates is vital to developing a healthier and more respectful local, state, and national identity" (EJI 2018), Stevenson and EJI set out to research historical racial violence in the United States. The organization spent six years researching the slave trade in Montgomery and the United States in general and carefully documenting over four thousand racial terror lynchings in the South and across the country. The reports that they produced on these often forgotten histories became the basis for the Legacy Museum and the National Memorial for Peace and Justice.

The National Memorial for Peace and Justice

In many ways, the National Memorial for Peace and Justice, colloquially known as the Lynching Memorial, was intended to be the centerpiece of EJI's efforts to confront the history that continues to shape today's inequalities. The memorial was conceived by EJI, which enlisted artists and architects as partners in its creation, to be a space for reflection on racial violence and injustice in the United States. It is on a small hill overlooking downtown Montgomery and is striking even from a distance. It's accessed by a gently sloping path lined with

panels giving an overview of lynching in America and featuring a powerful sculpture of enslaved and enchained Africans by Ghanaian sculptor Kwame Akoto-Bamfo, which links racial terror lynchings to slavery. At the top of the slope is the entrance to the memorial square, which was created in collaboration with MASS Design Group and is breathtaking in scale.[1]

The memorial is composed of a series of eight hundred suspended Corten steel columns, each representing a county in which one or multiple lynchings occurred. On each column is the name of the county and its lynchings listed by name and date, though many names are unknown; some columns have only one, some have over a dozen. The columns are arranged in a roughly square spiral around a grassy knoll, and as one walks through the columns, reading names and dates, the ground slowly descends, and the monuments, which in the beginning were bolted into the ground, rise until they are ominously suspended above one's head. The hanging columns at once evoke feelings of vulnerability (I have seen more than a few visitors nervously examining the mechanics of the memorial), but also place visitors in the position of spectator to the lynchings, eerily conjuring the photographs that circulated as mementos of bodies dangling over an eager crowd. And the relentless repetition of column after column, lynching after lynching, is overwhelming as "the full weight and experience of racial terror lynching are exposed and the vast expanse of steel begins to enclose you until it feels inescapable" (Brand, Inwood, and Alderman 2022, 47). The memorial is truly "emotionally overwhelming" (Pierce and Heitz 2020, 972).

Lining two walls are brief descriptions of the reasons some individuals were lynched, such as Calvin Mike, whose was lynched with his elderly mother and two young daughters, Emma and Lillie, for voting in Calhoun County, Georgia; or Henry Patterson, who was lynched in Labelle, Florida, for asking a white woman for a drink of water. Other panels describe the conditions under which individuals were lynched, such as Will Brown, who was lynched in Omaha, Nebraska, by a mob of up to fifteen thousand people; or Fred Alexander, a military veteran who was burned alive in front of thousands of spectators in Leavenworth, Kansas. The trivial nature of so many of the transgressions and the shocking number of white men, women, and children who eagerly witnessed these unthinkably violent acts serve to underscore the deep trauma and horror of this era of America's past. The petty justifications for murder are starkly different from the few specific examples in the NMAAHC of people lynched after being accused or found guilty of rape or murder. And the reminder that lynching was often a public spectacle helps the memorial "implicate the [white] visitor in the dreadful history of lynching by creating a visceral and personal reaction" to what they are learning (Schult 2020, 2). However, as scholar Jenny Woodley (2023b) explains, the memorial is not only a space intended to demonstrate to white visitors their complicity in

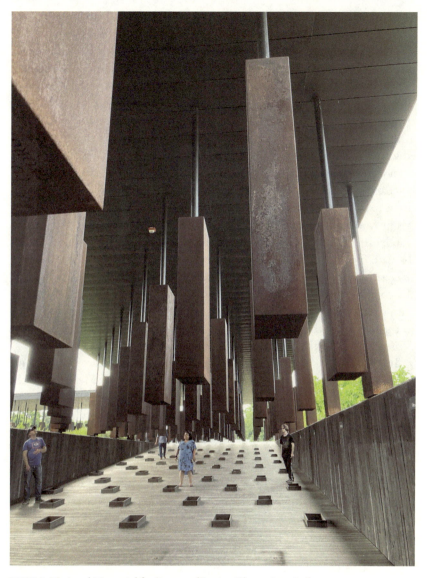

FIGURE 5 National Memorial for Peace and Justice. Photo: Amy Sodaro.

these heinous crimes; it is also—and especially—a space for mourning Black lives, which have long been considered "disposable" and, hence, "ungrievable" (1055). Woodley (2023b) cites Claudine Rankine's blunt statement that "the condition of Black life is one of mourning," and explains that in providing for both Black and white visitors a public space for mourning, the memorial demonstrates the "radical potential of mourning . . . to move society towards racial justice" (1066).

While the emotional power and scale of the memorial are stunning, the work that it is doing to move the nation toward racial justice is not meant to stop in Montgomery. The memorial is doubled when one leaves the memorial proper and enters a field of duplicate columns; for each column suspended in the memorial, there is another—a "take-away twin" (Schult 2020). While initially the plan was for counties to claim their columns after acknowledging their lynching history, EJI is shifting toward working with counties to install a "duplicate marker" that provides the narrative and historic background to educate people about this past violence that has been long silenced. This dispersion of memory work is what makes the memorial national—just as lynching occurred well beyond the South, so EJI believes the memory work needs to be done on a national level. As Marita Sturken writes, "This strategy is a provocation, demanding a site specificity to memory . . . and an ownership by these counties and towns of these histories of violence" (2022, 253). To date over a hundred markers have been erected or are in production, suggesting that there is momentum around facing this difficult past across the country. The memorial continues through the Civil Rights Movement with a sculpture by Dana King celebrating its women and brings visitors up to the present with a powerful sculptural contemplation of police violence, *Raise Up*, by Hank Willis Thomas.

In its affect, its abstraction, and the vastness of its scale, the National Memorial for Peace and Justice resembles Peter Eisenman's Memorial to the Murdered Jews of Europe in Berlin; and indeed, Bryan Stevenson was inspired by that memorial. However, like that memorial, the abstract columns can only go so far to explicating and giving context to so many lives lost. Thus, the Berlin memorial has the underground Information Center with exhibits that help to explain to visitors the history of the Holocaust, in particular emphasizing the affective experience of the memorial with stories of individual victims. Similarly, the Lynching Memorial has the Legacy Museum to provide the historical narrative necessary for understanding this past that has been so deeply buried.

The Legacy Museum

The first version of the Legacy Museum was a mere eleven thousand square feet, densely packed with text, photographs, videos, and the occasional object to help it tell its story of slavery's evolution into mass incarceration. From the very beginning it was meant to be a narrative museum; as EJI senior attorney Sia Sanneh explained, they approached creating a narrative for the museum in much the same way they would prepare a legal brief, as a means of persuading others to see things a certain way (personal communication, 2021). They also saw controlling the project themselves as the best way of telling an authentic story. Thus, in designing the museum, EJI was keenly focused on telling the

story their way and—in stark contrast to the NMAAHC with its army of museum professionals and historians—decided not to hire a professional curator or devote resources to developing a collection and creating more traditional museological displays. EJI did have some assistance with exhibit design and technology, including from Google; Madeo, a design studio focused on "social impact"; and the "experience design" firm Local Projects, which designed Greenwood Rising.[2] However, the EJI team wrote all of the museum text and developed most of the exhibits themselves; essentially, the museum was created by a "team of death row attorneys" (Sanneh, personal communication, 2021).

This is not to say that EJI was operating in a museological or commemorative vacuum. Stevenson and EJI were well aware of memorial practices around the world and part of their impetus for creating the memorial and museum was seeing the memory work that had been done in other countries. Stevenson was particularly influenced by the Berlin memorial, Johannesburg's Apartheid Museum, and the Kigali Genocide Memorial Center in Rwanda (Sanneh, personal communication 2021; J. Smith 2021) as examples of nations meaningfully reckoning with their own difficult pasts.[3] EJI also looked to other museums in the United States, including the USHMM, which is a model for memorial museums around the world, and the NMAAHC, which, as chapter 2 argues, in many ways has ushered in a new era of confronting past racial violence. However, EJI immediately recognized that the scale, the architecture, and the collection of both museums, particularly the NMAAHC, were in no way replicable in Montgomery. Instead, they realized that they could and should use the uniqueness of the museum's location in Montgomery to tell the larger story of slavery's impact on the United States (Sanneh, personal communication, 2021). The original museum harnessed this power of authentic place not only through exhibits on Montgomery's central role in the domestic slave trade and stories of continuing racial terror and injustice in Alabama, but also with a stark message to visitors, painted on a wall at the beginning of their visit: "You are standing on a site where enslaved people were warehoused." And while this message changed slightly with the new museum's opening, an emphasis on the authenticity of Montgomery as a location to tell this story has remained.

While EJI was deliberate in presenting these kinds of powerful, but difficult messages, as they began to develop the museum project in 2016 some supporters of the project warned that the museum's argument didn't fully reflect the racial progress that was exemplified by Obama's presidency (Sanneh, personal communication, 2021). But having worked in the trenches of the legal justice system for decades, Stevenson and the EJI team understood that the racial hierarchy that had developed around slavery was far too deep and durable to be dislodged so easily. They were also accustomed to resistance to the argument they were making and so created the museum knowing that it could be

controversial and invite pushback. They were convinced that this kind of memorial space is necessary to help Americans—and the United States as a nation—confront this difficult past.

Though EJI knew the value of what they were doing, even they did not anticipate just how well received the memorial and museum would be. Crowds far exceeded EJI's expectations, and they quickly found themselves turning thousands of visitors away from the museum. Not only were visitor numbers much higher than they had anticipated, but visitors were coming from all over the country and world, not just from Alabama and the South. To date, over a million people have visited the museum and memorial. Thus, EJI did what was almost unthinkable at the time: while museums across the world struggled to survive the pandemic shutdowns and simply keep their doors open, EJI used the opportunity to raise funds and rebuild the Legacy Museum to be four times the size of the original. While the new museum retains the ethos and many of the displays of the first version, it is able to do even more to tell its powerful story.

The Legacy Museum: From Enslavement to Mass Incarceration

The new version of the Legacy Museum is just a short distance from the old in a newly constructed building that EJI calls the Legacy Pavilion, which also has a tasteful gift shop selling mostly books and EJI merchandise, and a (delicious) soul food restaurant, Pannie-George's Kitchen. While the new museum is not in a historic building, EJI makes clear in the museum and in promotional material that the site, which was once home to a cotton warehouse, is as authentic and meaningful as the original locale. For Stevenson, this authenticity is extremely important; as he explained to NPR: "I do think there's something powerful when you're standing in these spaces learning about this history, knowing that the soil you're standing on is the same soil where enslaved people sweated. . . . I think it's important that the authenticity of this space be a part of the experience" (Martin 2021).

However, immediately on entering the museum, it's clear that the previous version's emphasis on its location in Montgomery has been augmented by a more global narrative. The museum opens with the transatlantic slave trade, introduced by a brief panel explaining that over 12 million individuals were kidnapped from Africa and an estimated 2 million died on the harrowing sea journey. Visitors are ushered into a dimly lit room evoking that journey: a massive wall of waves crashes over the room, while swirling lights and sound thrusts visitors into the sea; stark projections on the wall of waves reiterate the "terrifying journey" and "agonizing deaths" that were the beginning of "the story of slavery in America." The next dimly lit room gives a more in-depth

overview of the transatlantic slave trade, underlining in a few panels and a video the argument that the United States (and the world) were shaped by slavery. This abstract, universal framing for the story is picked up in a powerful installation, *Nkyinkyim* by Akoto-Bamfo, meant to lead visitors into the exhibition.[4] Visitors walk through the installation on a cobblestone path, disoriented by the uneven floor and surrounded on each side by African heads and torsos that emerge from a sandy beach with the sea stretching out behind them. It would almost be beautiful, but the faces are anguished, terrified, and resigned, and the heads and bodies are shackled, blindfolded, and in bondage. As the waves continue to crash, the almost unimaginable numbers begin to take on individual characteristics in the faces of the installation. When one later learns, from a video in the exhibit on slavery, about the research and emotional work put into the installation by Akoto-Bamfo as he sought to uncover stories of slavery in his native Ghana, the affective impact of the memorial / art installation grows even greater. Yet in a dramatic departure from other U.S. museums that address slavery and African American history, including the NMAAHC, there is no depiction of life in Africa before the transatlantic slave trade; rather, the museum begins its narrative on the ocean and with the violence of the slave trade.

After this powerful and emotional beginning, the museum moves into more traditional modes of historical narration. Reflecting EJI's desire to reach visitors who come from beyond Alabama and the South, the first room describes the major slave ports in the United States, stretching from Boston to New Orleans and underlining the significant impact of slavery on the country. But the next room brings the narrative back to Montgomery, telling of the city's central role in the domestic slave trade, which surged after the international slave trade was banned in 1808. The exhibit uses maps, text, and videos, in this case a fictionalized depiction of family separation,[5] as well as heart-wrenching quotes from enslaved individuals who were separated from their loved ones, to depict the new round of horrors inflicted on the enslaved when the international slave trade was banned. As visitors leave this room they are met with the museum's new message of locationality: "You are standing on a site where enslaved Black people were forced to labor in bondage." While this message tries to harness the power of that in the original museum, it also might occur to the visitor, after learning about the pervasive influence of the institution of slavery on all aspects of American life, that many or most spaces throughout the South (and the eastern United States) could claim the same.

But this is all still introduction, and, before reaching the heart of the exhibit, visitors have the first of what will be two deeply affective encounters in which past and present collide. Here, visitors enter the "slave pens": a wide, dark corridor lined on both sides with small cells. When visitors approach the barred

FIGURE 6 Legacy Museum slave pens. Photo: Equal Justice Initiative.

doors, a ghostly holographic image of an enslaved individual awaiting their imminent sale at auction comes to life and addresses the visitor. The slave pens were part of the original museum, where they were cramped and crowded but just as powerful; here they are more orderly, larger, and carefully distributed so as many people as possible can have this encounter at the same time, with the cells duplicated on each side of the corridor. The individuals tell the same heartbreaking stories as in the original museum, centered on the separation of children from their mother—a woman asks if you've seen her children while another wishes she could comfort the frightened children; a man describes the songs people sing in the pens and laments that he, too, cannot help; the children, terrified and timid, ask the visitor if she has seen their mother. In the background, a woman sings a mournful spiritual.

Visitors are told as they enter the pens that they will hear "authentic accounts by actual enslaved people who recorded their experience of being bought and sold in this region," but it is not clear the provenance of these stories and whether they are, in fact, archival accounts. This uncertainty about their source, however, does not distract from the affect of the experience. For visitors familiar with Holocaust and other memorial museums, these figures evoke the video testimony of survivors that has become a staple of historical exhibitions. Witness testimony has been increasingly incorporated into memorial museums as a key mode for restoring the voice and humanity of those who suffered and for helping those who were not there identify with victims in a more deep and affective way. Steffi de Jong even argues that video

testimony has been "musealized," becoming a museum object in and of itself as a central form of storytelling about painful pasts in that video testimonies can "represent the nonrepresentable" by allowing visitors a "glimpse" of the witness's trauma (2018, 18). This kind of testimony about the past is deemed to be central to the goals of memorial museums vis-à-vis moral transformation. As Paul Frosh argues in his analysis of the ethics of Holocaust testimony, we are saddled with three moral obligations in the wake of mass violence—one to the past and its victims, one to the present "witness-survivor," and one to "the future of the survivors . . . and humanity as a whole," which is predicated on the dissemination of knowledge about the past in order to learn its lessons (2018, 354). Survivor video testimony is a powerful means of bearing witness to the present witness-survivor and learning lessons of the past that they communicate to visitors, thus helping to place upon visitors their moral obligations vis-à-vis the past.

However, the holograms in the Legacy Museum take the form of "witness as object" further. Though narratives of the enslaved have been recorded (most famously by the WPA Slave Narrative collection, featured in exhibits of the NMAAHC and elsewhere throughout the Legacy Museum), there is virtually no video testimony of witnesses to enslavement and so the Legacy Museum has reconstructed this form of display with holographic images. It seems evident here that the Legacy Museum is drawing from new technologies that are being used to create "virtual witnesses" (Schultz 2021). As Holocaust survivors, whose stories have been a staple of educational programs at Holocaust museums, pass away, museums are creating digital representations of the survivors (often referred to as holograms) that can take the place of the living individuals and tell their stories to visitors in perpetuity.[6] While the individuals in the Legacy Museum don't have the sophisticated algorithms that allow them to answer thousands of questions like the Holocaust survivor holograms, they are able to bring lost voices of the past into the present and present visitors with what de Jong calls a "witness to history" that conveys "historically relevant information . . . in order to affect visitors, as a means for moral education" (2018, 36). Just as Holocaust testimonies have been privileged as a window into historical witnesses and their experiences, so the words of the individuals locked up in the slave pens have a haunting affective power over the visitor that places on them a responsibility to the victims and survivors of the trauma and violence of slavery.

But in the Legacy Museum, the burden of responsibility is different from Holocaust and other memorial museums that remember violence long past. As its name suggests, slavery is only part of the story that the museum tells. The museum's argument that slavery did not end but simply changed shape throughout American history is a radical departure from the work of more traditional history museums that seek to emphasize a break with the

past; even the NMAAHC, despite its centering of race to the American experience, has a clear end to the historical exhibit that suggests the United States' victory over racial injustice. The Legacy Museum's argument is one that has gained traction through books like Michelle Alexander's *The New Jim Crow* and Ava DuVernay's documentary *13th*, and the museum represents the first concrete, museological representation of this argument. Thus, the slave pens give way to the heart of the museum and of EJI's almost legal argument that slavery did not end but evolved—an argument the museum makes in a very deliberate and deeply compelling way. As Jesse Wegman wrote in the *New York Times*, "Stevenson is a very good lawyer, and he knows that the most effective way to make your case—particularly to people who see the world very differently from you—is not with outrage and condemnation but with a slow, thorough accumulation of evidence and argument leading to an inevitable conclusion" (2018).

The accumulation of evidence starts with a racial justice timeline that was the core exhibition at the original museum and that divides U.S. history into four periods of racial injustice, each designated by a single word: "Kidnapped" (slavery), "Terrorized" (lynching and convict leasing), "Segregated" (Jim Crow segregation), and "Incarcerated" (mass incarceration). Using photographs, quotes, reproductions of documents, and explanatory text panels, the timeline gives an overview of the evolution of racial injustice. The timeline is compelling: there are massive photographs of injustice both contemporary—prisoners in Malawi bound and cramped in an evocation of the Middle Passage—and past—white men and boys posing under the lifeless feet of a man they have just lynched. There are chilling quotes, such as one from Governor Adelbert Ames of Mississippi predicting in 1875 that African Americans "are to be returned to a condition of serfdom—an era of second slavery," and statistics, such as one in three Black baby boys born in the United States will go to prison. There is a list of Supreme Court rulings related to racial justice, with the decisions propping up white supremacy vastly outnumbering those supporting racial justice. The timeline and the division of U.S. history into four eras of racial injustice was the core of the original museum and remains such in the new version; for, in order to "dismantle the widely accepted triumphalist narrative that moves from slavery to abolition to Civil Rights, the visitor is asked to see *what has remained constant* throughout these four periods instead of what has changed" (Landsberg, qtd. in Sturken 2022, 232; emphasis in original). However, in the new version of the museum the timeline is just an overview, and the rest of the museum takes visitors in great detail through these four eras, using the same layers of text, photographs, and documents, together with interactive touchscreens, the occasional artifact or object, and many videos to tell the story of the development and evolution of what the museum calls the United States' "permanent racial hierarchy."

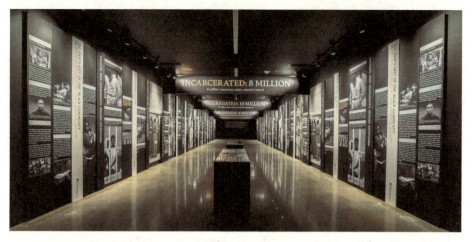

FIGURE 7 Legacy Museum timeline. Photo: Equal Justice Initiative.

In the first of the four sections of the museum, "Enslavement in America," visitors learn more about the centrality of slavery to the history of both Montgomery and the United States as a whole: a wall of bricks points out that the bricks were made and laid by enslaved people in Montgomery; panels describe industries reliant on slavery, with an emphasis on cotton, and the tremendous wealth that the institution allowed many white Americans to accumulate. A large wall describes the violence of slavery using quotes from those who were witness to such abuse and an extra-large version of the iconic photograph of Private Gordon's whipped back. In the center of the room are reproductions of advertisements for slave auctions and runaway slaves, shocking in their cruel detachment, and heartbreaking advertisements placed by enslaved and freed individuals seeking loved ones from whom they were separated. There are touchscreens where visitors can learn more about various aspects of slavery, such as rebellions, cultural tools of survival, sexual violence, and so on. And, as is the case with each era, there is a theater that plays films on loop; in this one, a film about the domestic slave trade and another about the *Nkyinkyim* installation. There is also a large timeline of Reconstruction that emphasizes not only the many failures of this period but also its utter violence, driving home the point that there was never a real commitment to racial justice and that Reconstruction simply ushered in a new century of racial injustice, thus laying the conceptual groundwork for the next section of the museum.

In this first section visitors begin to notice the museum's striking use of color, which has been carried over from the introductory timeline. Almost the entire museum is in black and white, with only some soft, terracotta orange—not unlike the color of the weathered brick buildings that line Montgomery's Dexter Avenue—breaking up the stark lines. But like everything in the

museum, these color choices are deliberate. White throughout the exhibits is used to represent ideas, statements, and actions by white people against racial justice, such as the advertisements for enslaved people being sold, while black is used to represent Black agency, ideas, and actions that advance racial justice, such as the advertisements searching for loved ones. The museum's core argument is thus given an added layer of color symbolism, reflecting the ways in which exhibit design and the forms that memory and historical narrative take in museums help to shape their content and messages.

In this section one also starts to notice the use of language that recurs throughout as part of the careful construction of an argument that slavery did not end in 1865, but instead evolved into new forms that continue today. Words like "permanent status," "racial hierarchy," "hereditary," and "caste system" are reminders that slavery constructed a racial hierarchy in the United States that laid the groundwork for the racial violence to follow, all the way up to today's structural and systemic racism. Thus, the racial hierarchy established by racialized slavery gives way in history and in the museum to what EJI refers to as "racial terror." Just as with color, the use of language in the museum is very deliberate and part of EJI's overarching argument. The exhibit reminds visitors that the very concept of race is a social construction, but one that has hardened into an enduring hierarchy.

The second section, "Lynching in America," is in many ways the most difficult of this very difficult museum because it is the story that has been most forgotten, subsumed by what Sherrilyn Ifill (2007) calls a "conspiracy of silence" about the complicity of white Americans in racial terror lynchings. This room immediately overwhelms with the vast and disturbing information that it displays. One large wall of newspaper headlines and articles announcing lynchings—such as one that reads "Merry Carnival as Texas Town Lynches Suspect"—reminds visitors that lynching was public knowledge. While the history has since been deeply buried, at the time lynching was open, public, and an excuse for celebration, with the perpetrators knowing there would be no punishment. Underlining this shocking cruelty of the practice, nearby walls describe the lynching of children (EJI has documented nearly a thousand) and women. Another displays last words, mostly recorded by reporters and other witnesses, and most proclaiming innocence. Reading these words that so starkly evoke the inhumanity of such violence is extremely difficult; however, as the wall text reminds visitors, "engaging with these accounts is a direct way to bear witness" to their suffering. Just as the ghostly holographic individuals in the slave pens forced visitors to engage with those who were lost to history, so these last words are another form of witnessing a past that has been long silenced and of acknowledging and remembering the humanity of lynching's victims.

Other parts of the exhibit depict EJI's Community Remembrance Project and the courageous effort to tell this little-known history. One of the central

"Shine the Light of Truth" • 77

visual elements of Lynching in America is the huge wall of jars of soil; double-sided, it holds eight hundred jars (echoing the eight hundred columns of the memorial), each with the name of a county, a date, and the name of a victim (though, as in the memorial, some are unknown). The range of soil colors is striking, and the scale is staggering; EJI initially documented over 4,400 lynchings and today counts over 6,500, so this is a mere fraction of the total. With "Strange Fruit" playing eerily in the background, visitors can begin to acknowledge the scope of the violence. Another display features descendants of lynching victims learning about and remembering the past, and describing the ongoing impacts on their families, such as their ancestors having been uprooted from their homes and communities and living in perpetual fear. These families also connect that past to today's racial violence. For example, the family of Anthony Crawford, who was lynched in Abbeville, South Carolina, in 1916 for arguing with a white merchant over the price of cottonseed, notes the similarities between his lynching and Trayvon Martin's 2012 murder by George Zimmerman.

A central part of this exhibit that helps visitors connect past racial violence to their own lived present is the interactive lynching maps, developed by EJI with Google. As has been stated, the museum is based on extensive research conducted by EJI into slavery and lynching. For their lynching report, EJI staff examined books, archives, and newspaper accounts and conducted interviews to document racial terror lynchings across the country, drawing on African American memory work that had been relegated to the margins of U.S. society but that had persisted nonetheless. This data became the foundation of an exhibit entitled "The Legacy of Lynching: Confronting Racial Terror in America," which traveled the country in 2017–2018 (I saw it in 2017 at the Brooklyn Museum) as a prelude to the opening of the memorial and museum, and today is accessible to visitors in touchscreen panels with interactive maps of the United States. Red dots, in varied shades depending on the number of lynchings, mark counties in which lynchings were perpetrated, and visitors can click on any county or state and see how many lynchings were carried out and of whom (where this information is available). While the red is concentrated in the South, lynchings occurred as far away as California, Colorado, and New York.[7] Some red dots have additional information, and visitors can click on them for stories detailing the lynchings.[8]

Yet while EJI has done critical work to confront this history, this section of the museum ends by reminding visitors that they have been largely alone in this effort. While the museum makes reference to anti-lynching activism, such as displaying a NAACP flag proclaiming "A man was lynched yesterday," and a column with the words of famous anti-lynching activist, Ida B. Wells: "Our country's greatest crime is lynching," this section's final panel explains that two hundred anti-lynching bills have been introduced in Congress over the last

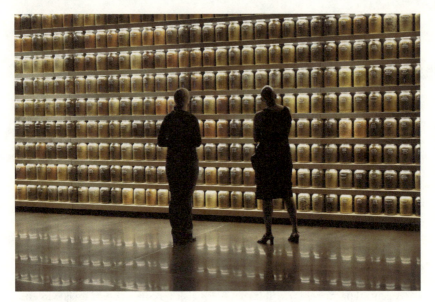

FIGURE 8 Display of Community Remembrance Project soil collections. Photo: Equal Justice Initiative.

hundred years and went nowhere until 2022.[9] Thus, although the exhibit focuses on the past, visitors cannot quite leave this racial violence in the past and are forced to consider its ongoing impacts and legacies. Further, "In defining racial terrorism as a form of state-sanctioned terrorism, these projects also engaged with questions of human rights, long absent from US memorialization" (Sturken 2022, 224). As already noted, the issue of human rights is often considered to be a concern only long ago or far away; the Legacy Museum forces American (and other) visitors to confront U.S. violations of human rights. Through this reminder, the interactive maps that position lynchings in many of our proverbial backyards and the jars of soil helping visitors visualize the staggering scope of racial terror, lynching is not allowed to stay in the past and is mere prologue to the next iteration of racial injustice.

The next section, "Segregation in America," like the parallel exhibit at the NMAAHC, feels the most familiar, though the emphasis is slightly different from other civil rights museums, which tend to focus on the movement's heroes and triumphs. The Legacy Museum shifts this common trope to focus not only on the violence of the civil rights era but also the legal frameworks that made such violence possible. The exhibit describes segregation as America's "era of racial apartheid" and emphasizes "violent white resistance" to racial equality. There is a huge wall displaying the signs of segregation ("This park for white people only"; "No negro or ape allowed in building")—a display almost requisite in a museum addressing race and civil rights in the United States, but this

wall is extra-large and is contextualized within the broader history of slavery and racial terror, giving greater affective force to the cruelty and injustice of segregation. There is a display on "segregating love," with a map showing states with laws against interracial marriage (shocking to learn is that Alabama's ban only ended in 2000), and stories of interracial couples. Underpinning the legalistic argument that the museum is making, there is a wall focused on the legalization of white supremacy with a range of Jim Crow–era laws, from the illegality of playing checkers with a member of the other race to those laws carving up public space and institutions into Black and white. There is a wall of quotes and videos of politicians and other public figures averring their commitments to maintaining segregation, such as George Wallace's infamous slogan, "Segregation today, segregation tomorrow, segregation forever!" reminding visitors of the many agents who fought hard to maintain racial apartheid in the United States. One powerful method they used in this fight is displayed in a room where visitors can try their hand at a poll test,[10] where just about the only laughter I heard in the museum is the shocked scoffing at some of the questions on the sample tests (such as "How many bubbles are in a bar of soap?" or "How many seeds are in a watermelon?").

There are also the expected videos of the Civil Rights Movement— speeches and songs at the March on Washington, Martin Luther King preaching. One wall in this section boasts what might be the most hopeful statement yet in this museum: "This country changed when ordinary people did extraordinary things to challenge racial injustice." As with the subtle reminder of anti-lynching activism and the suggestions of Black agency in the advertisements placed by those who had been enslaved searching for their loved ones, in this section visitors are reminded that despite the devastating narrative of racial injustice presented in the museum, Black Americans have found ways to fight against it. This is illustrated in the detailed display on the Montgomery Bus Boycott, which includes a massive wall of the mug shots of the ninety individuals who were indicted, another display of the Black women (other than Rosa Parks) who ended segregation on transportation, and a detailed film that plays on loop in the Segregation Theater. Like the other sections, there are touchscreens for visitors looking for more in-depth information both on the violence of segregation and the Black activism that helped to end it. However, the triumph of the civil rights era is tempered by the reminder here that the criminal justice system became an effective tool for the repression of the Civil Rights Movement and a new political emphasis on "law and order" enabled the war on drugs and mass incarceration to become a new form of racial terror lynching.

This new form is on display in the final section, "Incarceration in America." Having moved through slavery's evolving forms—from the transatlantic to the domestic trade to convict leasing, racial terror lynching, and segregation—this

section argues that our current criminal legal system, built upon the racialization of criminality, has effectively perpetuated the United States' racial caste system by disproportionately locking up people of color. The museum has brought the visitor to the present, showing visitors that mass incarceration and its staggering racial disparities is the new form of slavery in the United States today. The centerpiece of this section is the complementary affective encounter to the slave pens. Here the visitor comes full circle with the specters of U.S. racism in a simulated prison visitation room in which visitors can "talk" to incarcerated individuals. This feature was also in the original museum but has been vastly expanded so visitors can easily speak to one or several of the virtual prisoners. Taking a seat and reviewing the invasive list of prison rules for visitors, which leaves only to the imagination the indignities that prisoners are subject to, visitors pick up a telephone and hear the story of the prisoner on a video screen before them. All of the individuals are or were actually locked up and their stories are heartbreaking reminders of the injustices of our prison system: a woman describes giving birth, after being raped by a prison guard, only to have the infant taken from her after less than twenty-four hours; a young man describes his eighteen years in solitary confinement after being sentenced to life in prison at thirteen years old.[11] Though similarly locked up behind bars, unlike the ghostly specters in the slave pens these people are very much alive, telling their stories in high definition to the visitor, similarly imploring that visitors shoulder some responsibility for this injustice. But their stories of being "disposed, captive and silenced" in prison system suggests that they might be more akin to "living ghosts" in American society (Hudson 2017, 93). Just as enslaved individuals were stripped of their humanity and placed in cages, so these individuals are discarded and dehumanized in the contemporary manifestation of slavery in the United States.

The rest of this exhibit dives into EJI's work in the "criminal legal system"; even this particular terminology used in the museum is telling, suggesting that there is no "justice" in what is commonly called the "criminal justice system." There is a display of shockingly racist quotes from judges and jurors highlighting the racism that pervades the courts. There is a horrifying section on children in prison, highlighting the execution in 1944 of fourteen-year-old George Shinney, who was not big enough to fit in the electric chair that killed him, and the number of children in the United States who have been sentenced to die in prison. A nearby video details EJI's work to end excessive punishment for children, highlighting their success in persuading the Supreme Court to ban life sentences for children. There are other videos, as well, that highlight EJI's work, like a moving video on Walter McMillan's eventual release from prison (the topic of Stevenson's *Just Mercy*), and there is a wall of letters from incarcerated individuals seeking help from EJI: a woman sentenced to life without parole for possession of 2.2 pounds of marijuana

begging to get out to see her children; a man sentenced to life in Alabama's notoriously violent St. Clair Correctional Facility for stealing a bicycle. While EJI cannot help everyone who desperately needs help, they are doing the unprecedented work of giving those on the "inside" a voice.

These references to EJI's work are part of what gives the museum its tremendous power and ensures that it is not a place of pure despair. While the museum has chronicled the devastating consequences of racism and white supremacy stretching the entire history of the United States, the stories of EJI's remarkable work and unlikely successes serve as a reminder that there are organizations and individuals out there that are doing the difficult and necessary work of trying to change and improve American society. Throughout, the museum has interwoven its damning narrative of racism in the United States with examples of the kinds of Black activism that laid the groundwork for EJI— the enslaved who refused to give up their dignity and humanity, the individuals and groups who spoke out against lynching, the many activists who drove the Civil Rights Movement. Further speaking to these efforts to change the United States, at the end of this room is a powerful sculpture by Sanford Biggers called *BAM (for Michael)*, dedicated to Michael Brown, who was killed by police in 2014. The sculpture is accompanied by a video that shows it being shot multiple times until it comes off its pedestal. With a large photograph of a memorial to George Floyd next to it, the sculpture and video remind visitors of the ongoing threat to Black Americans, but also of the powerful Black Lives Matter (BLM) movement, as well as other activist groups and movements, that are challenging that threat.

From here the museum moves into what is essentially the only uplift on offer. The final room of the museum's historical storytelling is a cavernous, warmly lit room with music playing, comfortable seats to rest upon, and walls lined with photographs of individuals who fought for racial justice, from the well-known like Ida B. Wells, Harriet Tubman, and Frederick Douglass to lesser-known individuals like Anarcha Westcott, one of the women tortured by Dr. Marion Sims's experimental medical procedures,[12] and James Thomas Rapier, a freeborn Black Alabamian who was elected to Congress in 1875 despite threats and intimidation from the Ku Klux Klan. In the original version of the museum, this was a mere corridor that led visitors out of the museum with a modicum of hope after the despairing narrative they had just encountered, but here the "Reflection Space" is its own inviting and impressive space. If the inspirational music, much of which is spirituals that became the backbone of the Civil Rights Movement, and comfortable seats aren't enough, there are touchscreen computers where visitors can look up more information about the individuals pictured on the walls. This room seems to be a clear acknowledgment that visitors, in particular Black visitors, may need a respite from the relentless injustice and a moment of focus on resistance.

Stevenson has said that he believes "hopelessness is the enemy of justice" (UN News 2023), and the Reflection Space is aimed at reminding visitors that there is reason for hope. In further keeping with this celebration of resistance and agency in the face of oppression and suffering, the new version of the Legacy Museum ends with an art gallery. While artworks are sprinkled throughout the exhibition, a reflection of EJI and Stevenson's belief that art can "transform hearts and minds" and is a powerful tool of understanding the truth, the new museum devotes two rooms to the display of an impressive collection of artworks by some of the most prominent contemporary Black artists such as Jacob Lawrence, Faith Ringgold, and Glenn Ligon. While the overarching story is one of a past and present deeply marred by racial injustice and violence, the Legacy Museum also offsets some of the horror with hope.

"Reshaping the National Conversation"

The Legacy Museum envisions itself as "an engine for education about the legacy of racial inequality and for the truth and reconciliation that leads to real solutions to contemporary problems" (EJI n.d.-c). The museum serves as a powerful reminder that the past is not yet past in the United States; rather, the ideologies that justified and supported slavery, racial terror lynching, and segregation continue to shape contemporary society. Yet, a glance at other African American museums suggests that this past is most comfortably addressed in narratives that end in the uplifting triumph of the Civil Rights Movement and relegate slavery, segregation, lynching, and other past forms of racial violence to the past. As we have seen, in the NMAAHC, despite its centering of race in U.S. history, the past is literally buried deep underground; the museum culminates with Obama's 2008 election to the presidency, just before visitors ascend to a present filled with African American achievements. This is common to most memorial museums, such as the USHMM or 9/11 Memorial Museum, which tell narratives of very specific histories that are kept distinct from the present, in part through their representation in museum form (Sodaro 2018).

In the Legacy Museum, temporality functions differently because the museum's starting point is the present. Of course, those of us who study memory understand that it is always the present from which we define, remember, and represent the past (e.g., Halbwachs 1992), but the Legacy Museum's journey through the past is one that started with EJI's work to ameliorate problems in the present legal system. After two decades of doing this difficult work, EJI turned to the historical project of tracing the roots of the inequality that they witnessed on a daily basis with their research on slavery and lynching. Thus, the historical story told in the museum is not relegated to a bygone era but is the background and context for the present social problems that EJI

works to overcome. This is evident in the evenly divided space of the museum into its four periods of racial injustice. Slavery and mass incarceration are linked and given equal space, reminding visitors that slavery has not been left in the past. This is also evident in the weaving of the present into the past, such as the jars of soil collected today from sites of past racial terror, or the testimony of people who continue today to be haunted by this violent past. It is evident in the museum's exhibition design, particularly in the graphic use of color, with white denoting white supremacy stretching from four hundred years ago up into the contemporary era of mass incarceration. And it is particularly evident in the enslaved and incarcerated individuals who speak to the visitors and implore them to feel an individual, personal connection to—and responsibility for—this contentious past, its memory, and its contemporary legacy. Christina Simko, writing about temporality in the museum as a form of working through the trauma of racial violence, notes this connection between past and present that leaves the future open to change, arguing that "in embracing the future's indeterminacy, the Legacy Museum breaks with the triumphant narratives that drive most black history museums in the United States" (2020, 71).

In the Legacy Museum there are clear efforts to take the visitor "back in time" for an encounter with the past. The slave pens seek to introduce visitors to the ghosts of the past and the horrors they endured. Similarly, the transatlantic slave trade rooms, somewhat reminiscent of the NMAAHC's room on the topic, evoke a feeling of being engulfed in the vast Atlantic Ocean. But more often, and even in these experiential encounters, rather than visitors being taken into the past, the past is thrust into the present as an uncomfortable reminder of just how present it remains. The ghostly enslaved individuals speak to visitors using the most cutting-edge museum technology, inserting themselves into comfortable historical narratives like the belief that slavery was largely a benign institution. As cultural historian and memory scholar Alison Landsberg writes "The ghost, appearing in the present, is meant to collapse the distance between then and now—to render the past *alive*, animate in the present" (2023, 45; emphasis in original). They are echoed by today's ghosts—the millions who are caught up in the "criminal justice system," unjustly locked up, abused, and oppressed because of the "permanent racial hierarchy" that the institution of slavery created. The jars of soil are also interjections of the past into the present. Many believe(d) that the racial terror of America's past could stay safely buried under decades of social amnesia and narratives of racial progress, but EJI has shattered that myth. The jars of soil literally dig up a past that many Americans wish could be forgotten and prominently display it in a way meant to disrupt the present.

In this way, the museum is not letting its (white American) visitors off easily but is instead presenting them with a historical account in which they take

the position of implicated subjects. Rothberg sees implication as a reflection of the complicated relationship between the diachronic and synchronic; for while historical injustice occurred in the past, meaning today's beneficiaries are not directly guilty or responsible for it, its consequences are ongoing in the present. Thus, "Implication emerges from the ongoing, uneven, and destabilizing intrusion of irrevocable pasts into an unredeemed present" (Rothberg 2019, 9). In the Legacy Museum, the irrevocable past of slavery, racial terror lynching, and segregation intrude into our unredeemed present. For the museum does not offer a narrative of redemption like that of the NMAAHC or vindication like other African American museums but draws a line of continuity between the historical injustices of slavery and contemporary, synchronic structures, in particular mass incarceration. The past is not relegated to the past, but rather is presented as the foundation for the present structures that shape the lives and experiences of visitors to the Legacy Museum.

In making visible these connections between past and present, the Legacy Museum refuses visitors the "socially constituted ignorance and denial [that] are essential components of implication" (Rothberg 2019, 200). Just as the NMAAHC shatters the "privilege of unknowing" (Sedgwick 1988) the Legacy Museum presents the visitor with incontrovertible evidence of the centrality of slavery and the racial hierarchy that it created to American society. Though the museum is not "national" in the way that the NMAAHC is, it presents a thorough and compelling case that one of the most pernicious legacies of slavery was its creation of a "permanent racial hierarchy" that continues to shape American society and African American experiences. As visitors make their way through the museum's carefully constructed argument, supported by statistics and other potent forms of evidence, the pervasiveness of this hierarchy becomes inescapable for white Americans, who begin to see how this "caste system" (e.g., Wilkerson 2020) privileges them at the expense of Black Americans. For the concept of implication goes beyond traditional categories of victims, perpetrators, and bystanders, instead shedding light on the "large-scale histories and social dynamics" that perpetuate injustices but in which we all participate (Rothberg 2019, 199). It is, in part, the museum's intent to demonstrate to white Americans their implication in ongoing structures, processes, and practices that support and propagate racial injustice, in order to inspire them to help change society. As Stevenson says of the visitors to the museum so far, "Not only have they come, they've left with a new understanding about what we have to do to make progress in this country. I don't want to talk about slavery and lynching and segregation because I want to punish America. I want us to get to a better place. I want there to be real liberation" (Martin 2021).

While all memorial museums at least purport to have social transformation as a central goal, the Legacy Museum goes even further. For its work is not

meant to stop in the museum or even in Montgomery because it is just one part of EJI's larger project. In addition to their legal advocacy, which is the largest part of their work by far, EJI continues to conduct historical research, facilitate memory work in local communities all over the country through their Community Remembrance Project, and run the memorial, which is arguably the larger tourist and scholarly attraction in Montgomery. They have also just expanded their commemorative work further with the Freedom Monument Sculpture Park, which EJI opened in March 2024 on the banks of the Alabama River. The park uses artworks and artifacts, such as an authentic slave cabin, to tell the story of slavery and commemorate the enslaved (EJI n.d.-b). EJI and the memory sites they have created are deeply engaged in what has been termed "memory activism"—that is, "the strategic commemoration of a contested past to achieve mnemonic or political change by working outside state channels" (Wüstenberg and Gutman 2023, 5). Scholars are paying increasing attention to what has been described as the "activist turn" in memory studies and at the ways in which institutions and actors like EJI and the Legacy Museum harness the affective and political power of memory in their work to change society.

The Legacy Museum's memory activism is part of a larger constellation of projects, such as the other museums analyzed in this book, initiatives like the 1619 Project and the Universities Studying Slavery consortium, and movements toward reparations, that are engaging in memory activism in the effort not only to challenge hegemonic historical narratives in the United States but to create meaningful confrontation with the past that leads to real change in the present. Much of this activist work became apparent to the broader public in the 2020 BLM protests, which were not just protesting Floyd's death but the centuries of racism and racial injustice that preceded it and created the conditions in which it could occur—from slavery, through Jim Crow, to mass incarceration and other current forms of racial terror, often at the hands of the state. As Landsberg writes, though it's not that the Legacy Museum "enabled the massive Black Lives Matter protests of 2020 or the new urgency around racial injustice in the US," sites like the museum and memorial "feed these movements by publicly remembering racial inequality and racially-motivated violence that live on in the present, engaging forcefully in memory activism" (2023, 47). However, as I have argued, these efforts to engage memory activism for progressive means are met by illiberal memory activists seeking to ban critical race theory, preserve Confederate monuments and symbols, and "Make America Great Again," which is code for turning back the clock to a time when racial (and gender) hierarchies were solidly in place. This reminds us that the past continues to be a battlefield on which contemporary political struggles play out; museums like the Legacy Museum are important spaces in which the power of memory is activated, but they are by no means the only spaces.

Yet while the Legacy Museum has gained national and global attention for its memory activism in its radical and challenging narrative of race in the United States, it also reminds us of the importance of memory at the local level. This is perhaps where the museum and EJI's memory activism is most impactful. Though a museum like the NMAAHC can be a powerful symbol of national acknowledgment of a violent and painful past, much of its work and message remain within the walls of the museum. EJI's work is meant to engage communities not only at the national level but at the local level as well, so that those living with the presence of past violence must confront it in a direct way. This connection between national and local, like the Legacy Museum's connection between past and present, is critical to the work that EJI and the museum do. In her analysis of EJI's Lynching Memorial, Simko reminds us that "influencing the national conversation does not ensure engagement, let alone social change, in specific communities" (2021, 165). Thus, EJI and the Community Remembrance Project, through its soil collection and erection of historical markers, disperses its memory work across the country so that it does not simply end with visits to the Montgomery sites but will instead extend to localities across the country. Tanja Shult argues that this dispersal has the potential to "fundamentally reshape American identity based on acknowledgment of the country's history of racial violence" (2020, 2). Through the Legacy Museum's powerful storytelling that links past to present and implicates white visitors, and through EJI's memory activism that bridges the national and the local, both are working to be part of a broader and transformative national movement of reconciliation and repair.

Conclusion

As a private institution, created by a nonprofit organization and built with private funds raised from foundations and individuals, the Legacy Museum is free to tell the story that it wishes to tell, which is one of white America's implication in past and ongoing racial injustice. Rather than telling a story of racial progress and change over the four hundred years since enslaved Africans first arrived in this land, the Legacy Museum focuses on *what has remained constant* (Landsberg 2023, 45; emphasis in original), explaining to visitors that the legacies of slavery continue to shape American society. This is a radical narrative to tell anywhere in the United States, but particularly in the "Cradle of the Confederacy," in a state and city that continue to cling to the Lost Cause myth of southern glory. And indeed, some Alabamans grouse about the museum and memorials' potential to be "stirring things up" or "feed[ing] fuel to the fire" of racial antagonism (Levin 2018).[13] However, these criticisms appear to be few and far between, at least in any visible or public way. Despite the seemingly inhospitable environment for such a museum, the Legacy Museum and the

Lynching Memorial have received tremendous critical acclaim in the media and appear to be grudgingly popular in Montgomery as well (Lawrence 2018).

The EJI sites also appear to be powerful engines of revitalization for the depressed city of Montgomery. While efforts to revitalize Montgomery's downtown reach back a couple of decades (City of Montgomery n.d.), in the first year of the museum and memorial's opening, they attracted hundreds of thousands of new visitors, who booked 107,000 more hotel rooms than in the previous year (Schneider 2019). Since opening, and again as the pandemic recedes, multiple buses from out of town and state arrive at the museum and memorial each day, depositing hundreds of visitors to the once sleepy downtown. In the year between my first visit (2021) and my second (2022), two large new hotels had opened, together with a multitude of new restaurants all blocks from the EJI sites. Since their opening, the EJI sites have contributed an estimated $1 billion in tourist spending to the local economy (Brand, Inwood, and Alderman 2022, 472). As has been noted, it was the immediate and extreme popularity of the museum, which had to turn away tens of thousands of visitors in its first two years, that inspired EJI to use the pandemic lull to reopen the museum to be significantly larger. Though some in Montgomery and Alabama may want to leave the past in the past, there appear to be many more visitors from across the country (and world) who are eager for the museum and memorial's truth-telling—visitors who are both Black and white, and in fact span the United States' racial and ethnic makeup.

Like the NMAAHC, the Legacy Museum was created not only for African American audiences but also for white audiences who have long been resistant to the story that it tells. Simko (2021) describes "mnemonic cleavages" between Black and white Americans, who have vastly different understandings and memories of past events. Yet in the Legacy Museum, these memories come closer—mostly because white visitors are learning a story that Black visitors already know too well. As in the NMAAHC, white and Black visitors experience the horror of America's long and continuing history of racial violence and oppression together but, in many ways, they experience it differently. While I saw many visitors break down in tears throughout the museum's exhibits, often to be comforted by one of the ubiquitous EJI employees, almost all were white. White visitors, from my observation, were more likely to remain silent or only quietly and occasionally comment to their companions, seemingly shocked into silence but also absorbing the story in an almost reverent way. Black visitors, on the other hand, were more likely to discuss the exhibits, often with knowing nods and exclamations making it clear that the information on display is not new to their experiences. At several points, I saw the statistics in the exhibits being used as teaching tools, such as a Black man with a group of young Black boys, who pointed out the statistic that one in three Black boys will end up in prison in the United States; he used this to emphasize to the children

that they must take their education seriously, since the government is pouring money into prisons but not into schools.

Nevertheless, together Black and white visitors to the Legacy Museum are presented with a radical and new form of truth-telling; one which implicates white Americans in both past and present injustice by "evok[ing] the dormant depths of racism" (Brand, Inwood, and Alderman 2022, 479). The museum is intended to create discursive space for a broader local and national dialogue about the United States' past and ongoing racism. For Stevenson, and EJI, this dialogue is the first step toward social transformation: "Our nation's history of racial injustice casts a shadow across the American landscape. This shadow cannot be lifted until we shine the light of truth on the destructive violence that shaped our nation, traumatized people of color, and compromised our commitment to the rule of law and to equal justice" (EJI n.d.-c). It is not just African Americans who are not free because of slavery's persistent legacy, but *all* Americans. Thus, the Legacy Museum represents an important cultural space for the acknowledgment of the trauma, suffering, and terror of African Americans, but also for the acknowledgment of white Americans' implication and the concomitant responsibility for beginning the difficult work of redressing past wrongs and reshaping a more equitable society.

4

"After a Century of Silence"

• •

Greenwood Rising

In August 2021, Greenwood Rising opened in Tulsa, Oklahoma.[1] The museum was created for the centennial commemoration of the 1921 Tulsa Race Massacre, which for the last century has been largely forgotten or speciously described as a riot. Greenwood Rising (n.d.-c) is intended to counter this long silence as a space of "truth-telling and education . . . aimed at repairing lingering historical racial trauma." The museum, the flagship project of the 1921 Tulsa Race Massacre Centennial Commission, is described as an "immersive journey" that "brings to life the memories of the past and the visions of success for the future and catalyzes important dialogue around racial reconciliation and restorative justice" (Greenwood Rising n.d.-b). Very much inspired by the Legacy Museum, Greenwood Rising's narrative is experientially told using cutting-edge digital technology. Its temporal frame stretches all the way back to Greenwood's Native American roots and brings visitors up to the present, via an affective, minute-by-minute experience of the horrors of the massacre, situating the particular, local story of Greenwood within the larger national "social systems of anti-Blackness." But it is also focused on the future, ending with dialogue and commitment spaces, in which visitors are asked to think about their role in fighting systemic racism.

However, despite its efforts to confront the past in a way that will help shape a better present and future, Greenwood Rising has been controversial in a way

that the NMAAHC and the Legacy Museum have not been. Many members of Tulsa's African American community, in particular, see the museum as a "symbolic gesture" and believe that the $20 million spent on the museum could have gone to reparations or programs that would more directly benefit Black residents of Greenwood. In its immersive and experiential exhibits and attempts to draw a line of continuity between past, present, and future, Greenwood Rising is very much part of this new wave of museums that are working to challenge hegemonic narratives of racial progress in the United States. However, the controversies surrounding the museum are a reminder of the ongoing tensions between past, present, and future at the local level and raise questions about the limits of the ethics of remembering in the face of ongoing injustice.

A Brief History of Greenwood

Unlike the NMAAHC and the Legacy Museum, Greenwood Rising focuses on a particular, localized instance of historical racial violence: the Tulsa Race Massacre of 1921. However, like the others, its narrative is much broader; it situates this local event in the national and international history of slavery and settler colonialism and brings its historical narrative up to the present day. In this way the museum works to connect past and present in its efforts to educate, enlighten, and spur racial dialogue and reconciliation. But central to the museum's work is remembering and educating about the events of May 31–June 1, 1921.

The Tulsa Race Massacre is today considered one of the worst incidents of racial violence in the United States. It occurred in the Greenwood neighborhood of North Tulsa, which was a thriving Black enclave where an estimated 10,000–12,000 African Americans lived, owned businesses, worked, and frequented the local restaurants, theaters, barber shops and salons, grocery stores, hotels, and other establishments. The roots of Tulsa and Greenwood go far back, to before Oklahoma was decreed "Indian Territory," and many residents of Greenwood were "freedmen" of the so-called Five Civilized Tribes;[2] others landed there after fleeing enslavement, sharecropping, and racial violence in the deep South (H. Johnson 2020, 184). Despite growing racial discrimination and a series of Jim Crow laws enacted when Oklahoma became a state in 1907, Greenwood's population built a neighborhood so booming and prosperous that Booker T. Washington dubbed it "Black Wall Street" (Crowe and Lewis 2021), a name that persists today and has taken on a particular touristic cachet. However, even in a segregated city like Tulsa, this kind of growing African American power was threatening to the white supremacist status quo (Ellsworth 1992). The threat of Black success, coupled with the vigilantism of the South under Jim Crow and the inaction and deeply ingrained biases of the

government and city institutions (Ellsworth 1992; Messer 2021), meant that Tulsa was a "tinderbox" just waiting for a match to be lit (Armstrong 2021).

That match was lit on May 30, 1921, when a young black man, Dick Rowland, was accused of assaulting a young white woman in an elevator. Though he would later be cleared of all charges, Rowland was arrested on May 31 and an inflammatory article urging Tulsans to "Nab Negro for Attacking Girl in Elevator" ran in the *Tulsa Tribune*. Word got around and a white crowd gathered outside the courthouse, numbering in the hundreds by evening (Messer 2021, 4). Fearing that Rowland would be lynched—threats had been circulating widely—a group of armed Black men from Greenwood approached the courthouse and offered to help enforce order but were turned away. As the white crowd continued to grow to as many as two thousand, more armed Black men returned to try to protect Rowland. Most accounts agree that a gun accidentally went off and "the war began" (Messer 2021, 4).

Over the course of the next twenty-four hours, a mob of armed white Tulsans, many of whom had been given guns and deputized by the police department, rampaged the Greenwood neighborhood, looting, setting homes and businesses on fire, and indiscriminately killing African Americans (Ellsworth 1992). Multiple eyewitnesses describe planes flying overhead and dropping turpentine or kerosene bombs on the people below (Armstrong 2021). The attack ended at 11:30 P.M. on June 1, when martial law was declared. Thirty-five square blocks had been destroyed and the mob had torched over 1,200 homes, 60 businesses, a school, a hospital, a library, and dozens of churches (Human Rights Watch 2020). The official death count in 1921 was 36, but most experts estimate that it was closer to 300.[3]

In the aftermath, thousands of African Americans were interned in Tulsa's convention hall, stadium, and fairgrounds. Housed in tents, some spent months in internment camps, and others were only freed when white employers "claimed" them. Those who were freed were forced to carry green cards to move about the city and had nothing to return to. Their internment left the neighborhood empty and open to looting and destruction of the little that remained (Human Rights Watch 2020, 7). The damage caused by the massacre was estimated at $1.8 million, which today would be equivalent to $27 million, but scholars estimate that the true cost of lost generations of wealth is closer to $200 million (Perry, Barr, and Romer 2021). But in the aftermath of the massacre, the institutions of Tulsa rallied around the *Tulsa Tribune*'s editorial argument that "such a district as the old 'N——town' must never be allowed in Tulsa again." Insurance companies denied claims based on a "riot clause" and the "City Commission" established to review the events, which were at the time deemed a negro "uprising," denied all claims except one from a white pawnshop owner for ammunition that had been taken during the attack (Human Rights Watch 2020, 11). Just days after the massacre, the city

began to make plans to turn the neighborhood into an industrial and wholesale district aimed at attracting white business owners. For those Black Tulsans who might have been able to rebuild, a new fire ordinance required that any new structures "be at least two stories high and made of concrete, brick or steel," prohibitively expensive for most who had lost everything (Human Rights Watch 2020, 12).

Nevertheless, the residents of Greenwood slowly and painstakingly rebuilt. Lawyer B. C. Franklin got the fire ordinance thrown out and those who could regrouped, gathered resources, and rebuilt the neighborhood. By the beginning of World War II, a Chamber of Commerce business directory described Greenwood as "unquestionably the greatest assembly of Negro shops and stores to be found anywhere in America" (qtd. in Human Rights Watch 2020, 14). The neighborhood again boasted hundreds of businesses and provided a haven for African Americans navigating Jim Crow and segregation. However, Greenwood's heroic rise from the proverbial ashes was not to last. In a cruel twist of irony, the end of segregation helped to bring about Greenwood's second demise; as commerce and opportunities opened to African Americans beyond the confines of North Tulsa, Greenwood residents took their business and money elsewhere. The final death knell was dealt by so-called urban renewal projects (nicknamed "urban removal" by residents of Greenwood). As historian John Hope Franklin, son of B. C. Franklin, astutely pointed out, "There are two ways which whites destroy a black community. One is by building a freeway through it, the other is by changing the zoning laws" (qtd. in Ellsworth 1992, 109).[4] Rezoning and the construction of intersecting freeways that bisect the neighborhood effectively destroyed Greenwood yet again.

For decades the Tulsa Race Massacre had been relegated to silence, largely forgotten. In the immediate aftermath, white Tulsans, in particular the media and government, framed the massacre as a riot, claiming that Black Tulsans started it and effectively ensuring that the city and state did not bear any responsibility. The silence persisted and was exacerbated by the deliberate cover-up of the massacre. For example, the original *Tulsa Tribune* article and many others that recounted the events of the massacre have been destroyed or have disappeared from the archives (Ellsworth 1992, 47–48). In the face of this concerted effort to whitewash history, Black Tulsans continued to fear for their lives and had little recourse for challenging the official narrative. This silence deepened over the decades, with the riot/massacre entirely left out of Oklahoma public school history lessons and many Oklahomans only learning about the massacre in other states and school systems (Armstrong 2021). In fact, it was not until 2020 that the massacre entered public school curricula.

Nevertheless, over the last century, various actors and events have chipped away at the silence. Black Tulsans, of course, never forgot. The *Tulsa Eagle*, Tulsa's Black newspaper, mentioned the massacre over the years, and the story

was passed down through African American families. In 1971, over two hundred Black Tulsans quietly commemorated the massacre for the fiftieth anniversary and the *Tulsa Tribune* even wrote a story on the "riot," though it failed to mention its own role in inciting the violence (Ellsworth 1992, 107). These small steps toward remembering helped to pave the way in 1997 for the Oklahoma State Legislature's creation of the Oklahoma Commission to Study the Tulsa Race Riot of 1921 (hereafter the Oklahoma Commission). This state-appointed investigative body extensively researched the massacre over the next three and a half years; in fact, their mandate resonated so widely, scores of individuals volunteered to help with the research, and they received hundreds of phone calls from people offering information (Churchwell 2001, v–vi). The Oklahoma Commission interviewed survivors, whose testimony remains one of the most important sources of information about the massacre today; they studied hospital and autopsy reports, official documents and legal records, personal correspondence, newspaper clippings, and family photographs; and they spoke with hundreds of individuals who helped to put the pieces of the puzzle together. In 2001, the Oklahoma Commission released a report of their findings, concluding that "through the night of May 31, and into the morning of June 1, whites virtually destroyed the Greenwood section. There were an undetermined number of deaths, both black and white, with estimates ranging from the official count of 36 to approximately 300. Over 1,000 residences were burned and another 400 looted. The business district of Greenwood was totally destroyed and probably accounts for much of the $4 million in claims filed against the city in 1921" (Brooks and Witten 2001, 123).The Oklahoma Commission also made a series of recommendations, including direct reparations payments to survivors and descendants, a scholarship fund for those affected by the massacre, the establishment of an economic development zone in Greenwood, and a memorial for the reburial of human remains found in the search for mass graves (2001, 21–22).

However, none of the recommendations were acted upon. Though a scholarship fund was established, it did not even specify that recipients be Black, let alone that they have any connection to the massacre (Human Rights Watch 2021). The closest the city and state came to enacting the other recommendations was the creation in 2007 of the John Hope Franklin Center for Reconciliation, which oversees the John Hope Franklin Reconciliation Park, which opened in 2010. The center, which was created through a public-private partnership but does not have a dedicated building, has the mission "to transform the bitterness and mistrust caused by years of racial division, even violence, into a hopeful future of reconciliation and cooperation for Tulsa and the nation" (John Hope Franklin Center for Reconciliation n.d.). The center is a member of the International Coalition of Sites of Conscience and the African American Civil Rights Network.[5] Its primary manifestation, Reconciliation Park, is

94 • Lifting the Shadow

a peaceful green expanse that tells the story of Greenwood and the massacre through a set of bronze sculptures by artist Ed Dwight. The park's Hope Plaza boasts a granite sculpture with three bronze figures depicting hostility, humiliation, and hope, which are modeled on photographs of the massacre. At the park's center is the Tower of Reconciliation, a bronze memorial column depicting African American history from roots in Africa up to today. Though a lovely respite from the surrounding pavement, the park is tucked under a freeway and behind a baseball stadium, well off the beaten track, suggesting that this history is not a priority for many Tulsans.[6]

Despite these local efforts at memory, it would take a pop culture phenomenon to shatter the silence: it was through HBO's *Watchmen* television series that most Americans appear to have learned about the massacre. *Watchmen*, which is based on the 1986–1987 DC Comics series by Alan Moore and Dave Gibbons and was released in fall 2019, is set in Tulsa and opens with a graphic—and well-researched—depiction of the massacre; in the first episode the lead character, Angela Abar, even visits an imagined memorial museum commemorating the massacre. Millions watched the series, and it was awarded eleven Emmy awards, testament to its popularity. Historian Scott Ellsworth writes, "It is likely that no single event has spread awareness of the Tulsa race massacre, both globally and among the under-twenty-five set, more than HBO's *Watchmen* series" (2021, 302). Just one year later, another HBO science fiction series, *Lovecraft Country*, depicted the massacre in its ninth episode, in which the characters find themselves caught up in the 1921 violence. Together these two series helped end a hundred years of silence around the massacre and brought the Tulsa Race Massacre to America's (and the world's) attention (Hill 2021).

Greenwood Rising

It was in this context of growing public awareness and interest that Greenwood Rising was conceived. The museum is the flagship project of the 1921 Tulsa Race Massacre Centennial Commission (hereafter the Centennial Commission), which was formed in 2015 by Oklahoma state senator Kevin Matthews to lead the centennial commemoration. Matthews handpicked a group of political, corporate, and community leaders in Tulsa, including individuals from the John Hope Franklin Center, the Greenwood Chamber of Commerce, and the nearby Greenwood Cultural Center, to "outline projects which would meet the core purpose of truth-telling, educate the world about the history of Greenwood, and spur entrepreneurial opportunities" (Greenwood Rising n.d.-c). The Centennial Commission presented itself as building on the work of the Oklahoma Commission; however, from the very beginning, the Centennial Commission's remit was focused primarily on the creation of a "history center" (Human

Rights Watch 2021). There was already a Reconciliation Park and a Black Wall Street memorial at the Greenwood Cultural Center, so the Centennial Commission envisioned a museum that would tell the full story of Black Wall Street and in doing so serve as a symbolic, communal form of reparation—a "platform where issues [like reparations] can be discussed and moved forward in a meaningful manner" (Greenwood Rising n.d.-c).

However, this limited mandate that the Centennial Commission set for itself meant the question of how its work would fit into broader community efforts at remembrance and redevelopment was fraught from the beginning. Initially, the Centennial Commission announced the historical center as "a joint collaboration" with the John Hope Franklin Center and the Greenwood Cultural Center (Krehbiel 2019). The new museum was going to be built on the grounds of the Greenwood Cultural Center and $5.3 million of the $30 million raised by the Centennial Commission would go toward renovations of the Cultural Center (Human Rights Watch 2021). However, when the Cultural Center and Centennial Commission failed to reach an agreement, the museum was moved to its current location, on the corner of Greenwood and Archer on land donated by the Hille Foundation, a local foundation working to redevelop Greenwood (Human Rights Watch 2021).[7] And though funds are still earmarked for the Cultural Center renovation, they are tied up in a bond measure, meaning the Cultural Center only received $500,000 for a set of quick upgrades in time for the centennial.[8] Instead, most of the attention, funding, and energy around the centennial ended up going to the creation of Greenwood Rising.

To develop their plans for the museum, the Centennial Commission looked to other, similar museums to better understand how societies musealize past atrocity. While they took inspiration from Holocaust and other memorial museums around the world,[9] it was on a visit to civil rights memorial sites in Montgomery that they found their model in the design of the Legacy Museum (Greenwood Rising n.d.-a) While EJI took the lead on the creation of the Legacy Museum, as described in chapter 3, they had help with some exhibits from the experiential exhibit design firm Local Projects, a relative newcomer to the exhibit design scene that aims to "push the boundaries of meaningful experiences and emotional storytelling" and that is perhaps best known for its work on the 9/11 Memorial Museum (Local Projects n.d.). Learning this, the Centennial Commission immediately hired Local Projects to take the lead on Greenwood Rising. They also recruited Hannibal B. Johnson, local lawyer and amateur historian of Black Wall Street, as head curator.

One of the first things that Local Projects and the Centennial Commission did was reach out to Greenwood community leaders and stakeholders, including individuals from the Greenwood Cultural Center and John Hope Franklin Center, as well as leaders of local churches and businesses and other

community members. For three days they asked these representatives of the community what they would like in a history center dedicated to the history of the massacre and, as Local Projects project director L'Rai Arthur-Mensah told me, they just "listened" (personal communication, 2022). While they heard many things from the community, one of the key points was that people wanted the story told but did not want the museum to focus solely on the massacre (Arthur-Mensah and Armstrong 2021). Local Projects, underlining that this was not their story to tell but that of the community, worked to integrate these ideas into their designs, eventually bringing their plans back to Tulsa for community members to review.

It was during this process of community engagement that the Centennial Commission brought in Phil Armstrong, a local businessman and entrepreneur who was chair of the Greenwood Cultural Center Board, to be their project director. While Local Projects developed the design, Armstrong and the Centennial Commission set to work fundraising. They ultimately raised $30 million for the centennial, mostly in private funds from individuals, corporations, and foundations, though with some state funding.[10] Approximately $20 million of the funds raised went to the creation of the museum, with the remaining funds going toward the Greenwood Art Project, a series of

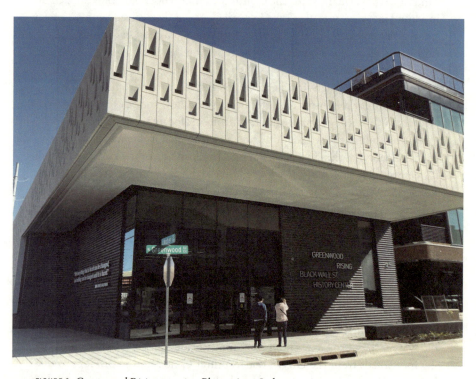

FIGURE 9 Greenwood Rising exterior. Photo: Amy Sodaro.

murals and other public art throughout the neighborhood; the "Pathway to Hope," a walkway hugging an elevated highway that cuts through the neighborhood, "symbolically reconnect[ing]" the neighborhood Greenwood Rising (n.d.-d); neighborhood historical markers; the above-mentioned partial renovation of the Greenwood Cultural Center; and centennial programming (Greenwood Rising (n.d.-c). Once the location of the museum was confirmed, in a relatively quick process ground for the museum was broken on August 21, 2020, and the museum was completed in time for a community preview for the anniversary and for public opening on August 4, 2021.

The Greenwood Rising Experience

The finished museum is sleek and technologically sophisticated and conforms to many of the memorial museum tropes that we have seen in the NMAAHC and the Legacy Museum and which have become part of the global standard, in particular the affective experience of the past that it creates (Micieli-Voutsinas 2021; Sodaro 2018; Williams 2007). While the museum's location on a corner of Greenwood Avenue, which was once a gateway to Black Wall Street, evokes the authenticity of the historical site, the brand new, concrete structure employs the "affective architecture" common to memorial museums that are "purpose built" and not located on authentic historic sites (Jinks 2014). The museum building, designed by Tulsa architectural firm Selser Schaefer (now Narrate Design),[11] incorporates references both to the historic brickwork of Black Wall Street in its façade and to contemporary memorial architecture, like the Jewish Museum Berlin or the National September 11 Memorial & Museum, in its ascending series of "voids."[12] The voids are also reminiscent of the NMAAHC's bronze corona in the way they allow light and shadow to "activate" the building. With similarly symbolic meaning, Greenwood Rising's voids are intended to be "representative of a commitment to the sustained presence and revitalization of the historic district" (Narrate Design n.d.-a) seemingly reflecting the hope that Greenwood Rising can do for Tulsa what the Legacy Museum is doing for Montgomery.

Like the Legacy Museum, Greenwood Rising is small for the long history it addresses; the eleven-thousand-square-foot museum leads visitors through the story of Greenwood, from its origins as a site of the Muscogee / Creek Native Americans through the Trail of Tears, discovery of oil, and development of Black Wall Street to its destruction in the 1921 massacre, through its rebirth and subsequent decline, up until today. And like the Legacy Museum, Greenwood Rising was largely created by a team of people who are not museum professionals, with the only curator being Hannibal B. Johnson, who is a trained lawyer with no previous museum experience, as noted above.[13] It also displays relatively few artifacts compared to more traditional museums

like the NMAAHC, though it has more than the Legacy Museum, many of which come from Phil Armstrong's (2021) mother's collection. Instead, it relies primarily on digital displays and reproductions of photographs and documents. In a dramatic departure from the Legacy Museum, Greenwood Rising takes visitors through the museum on "tours," with a guide who offers some description and context for the exhibits but primarily ushers visitors through the space following a carefully calibrated timing to ensure that they see the entirety of the various films and digital displays.

The museum's history telling begins in the lobby with a series of "viewports" of historical photographs of the neighborhood that morph into contemporary shots of the same places. These are followed by an introductory film by Tulsa filmmaker Trey Thaxton. Set to Maya Angelou's poem "Still I Rise," the stylized "media piece" weaves together stories of contemporary Greenwood residents and leaders with the neighborhood's history. With this juxtaposition of past and present and the hope and resiliency of Greenwood's "rising," the tour begins, sweeping the visitor back in time. The history of Greenwood starts in a room called "The Greenwood Spirit." Railroad tracks bisect the room, and the guide explains that these are real tracks taken from the nearby Frisco rail, which continues to bisect the city into north (Black and poor) and south (white and rich). Armstrong (2021) describes crossing these tracks as the most important element of the museum—evoking the "racial divide" in the United States, it feels almost like the Apartheid Museum's dual entrance for "Whites" and "Non-Whites" or the Legacy Museum's stark reminder to visitors of this history of the site on which the museum stands, though the meaning of the tracks is much less clear to visitors from beyond Tulsa. The walls in this room are lined with panels explaining the history of Greenwood and the building of Black Wall Street, highlighting key historical leaders. A time-lapse film called *Shaping the Land* shows the development of Tulsa and Black Wall Street from a dusty plain to a bustling economic hub. As the film wraps up, guides hustle visitors through a closed door and into the next room.

Greenwood Rising's Local Projects team believes that museums can "humanize history" in a way that is transformative for the present by creating "empathy and understanding" within the visitor (Arthur-Mensah and Armstrong 2021). The next part of the exhibit attempts to do just this: in it, visitors are taken back in time to a period barbershop. This is a clear attempt to give visitors a window into the critical spaces in African American communities where, in the words of Ralph Ellison, "a whole unrecorded history is spoken" (qtd. in Fabre and O'Meally 1994, 3)—a place where African Americans could speak freely, remember the past openly, and imagine the future. Re-created in painstaking detail, minus hair clippings littering the floor, the barbershop invites visitors to sit in barber chairs while holographic barbers "cut" their hair and talk about the ups and downs of life in Greenwood. As in the Legacy Museum, these figures are

intended to give visitors an "affective, embodied experience" that, according to media and memory scholar Victoria Walden in her discussion of virtual Holocaust memory, places the visitor "between past and the present in critical ways that encourage them to take on the responsibility for ... memory" (2022, 626). The embodied act of sitting in a barber chair and "listening in" on these voices from the past is intended to make visitors feel that they are "part of the community" that was Greenwood and, in this way, better understand what had been built and so viciously destroyed (Arthur-Mensah and Armstrong 2021). However, Walden points out that many digital memory projects, such as this one, fall short of creating this ethical relationship to memory because they simply re-create the past for visitors rather than asking them to do the hard work of "reactualizing" the past themselves and thus taking responsibility for its memory (2022, 627–628). While the barbershop creates an experience for the visitor, it is one in which the simulation of the past is so complete that the visitor is placed in the position of a mere spectator; visitors are not burdened with the same kind of moral responsibility that the ghostly figures of the Legacy Museum demand. Nevertheless, the barbers' witty and prescient banter gives visitors insight into not only the successes of Black Wall Street, but also the pervasive racism simmering just outside the neighborhood, setting the stage for the centerpiece of the museum: the "immersive journey" into the massacre. As the barbers finish up their chat, the guide escorts visitors into "The Arc of Oppression."

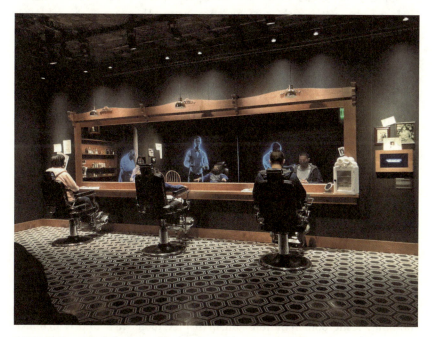

FIGURE 10 Re-created Greenwood barbershop. Photo: Amy Sodaro.

"The Arc of Oppression" begins with a content warning, offering visitors who might be traumatized or triggered by the violence an "emotional exit." Arthur-Mensah explained that the museum team was designing the exhibit at the time of the murder of George Floyd; thinking of her young son and others in the African American community who had been triggered and traumatized by the violent images of Floyd's death, she and her team wanted to give visitors the opportunity to learn about the massacre, but not have to see the atrocity (personal communication, 2022). Thus, visitors have the option of skipping the exhibits in "The Arc of Oppression" and instead turning off the path to a small room that outlines the massacre in less graphic detail. However, on my visits, I did not see any visitors opting for the emotional exit (which, considering the diminutive size of the museum would make for a very short visit); rather it seemed that they were there to learn as much as possible about the massacre.

This education begins in a small room outlining the "Systems of Anti-Blackness" that led to the massacre. Reflecting the importance of language choices in museums, such as we have seen in the Legacy Museum, the Greenwood Rising team was very intentional about the use of the term "anti-Black" as part of their goal of "truth-telling" in a way that wouldn't "sugar-coat" the past (Arthur-Mensah and Armstrong 2021) or allow for potentially more elastic interpretations of terms like "racism" (e.g., ross 2020). While "racism" can have vague and varied meanings (including being speciously distorted as "reverse racism" to indicate "racism" against white people), the meaning of "anti-Black" is clear and specific to the museum's argument. This part of the exhibit is intended to give context to the massacre, and it describes how anti-Blackness and white supremacy became embedded in the United States' institutions and structures. It begins with the year 1619; though no context is given for this year, its meaning has by now perhaps filtered through society so visitors can recognize it as the year slavery in the United States began (and, with it, anti-Blackness) with the arrival of the first enslaved Africans in Virginia. Using photographs and explanatory text interwoven with occasional artifacts, this section traces the development of anti-Blackness in three key institutions: social, economic, and political. In a nod to more traditional museum displays, it follows a (somewhat jumbled) timeline that highlights some of the key moments, events, and examples of anti-Black policy and practice—from instances of resistance like Bacon's Rebellion to sundown towns and Black codes to Jim Crow and the Ku Klux Klan (KKK). But it feels almost as if two vast floors of the NMAAHC have been crammed into one small room, meaning many things have been necessarily left out. This lightning history lesson, however, has one primary job, it seems, which is to lead visitors up to 1921, and it does so with a small wall devoted to explaining the massacre. And although this concise overview is arguably the most important room in the museum, in that it is intended to impart an understanding of the deep systemic roots of racial injustice in the United States,

"After a Century of Silence" • 101

most visitors are rushed through it by their guide so that they can make it through a heavy curtain and into the next room for the presentation of the massacre.

Visitors are directed to a set of benches and seats along one wall of a darkened room, where a stylized film titled *It Was an Ordinary Day* is projected across four staggered, ragged pillars that evoke Greenwood's post-massacre devastation. Overlapping images and film are set to audio testimony of massacre survivors, which is drawn from that collected by the Oklahoma Commission for their 2001 report. As the images shift and morph to depict the violence, the individual stories and memories meld into one narrative of the day. Against a backdrop of images of peaceful streets and brick homes with flower boxes in the windows and people strolling by, the survivors, who were young children at the time, recall the morning of May 31, 1921, when excitement over that evening's high school prom gave way to rising tension as word spread that a young Black man who had been arrested for assaulting a white woman was going to be lynched. They recall being woken from their slumber that night by armed white men setting fire to their homes, as the film shifts to show a faceless man holding a torch and standing just outside a living room window. As the images become more terrifying, with fire and darkness descending as angry mobs move across the pillars, the survivors describe cars of white men indiscriminately shooting, mobs torching homes and businesses, and Greenwood residents fleeing for their lives. One man remembers his father pleading: "Please don't set my house on fire" to no avail, and a woman recalls "black birds"—bullets and turpentine bombs—dropping from the sky. The sounds of the massacre surround the visitor, evoking the immersive nature of a 4D film: planes zoom overhead and bullets rain down while fires burn and smoke builds until it covers the pillars. As the smoke clears and billows through empty streets, images emerge of the neighborhood reduced to rubble, calling to mind Dresden, Hiroshima, or Syria.

It is not just the images of destruction that transport visitors to other sites of atrocity; rather, the entire experience references the affective practices of memorial museums around the world. As previously discussed, moving testimony of survivors has become a fixture of Holocaust and memorial museums, inflecting historical exhibits with the affective power of memory. From Rwanda to Germany to Chile, testimony has become an integral part of telling the story of mass violence. Bearing witness to testimony is considered an act that demands individuals take responsibility for what they see (e.g., Felman 1992). Roger Smith has theorized this responsibility as a "pedagogy of witness" that occurs in spaces like memorial museums where "the animation of specters . . . has the potential to deeply haunt the formation of contemporary consciousness and conscience" (2012, 2). The trembling voices of the elderly survivors, whose memories, emotion, and trauma are still so palpable one hundred

years after the massacre, act as these haunting specters demanding that visitors bear witness. And yet, though this sort of testimony is intended to put an individual face to mass atrocity and humanize those individuals who were victimized, in this telling the individual memories are melded into one story and, as the voices overlap and the survivors' words are interposed so that they finish each other's sentences, the individuality is superseded by the museum's overarching narrative.[14]

The dim lighting, audio effects, and other theatrical tropes like the blending of individual narratives into one provide for visitors "a highly mediated, technologically savvy, multi-sensory mnemonic experience, instilling an experiential, embodied awareness of a historic event" (Micieli-Voutsinas 2021, 10). This kind of embodied experience is intended to produce the "reactualization" of the past via virtual memory practices that Walden (2022) writes of. These experiential and affective strategies are very common in memorial museums like Greenwood Rising, which work to be transformative because of their potential to produce in visitors what Alison Landsberg terms "prosthetic memory," a "personal, deeply felt memory of a past event through which [the visitor] did not live" (2004, 2). By creating this empathy and understanding, the Greenwood Rising team hoped to "change hearts and minds" (Armstrong 2021), ensuring that visitors come away committed to preventing such atrocities in the future. Thus, in its presentation of the massacre, Greenwood Rising draws from the international memorial museum canon to create an affective experience for visitors in the effort to morally transform them.

While the Tulsa Race Massacre "journey" is the emotional centerpiece of the museum, the exhibits proceed to discuss the aftermath. At this point, because the films and digital displays are largely over, the guides tend to show visitors where to go and leave them on their own, so the guides can begin their next tour. A small room on the other side of the pillars outlines the number of city blocks (35) and homes and businesses (over 1,200) that were destroyed, the number of people displaced (10,000), and discrepancies in the death toll, from the 1921 official count of 36 to the Oklahoma Commission's estimate of 150 to 300. The exhibit describes efforts to prevent Black Tulsans from rebuilding Greenwood, through the "riot clause" that insurance companies used to deny claims and the fire ordinance that would make building prohibitively expensive. It also explains that Greenwood's African American population overcame these efforts and rebuilt, though the emphasis is less on how this Herculean task was accomplished and more on the spirit that drove it.[15]

By the 1940s, Black Wall Street was again thriving, as noted above. However, that success did not last long. The next room and final exhibit, "Changing Fortunes," succinctly covers the seventy years of Greenwood's history after the massacre. Brief displays on the rebuilding of Black Wall Street are illustrated by vibrant, jaunty signs from resurrected Greenwood—the (new and

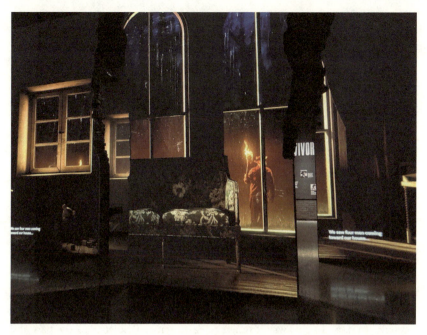

FIGURE 11 Immersive journey into the 1921 Tulsa Race Massacre. Photo: Amy Sodaro.

larger) Williams Dreamland Theatre, the welcome sign of Vernon AME Church. But this celebration of Greenwood's rise from the ashes is quickly dampened by the panels tracing Greenwood's second decline. Here the museum challenges triumphant narratives of the Civil Rights Movement by pointing out that it was in part *because of* its successes that Greenwood declined, together with the "urban renewal" projects, in particular the highways that continue to provide easy access to downtown Tulsa and other (white) neighborhoods but that cleaved the neighborhood and, again, robbed Black Tulsans of their property, this time through eminent domain.[16]

Greenwood Rising ends with the "Journey Toward Reconciliation." There is a small amphitheater here for dialogue and discussion, and provocative questions are projected onto the wall, such as "Is there such a thing as one truth?" "Can you imagine a world without racial hierarchy?" and "What would reparations look like?" This is where visitors are supposed to debrief and deconstruct what they have learned to encourage deeper understanding (Arthur-Mensah and Armstrong 2021). However, because the guide has generally left at this point, visitors are on their own to engage in dialogue. While some speak with other members of their group, most focus on the panels along one wall discussing contemporary forms of racial injustice in Tulsa: inequality in the criminal justice system; the debate over reparations; systemic racism in Tulsa's housing, public health, and education; and

gentrification—as Greenwood tries yet again to rise from the proverbial ashes, most of the trendy new businesses are white-owned and the few remaining Black residents are being pushed out.

With these ongoing inequalities in mind, visitors are asked to write a commitment to racial justice to be projected onto the Commitment Wall. Using iPads provided by the museum or scanning a QR code on their phone, visitors are invited to become part of the solution to the problems that have been laid out in the preceding rooms. The commitments range from the vague and utopian ("I commit to dismantling systems of oppression" or "Love and learn relentlessly") to specific and realizable ("I commit to citing Black scholars in my research" or "I commit to supporting Black-owned businesses in and around my community") to cringeworthy ("I commit to helping a Black child in distress find a stable, supportive home"). According to Armstrong (2021), the Commitment Wall is one of visitors' favorite parts of the museum and a key mode in which the museum is promoting reconciliation. It also stresses the museum's efforts to not only connect past and present but to include visitors in this connection.[17] Greenwood Rising is not only a memorial to the victims; it is also a space intended to "examine the lessons of the past to inspire meaningful, sustainable action in the present" (n.d.-a). In this way it resists relegating racial violence to the past and instead asks visitors to consider their role and responsibility in contemporary problems, thus implicating white Americans in past and present injustice.

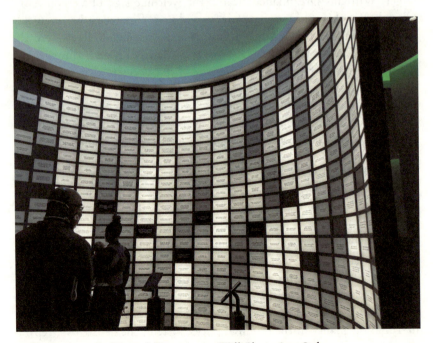

FIGURE 12 Greenwood Rising's Commitment Wall. Photo: Amy Sodaro.

Implication and Temporality in Greenwood Rising

Like the Legacy Museum—and the NMAAHC, to a lesser extent—Greenwood Rising seeks to draw a line of continuity between past and present; in this case between the establishment of anti-Black structures and systems that led to the 1921 Tulsa Race Massacre and continue to haunt contemporary Tulsa and the United States. And like the NMAAHC and the Legacy Museum, it does this in part by centering racial inequality in U.S. history; in this case, demonstrating how anti-Black systems emerged with slavery and have persisted ever since. This centering of race and the collapse of past and present, as in the NMAAHC and the Legacy Museum, is intended to bring visitors closer to understanding their own implication—not only in historical anti-Blackness, but in its present and ongoing consequences. For, as discussed in chapter 3, implication has its own temporality and is "produced and reproduced diachronically and synchronically" (Rothberg 2019, 11)—which makes museums like those analyzed in this book particularly important social spaces for its representation. Most museums operate diachronically, presenting the past as separate from the present. However, Greenwood Rising, like the NMAAHC and Legacy Museum, attempts to demonstrate the connection between past violence and present injustice, "drawing attention to the simultaneously historical and contemporary production of the scene of racialization and racial violence" (Rothberg 2019, 10). The museum does this both when its historical narrative extends to contemporary forms of racial injustice and in the way that it takes visitors back in time to a visceral experience of the massacre. Past and present are elided in the museum experience.

In addition to this effort to bridge diachronic and synchronic forms of racial violence, Greenwood Rising also seeks to go beyond the victim-perpetrator dichotomy. Many memorial museums present innocent victims and evil perpetrators as one-dimensional and essentialized in a sharp juxtaposition of good and evil that can obscure the complexities and ongoing ramifications of violence (Sodaro 2019). In Greenwood Rising, though some individual victims and perpetrators are identified—such as in the well-known photograph of Private Gordon as victim of slavery, or a roster of Tulsa KKK members that lists individual names—most of the narrative focuses on systemic anti-Blackness; even the survivors whose testimony tells the story of the massacre are only individually named on a very small placard at the entrance to the massacre exhibit. The exhibit emphasizes racism structured into social systems, demonstrating that the massacre was enabled and abetted by government institutions such as the police, the fire department, and the military. In the massacre's aftermath, the media, together with the city and state governments, worked to reframe the event as a "Negro uprising" or "race riot" to remove responsibility from white Tulsans and shape the historical narrative. In the following decades,

it was institutional entities like urban planning agencies that once again decimated the community. Thus, there is little emphasis on individual perpetrators and victims, but rather on collective, systemic oppression. In this way, the diachronic-synchronic and victim-perpetrator binaries are dissolved in Greenwood Rising to implicate visitors in past and ongoing anti-Blackness. And it is not just white Tulsans who are implicated; as Rothberg explains, "Implication emerges from genealogies *and structures*: from the different ways that historical legacies and contemporary conflicts, intimate inheritances and diffuse social forces, intertwine" (2019, 201; emphasis added). All of us who have benefited from anti-Blackness are implicated in this history.

The narrative of implication that is first suggested in the uncomfortable history of the NMAAHC and develops in Greenwood Rising and the Legacy Museum suggests a move toward a more meaningful confrontation with the ongoing legacies of historical violence. In the mnemonic struggles over the legacy of slavery in the United States, this shift in the memorial museum paradigm is a particularly important one. As understanding of the historical dimensions of racism collide with present systemic injustices, it is perhaps becoming more difficult for white Americans to absolve themselves of responsibility for the past. The implicatory narrative reflects a deepening commitment to political regret and the assignation of responsibility for historical wrongs—a commitment that will help shape future memorial ethics.

A Symbolic Gesture

However, despite the important work that it is attempting to do, and unlike its inspiration, the Legacy Museum, Greenwood Rising has been controversial among the African American community in Tulsa. Many see the museum as a "symbolic gesture" intended, in the words of Tulsa's only Black elected official, City Councilor Vanessa Hall-Harper, to "make Tulsa appear not to be the racist-ass city that it is" (Smithson 2021). Activist organization Justice for Greenwood (2021) echoed this sentiment in a March 2021 tweet:

> Dear @GreenwoodRising: We don't want your Tulsa Race Massacre-themed Disneyland. Shiny buildings, museums and coffee shops won't make us forget how you and the City of Tulsa refuse to acknowledge the inherent anti-blackness Tulsa is built upon.

The controversy surrounding the museum stems in large part from ongoing and unmet demands for reparations to survivors and their descendants. Property losses in the massacre, as has been noted, were in the tens or even hundreds of millions of dollars, but no restitution has ever been paid. The

Oklahoma Commission's report listed financial compensation as its first recommendation, but reparations still have not been enacted.[18] Yet the ongoing economic impacts of the massacre are still acutely felt in Tulsa, a highly segregated city with rampant inequality. The majority of Black residents are concentrated in North Tulsa where poverty and unemployment rates are two and a half times that of white neighborhoods; life expectancies are six years lower than in South Tulsa; schools are underfunded and underperforming; and aggressive policing, crime, and criminal debt ravage the neighborhood (Human Rights Watch 2020, 20–21). Black households in Tulsa have just 9 percent of the wealth of white Tulsan households (Duke University 2021), Black-owned businesses make up just 1.25 percent of the city's businesses (Perry, Barr, and Romer 2021), and Black households lag 38 percent behind white households in home ownership (Duke University 2021). The "catastrophic" economic losses of the massacre still very much shape the sharp inequalities found in Tulsa today (Perry, Barr, and Romer 2021).

Against this backdrop, critics of Greenwood Rising argue that the $20 million spent on the museum should have gone to reparations or programs that more directly benefit Black residents of Greenwood. Reparations are central to today's "worldwide preoccupation with righting historical injustices" (Torpey 2006, 8), but it is very rare that financial reparations are paid out to survivors of mass atrocities.[19] Rather, "by privileging reconciliation over justice, [today's dominant] human rights discourse demands that victims give up their claims on material redistribution and settle instead for a 'moral victory' that declares that evil has already been overcome" (Rothberg 2019, 15). It is much easier to symbolically acknowledge and ethically remember atrocities than it is to materially compensate their victims. While the question of reparations for slavery has gotten renewed traction, with legislation to study such reparations advancing in Congress for the first time in history and survivors and descendants of the Tulsa Race Massacre testifying before Congress in 2021, a recent poll found almost two-thirds of American oppose reparations (J. Sharpe 2021).[20] With Tulsa's (white, Republican) mayor prioritizing development over reparations, arguing that "cash payments divide the community on something we should be united on" (Hemeon 2021), and a Republican-led state government that recently passed legislation that protects motorists who injure or kill protesters and that bans teaching about race (and gender) in schools, the fight for reparations is an uphill battle. The two remaining survivors of the massacre, Viola Fletcher and Lessie Randle (both of them, of course, over a hundred years old), have sued the city of Tulsa and Greenwood Rising / the Centennial Commission for reparations.[21] The lawsuit was dismissed in June 2023 and upon appeal was taken up by Oklahoma's Supreme Court. Though the survivors did receive a $1 million donation in 2022 from the philanthropic group Business

for Good, which was frustrated by the lack of progress securing reparations from the government (Albeck-Ripka 2022), they maintain that the city of Tulsa was responsible for the massacre and so should be responsible for restitution.

Phil Armstrong, Greenwood Rising's founding director, argues that the museum is not the culmination of the process of remembrance and repair, but is in fact the beginning—a way to "capture the hearts and minds" of visitors who can pressure the government to act (2021). The museum's website says unequivocally that "Greenwood Rising believes strongly in reparations," but goes on to clarify that reparations come in many forms and that "Greenwood Rising's work toward reparations falls in restitution through advocacy for investment in education, infrastructure, and economic development in North Tulsa," which is clearly very different from the individual monetary reparations sought by survivors and descendants (Greenwood Rising n.d.-c.). And it is further clear that this stance on repair and reparations is not sufficient for those who see the museum as the result of a closed, politically elite process that excluded key stakeholders. While there were descendants on the Centennial Commission—according to Senator Matthews he is a descendant and had engaged another descendant, Brenda Alford, to do much of the community outreach (Human Rights Watch 2021)—many descendants said that they were not consulted in the process. For example, Barbara Barros, granddaughter of two massacre survivors, told Human Rights Watch, "I can tell you I've received a big fat zero from them [the Centennial Commission] in terms of contact" (2021). Another descendant, Tedra Williams, was turned away from a meeting in 2016, and was told by Senator Matthews that "we are not adding survivor families at this point in the process."

The remaining survivors have been particularly alienated. One-hundred-six-year-old Lessie Benningfield "Mother" Randle issued a cease-and-desist order in 2021 to the Centennial Commission to stop it using her name, stating, "My family and I were shocked to hear that the Commission is 'dedicating' much of their work to me since they have refused to meet with me, did not allow me an opportunity to participate in the Commission's planning, and declined to enter discussions on how I, a living survivor of the massacre, feel about their activities around the centennial" (Trotter 2021). The Centennial Commission's main anniversary commemorative event, "Remember and Rise," was canceled at the last minute because of a dispute with survivors, who had agreed to participate only in exchange for a cash payment and seed money for a reparations fund (Hampton 2021). The frequently asked question on the Greenwood Rising (n.d.-c) website, "What has the Centennial Commission done to honor survivors and descendants?" is answered in the following way: "The Greenwood Rising creative team read survivor testimonials and listened to recordings of survivor interviews to inform its exhibits" (Greenwood

Rising n.d.-c). Thus, many descendants and members of the African American community like Randle, who embody the living memory of the 1921 Tulsa Race Massacre, feel that the museum is primarily for tourists, not for them. As Chief Egunwale Amusan, a descendant and activist who leads "The Real Black Wall Street Tour" and is involved in the fight for reparations, told me: "Jewish people visit Holocaust museums and feel that they have come home; I visit the Montgomery [Legacy] Museum and feel that I am home; Greenwood Rising is not home." Greenwood Rising, for many in Tulsa, feels like just another piece of the gentrification that is dismantling the neighborhood yet again.

Conclusion

While Greenwood Rising has many detractors, it also has supporters who believe it provides an important form of acknowledgment by telling a story that was long silenced and that it has potential to bring much needed tourism and investment into the neighborhood (Smithson 2021). It has also been critically praised. *New York Times* critic Holland Cotter writes: "In Greenwood Rising the links [between past and present] are made overt and we're urged to ponder them, to recognize that the white-on-Black violence of 1921 is still with us, and that Black disenfranchisement, like racism, remains entrenched" (2021); Chadd Scott writes in *Forbes* that the museum "challenges guests with frank presentations of America's, Oklahoma's and Tulsa's racial hatred and violence" and should be "a mandatory American History and civics pilgrimage for every citizen of the United States" (2021). *USA Today* named it 2021's seventh-best new attraction in the United States ("Best New Attraction of 2021?" 2022).

Nevertheless, many in Greenwood's fractured and disenfranchised African American community feel that the museum is a political project meant to replace monetary reparations and foreclose ongoing confrontation with racial injustice by relegating it to the past, neatly packaged away in a slick and shiny new museum. For survivors and descendants in particular, Greenwood Rising is not a memorial museum like the Legacy Museum, which attempts the difficult work of telling the truth about the past and serving as a place of healing and repair—the "home" that Chief Egunwale Amusan is looking for. Rather, it is a simulacrum of the memorial museum form—a hollow imitation that uses the museological rhetoric of political regret but in fact packages and commodifies the painful memory and trauma of the massacre for tourists to consume. In the words of Greg Robinson, a nonprofit director in Tulsa who ran for mayor in 2020: "If you're building a museum so that you can elevate conversation, so that then you can atone, bravo. . . . If you're just doing it to essentially check a box or to claim tourist dollars or to look good, then I think we're in a totally different ballgame, where we're actually perpetuating the

massacre" (Gayle 2021). For many in Tulsa's African American community, the museum perpetuates the pain of the massacre as an empty gesture that, according to City Councilor Hall-Harper, "gloss[es] over what really happened" and exploits their ongoing pain in the effort to demonstrate that Tulsa has confronted its past demons while attracting tourists and their revenue (Gayle 2021).

Thus, in many ways, Greenwood Rising also commodifies a sense of repair and healing. Rothberg's concept of the implicated subject opens important new avenues for thinking about responsibility for historical violence, but as Greenwood Rising demonstrates, merely presenting implication is not enough. If implication is not "transfigured" into "collective action" (Rothberg 2019, 200), it risks losing any meaning. Visitors to Greenwood Rising are invited to engage in the feel-good "slacktivist" act of listing their commitment to racial justice on the Commitment Wall, but are not asked for any specific action, such as petitioning elected officials to support reparations or donating to a survivor fund or racial justice organization. The museum itself, and the Centennial Commission that created it, are not linked to any activist work, as the Legacy Museum is. While the impulse to build a museum is understandable—symbolic reparations are generally easier to enact and wider-reaching than material forms—because Greenwood Rising does not attach any material, concrete action to a visit, any responsibility visitors experience is also primarily symbolic. Ironically, this museum that emphasizes the systemic nature of racial injustice in the end leaves it up to individuals to transfigure implication and responsibility into action; most, however, likely walk away content that they have reckoned with the burdens of the past through their museum visit. As Rothberg warns, "Recognizing ourselves in the position of the implicated subject . . . will not automatically make us better people; such self-reflexivity can indeed become a form of narcissism or solipsism that keeps the privileged subject at the center of analysis" (2019, 19). It seems that there is a real danger of this in the case of Greenwood Rising.

Greenwood Rising, despite its world-class exhibits and challenging and implicatory narrative, demonstrates the limits of memorial museums, including this new wave of U.S. museums focused on slavery and its legacies, as mechanisms for confronting historical violence. While museums have become important players in global mnemonic battles, in the case of Greenwood Rising, new commemorative practices came up against the living memory of the history it tells and the concrete material needs of a community that continues to suffer the impacts of racial injustice. The entire centennial project, given a limited mandate and headed by elites who were (at the very least perceived to be) insensitive to the needs of the community, was constrained by local realpolitik, reminding us that memorial museums are highly political institutions. But Greenwood Rising is also constrained by the global ethics of remembrance,

which have manifested in increasingly standardized forms of commemoration vis-à-vis the politics of regret. These standardized forms of "proper memorialization" (David 2020), like memorial museums, are often viewed as a panacea for historical wrongs. However, the "abstract remembrance" that they present—such as the stylized images depicting the massacre and the individual survivor testimonies that are subsumed into a single narrative—can serve as a screen for concrete and ongoing forms of violence and injustice (David 2020). Thus, Greenwood Rising presents an important reminder that without attending to the local needs of their communities, no matter how well memorial museums represent and perform political regret, they may fall short in their efforts to truly confront the deep roots and lasting legacies of historical violence.

5

America's New Memorial
Museums

● ●

The opening of the NMAAHC, the Legacy Museum, and Greenwood Rising within the relatively short span of five years, together with the ways in which these museums seek to challenge more triumphant narratives of racial progress, indicates a notable shift in the memory of racial violence and injustice in the United States. Though for decades prior museums and historic sites were working to incorporate the historical memory of slavery and its legacies into their interpretation and exhibits, these three museums mark the first newly created museums that address this past in a more critical way that has gained national and international attention. As such, they usher in what might be thought of as a third phase of African American museums in the United States, and, as I argue in the preceding chapters, a new form of American memorial museum that is working to confront slavery and its legacies, a past that has long been silent or ignored in U.S. historical memory. Against the backdrop of post-postracial America, where issues of race are being hotly debated from the boardroom to the classroom, these museums represent a significant contribution to public debate and discussion about the shadow of slavery that continues to linger over the United States and its historical memory.

These museums have many similarities. They seek to center racial injustice in U.S. history and draw a line of continuity between historical slavery and contemporary injustices. In this way, they resist (to varying degrees) narratives of racial progress and tell a story of America's past (and present) that is uncomfortable for many visitors and does not fit many of the myths of America's

founding and exceptionalism. Unlike previous African American museums, which were largely aimed at African American communities, contributing to a memorial landscape "bifurcated along racial lines" (Autry 2017, 7), they are aimed at *all* Americans, and particularly white Americans who have often been resistant to the kinds of narratives they convey. In this they seek to make what has been thought of as a history particular to African Americans a more universal American history. And they do all of this using relatively new museological and exhibitionary strategies that create affective and experiential encounters for visitors in order to give their narratives greater emotional power. In short, they embrace the functions of memorial museums to combine the truth-telling and educative powers of history with the affect of memory in a way that is meant to morally transform visitors, changing their attitudes and beliefs. However, unlike previous American memorial museums, such as the USHMM or the 9/11 Memorial Museum, these museums confront the United States' own past violence and injustice, belying narratives of American innocence and implicating America and Americans in the past and ongoing violence.

However, there are also significant differences in these museums that are as, or more, important to understand. The museums have very different origin stories, and there is a vast difference in the resources, power, and expertise that each of these museum projects has access to. Further, the various institutional structures of these museums shape their storytelling and the ways in which they work to harness authenticity, affect, and experience in their exhibitions. While all adhere to museological tropes common to memorial museums, it is also instructive to trace the differences in their exhibitions. The shift from an emphasis on meaningful and authentic artifacts displayed in fairly traditional exhibits in the NMAAHC to the more narrative-driven Legacy Museum and experiential and immersive Greenwood Rising marks an evolution in memorial museum design, and their design choices produce different temporalities that shape visitor experiences and understanding of the past. Thus, a comparison reveals the potential of these museums to reshape U.S. historical memory but also the limits of the work museums can do to right historical wrongs, shape societal attitudes and beliefs, and contribute to meaningful and lasting social change.

Political Economies of Memory

While most people's experience of museums is limited to what is displayed within their walls, museums are complex institutions that are developed within specific political, economic, and social contexts that shape them in obvious and less obvious ways. Sociologist Robyn Autry uses the concept of the "political economy of memory" in her analysis of the development of a metanarrative of

race in fifteen African American museums to describe a framework that considers how external forces, such as politics, economic factors, social activism, and processes of institutionalization, shape the memory work that museums do (Autry 2013, 62). It is a useful concept here to consider the varying contexts in which these three museums were created and how these contexts have shaped their contributions to U.S. historical memory. They are also an instructive set of institutions for considering the varied models of museum funding and development from public to private to a hybrid public-private partnership, and how the economics of museums shape the narratives and memory that they produce. Examining the political economy of memory in these institutions reminds us that museums are always—and inevitably—political institutions.

As chapter 2 recounts, the NMAAHC developed over the course of a century, from a private initiative to build a monument to Black soldiers to a state-sponsored Smithsonian institution located on the National Mall, which many believed was already "full." The museum's construction cost approximately $500 million, with half of the funds coming from Congress and half from what was the largest private fundraising campaign by a Smithsonian institution (CCS Fundraising n.d.). Like the other Smithsonian museums, the NMAAHC receives just over half of its funding from Congress and the rest through private fundraising, including from individuals, corporations, and foundations (Smithsonian 2023). The NMAAHC website lists the museum's founding donors, from its Pinnacle donors ($20 million and over, such as the Oprah Winfrey Charitable Foundation) and Capstone ($10 million and over, such as the Bill and Melinda Gates Foundation and the Andrew W. Mellon Foundation) through its dozens of Milestone contributors ($1 million or more) and hundreds of individuals, foundations, and corporations giving in the tens and hundreds of thousands. The museum also boasts over a hundred thousand individual members and has a prominent "Donate" button on its homepage. Because it is a Smithsonian institution, it is free to visit, but because it's so popular, tickets must be reserved in advance. They are often fully sold out for weeks or months ahead. According to Smithsonian (n.d.) data, it was the fourth-most visited Smithsonian institution in 2022, following the National Zoo, the National Museum of Natural History, and the National Museum of American History. It is thus a very prominent institution with a powerful fundraising machine and the full resources of the Smithsonian supporting it.

One way that the resources of the Smithsonian have greatly shaped the museum can be seen in the expertise of the many individuals involved in its creation and operations. From its founding director, Lonnie Bunch, who is currently the secretary of the Smithsonian and had worked in various curatorial positions at the National Museum of American History previously, to the curatorial staff, which is composed of some of the nation's foremost museum

experts, the NMAAHC is a museum developed and run by professionals. A massive team of historians was recruited by Bunch to create the historical exhibition and the exhibits were designed by Ralph Appelbaum Associates (RAA), one of the most prominent exhibit design firms, particularly for memorial museums. Compared to the Legacy Museum and Greenwood Rising, the NMAAHC is a model of museum professionalism. With the full force of the Smithsonian behind it, the museum operates on a vastly different scale; with over 85,000 square feet of exhibitions and a collection of 35,000 objects, it dwarfs the Legacy Museum and Greenwood Rising (and in fact most museums in the United States).

Further, with its prominent place on the National Mall and its striking building that looks nothing like the museums that surround it, the NMAAHC carries a symbolic weight that the others cannot approach. After a century of advocacy and struggle, for the African American experience to be quite literally placed at the symbolic heart of American culture and society gives the history that it tells the kind of national recognition and legitimacy that would not be possible in another institution. And yet, as the long history of its development and the many naysayers that the process encountered demonstrate, the museum's creators have had to tread very carefully in their efforts to center this difficult history in such a nationally prominent institution. Its creators thus had to reconcile the competing narratives of slavery as an institution of total repression and violence with the resiliency and agency of those who were enslaved. But they also had to make this history accessible to all Americans (and many international visitors as well). Though previous African American history and culture museums served as primarily community spaces aimed at countering mainstream historical narratives and providing a sense of empowerment and pride for their African American communities, this museum had to not only get congressional approval in order to exist but, once created, it has had to appeal to *all* audiences. Thus, the NMAAHC is constrained in its ability to dismantle the dominant triumphal narrative of race in the United States. Although it does center the African American experience, including slavery and segregation, and tells an extremely detailed and brutal story of the foundation of slavery to the founding of the United States, it also ends its historical exhibit with the triumph of Barack Obama's election to the presidency, suggesting that all that preceded it is safely contained in the past. Thus, the political economy of the NMAAHC allows for a scale, stability, and prominence that is unmatched for a museum of African American history and culture, but, at the same time, because it must navigate the complicated political, social, cultural, and economic contexts of a federal institution, the museum is constrained in just how critical its historical narrative can be.

The political economy of memory in the Legacy Museum is very different. Even in its new iteration, the museum is a mere forty thousand square feet with

only a handful of artifacts making up its collection. Rather, as chapter 3 argues, it is a narrative museum, using text, photographs, documents, and innovative digital media to make its powerful and quasi-legal argument that slavery did not end but evolved into mass incarceration. But these dramatic differences in scale and exhibitionary strategies reflect the deeper differences between the NMAAHC and the Legacy Museum. For the Legacy Museum is an entirely private institution. It was conceived and developed by the nonprofit Equal Justice Initiative (EJI), a legal advocacy group that still spends most of its time and energy on legal representation for vulnerable populations. EJI, including the museum and memorial, operates entirely on private fundraising. The first Legacy Museum and the National Memorial for Peace and Justice cost an estimated $20 million, raised from private funds (Dafoe 2018). Since their opening in 2018, EJI has continued to raise substantial funds for their various projects: in 2021, it raised $117 million, most of which goes to salaries, site maintenance, and operation and other expenditures, and $20 million of which went to the new museum expansion (EJI 2021). Not only does EJI not rely on any public funding, it has also been able to heavily subsidize entrance tickets to the museum and memorial, which have cost $5 for a combined ticket to both sites for the last several years. This is astonishing, particularly given the devastating impact of the COVID-19 pandemic on museums. A recent American Association of Museums (2022) poll found that U.S. museums are still struggling with ongoing impacts of the pandemic, including dramatic financial losses and reduced visitorship, and for many museums only federal relief funds have allowed them to keep their staff. EJI not only managed to retain museum staff and visitor numbers, but also redesign and expand the museum. EJI is a fundraising powerhouse, which gives the Legacy Museum tremendous flexibility and a layer of security that many museums do not enjoy today.

However, unlike other museums that proudly display their donors, EJI does not make this information easily accessible. Their annual reports do not list funders, nowhere on their website is a list of donors, and the seemingly requisite museum wall dedicated to honoring museum supporters does not exist at the Legacy Museum. Online searches reveal a range of funders, from the Open Society Foundation, Ford Foundation, and Andrew W. Mellon Foundation to corporate donors like Google, Microsoft, and Coca–Cola. Part of the fundraising prowess of EJI must be attributed to its leader, Bryan Stevenson, who shot to fame after publishing his 2014 memoir *Just Mercy*, which was made into feature film in 2019, the same year HBO produced the documentary *True Justice: Bryan Stevenson's Fight for Equality*. Stevenson has received a MacArthur Genius grant, an American Bar Association Medal, and a National Medal of Liberty from the American Civil Liberties Union, among many other awards and commendations. He was also named to Time's Top 100 Influential People of 2015 and has received over forty honorary doctoral degrees, including from

Harvard, Yale, Princeton, the University of Pennsylvania, and Oxford University. Archbishop Desmond Tutu has called him "America's Nelson Mandela" (T. Adams 2015).

Despite Stevenson's impressive list of accomplishments and the extremely important work that EJI does, he is not a museum professional and would not be an obvious choice to launch such a prominent museum. Nevertheless, and remarkably, both versions of the Legacy Museum were created primarily by Stevenson and his team of attorneys with very little input from professional designers, curators, and other museum experts. While EJI engaged a number of outside firms for assistance with the first version of the Legacy Museum—including Google, which helped in particular with their lynching map; HBO, which contributed to some of the museum's films; Madeo, a Brooklyn-based design studio with an emphasis on "social impact"; and Local Projects, which also designed Greenwood Rising, for help with exhibit design and fabrication—most of the work was done by EJI's team of attorneys. While they have a particular and important area of expertise, it cannot compare to the team of museum professionals that created the NMAAHC. And yet, because EJI is not beholden to any public funding bodies (such as Congress) or even any design firms like RAA that might shape the story it is telling, it has been able to fully control the narrative of the museum. While this can be frustrating for those of us trying to write about the museum, it also means that EJI is able to tell the complete, unedited story it wishes to tell in the museum.[1] Thus, the Legacy Museum allows—in fact encourages—the painful past of slavery, lynching, and segregation to intrude upon any notion of present racial progress. Though it is accountable to funders, EJI is able to eschew the triumphal history presented in the NMAAHC in favor of a more honest—and difficult—account of America's racism, past and present.

While it might seem that this kind of difficult history would not be welcome in the city of Montgomery, which is located in one of the reddest states in the United States and proudly displays its Confederate heritage, it is in large part the juxtaposition of this conservative, regressive version of the past with EJI's progressive challenge to traditional historical narratives that gives the Legacy Museum its power. As Brand, Inwood, and Alderman write, "By telling some truths, memory work in Montgomery evokes the dormant depths of racism—the existing but not fully realized work of truth-telling" (2022, 479). The Legacy Museum's location within a city and state that have for so long silenced the past it tells calls attention to this silence, giving even greater force to the argument the museum makes. And for the city of Montgomery, this critical revision of historical memory has been an unimagined boon, bringing hundreds of thousands of visitors to the city (2022, 5). EJI's work demonstrates how the power of memory can be harnessed not only for social justice activism, but also as an economic engine for development and revitalization, extending the role memory

can play in meaning-making in contemporary societies: "EJI exposes memory work as not just the labor of remembering and creating public memorials, but also the power of memory to rework or influence the circulation and flow of meaning, people and capital that frame broader understandings of politics, culture and the economy" (Brand, Inwood, and Alderman 2022, 472).

It is precisely this potential of memory work to revitalize neighborhoods and positively impact local economies that was one of the driving forces behind the development of Tulsa's Greenwood Rising. And yet again, because of how different the political economy of memory in Tulsa was from that in Montgomery, Greenwood Rising ended up a powerful but flawed institution that has been constrained (to date) in its efforts to activate the memory of the Tulsa Race Massacre for social justice and economic advances. Unlike the Legacy Museum as a fully private institution, but also diverging from the NMAAHC as a federal institution, Greenwood Rising was a public-private partnership from the start. The 1921 Tulsa Race Massacre Centennial Commission was a quasi-political body formed by state senator Kevin Williams in 2015, purportedly to continue the work of the state-appointed Oklahoma Commission to Study the Tulsa Race Riot of 1921. Like its predecessor, the Centennial Commission was a handpicked group of political, economic, and cultural leaders in Tulsa, the primary function of which was to organize the 2021 centennial commemoration. The array of individuals selected for the Centennial Commission, including the governor of Oklahoma, Kevin Stitt (until his ouster for signing legislation preventing the teaching of topics related to race), as well as its status as the central body for coordinating the centennial suggested that the Centennial Commission was the official body dedicated to the memory of the Tulsa Race Massacre.

Thus, when the Centennial Commission decided to commit most of the funds that it raised—both private and public—to the creation of Greenwood Rising, this was a highly charged political decision that continues to reverberate. There were already community-based organizations devoted to the memory of the massacre, and though members of these organizations were on the Centennial Commission, the new project diverted not only much-needed funding from these institutions but also public attention. As the official project of the official body charged with disseminating memory of the massacre, Greenwood Rising became the de facto official memory institution. In her analysis of civil society and memory in Germany, Jenny Wüstenberg develops the concept of "hybrid memorial institutions," which are public-private partnerships, not unlike Greenwood Rising. While the legitimacy and resources that the state bestows on such memory projects can provide strong institutional frameworks for memory, Wüstenberg argues that such arrangements inevitably take some "critical potential" from civil society memory work (2017, 283). This indeed appears to be the case in Tulsa.

The hybrid nature of Greenwood Rising, together with its relatively small budget, meant that, like the Legacy Museum, it was not created by a team of museum professionals. The founding project director, Phil Armstrong, had a background in business, and the lead curator, Hannibal B. Johnson, was trained as a lawyer and is a self-taught historian. With no museum experience, but inspired by the Legacy Museum, they turned to Local Projects for exhibition design. Greenwood Rising's design in many ways reflects the ethos of the "experience design" firm and seems inspired by many of the affective, immersive elements of the Legacy Museum; the holographic barbers seem a direct inspiration, as does the emphasis on narrative and storytelling over the display of artifacts. And yet, with the wounds of the past still very raw in Tulsa, though this sophisticated museum does indeed bring visibility to the long silenced massacre and its ongoing impacts, the institution has alienated a significant portion of the African American community in Tulsa and is perceived to be aimed primarily at tourists.

In the case of the NMAAHC, we have seen how carefully the museum's creators worked to address the contradictions of this difficult history, while centering it in U.S. history in ways intended to appeal to as wide an audience as possible, befitting its place on the National Mall. In the Legacy Museum we similarly see an effort to center Black history with a focus on the evolution of slavery, spanning centuries and crossing continents. Because the museum is freed from the expectations that constrain public institutions and because it is meant as a counter to the whitewashed Lost Cause history that had defined Montgomery until its opening, the story that it tells is unrelentingly difficult and challenging in its universal condemnation of this history and how it has always been told. In Greenwood Rising, there is a similar effort to challenge hegemonic narratives and connect past racism to present injustices, but it seems that the effort to create a world-class museum with universal messages for a general public took Greenwood Rising too far from its local context. Even as the Centennial Commission poured money and resources into the museum in the hope that it would tell this long-silenced story in a way that would deeply, emotionally impact its visitors, the remaining survivors of the massacre and their descendants were continuing to experience the massacre's ongoing impacts—poverty, marginalization, and exclusion. To them, the museum represents an effort on the part of the Centennial Commission, museum, and the city of Tulsa to profit from the suffering of the victims, survivors, and descendants and revitalize a neighborhood whose gentrification had already left Black Tulsans behind (T. Butler 2023). Thus, although the contemporary memorial museum practices tend to emphasize universal moral messages as a part of symbolic reparation, in Tulsa—where monetary reparation was never enacted but desperately needed—the political economy of memory of the massacre and how the museum presents it has alienated a critical set of stakeholders and undermined the work the museum is trying to do.

Taken together, these three museums represent the potentials and pitfalls of differing institutional structures. While public institutions like the NMAAHC have a much higher profile, can reach significantly larger audiences, and have vast resources at their disposal, they are also constrained by the many different communities of stakeholders to whom they are beholden. For fully private institutions, like the Legacy Museum, these constraints disappear and the museum is able to tell the story it wishes to tell; because the Legacy Museum is fortunate to have a powerful fundraising apparatus, it (for now) does not face the precarity that private, grassroots institutions usually do. And Greenwood Rising is in an unfortunate limbo, caught between the expectations of a public institution to appeal to as wide an audience as possible and the limits of a small, mostly privately funded budget that—at least according to public perception—forced the Centennial Commission to choose between symbolic and monetary reparation, reminding us of the power of local demands vis-à-vis memory, even in the face of a well-executed memorial museum adhering to global commemorative tropes. Together they are also an instructive trio of institutions for understanding just how powerfully memory, and the political economy which shapes it, can both galvanize and divide communities and collectives.

Memory, Authenticity, and Affect

As Robyn Autry writes, there is an "array of tensions and contradictions [that] influence museum content, especially the simultaneous needs to educate and to entertain the public, in order to attract audiences and donors" (2013, 61). The political economies of memory that these three museums must navigate do indeed shape their content as well as the exhibitionary forms they use to shape and convey that content. One of the key elements that all three museums grapple with, and one that provides a striking set of differences, is their relationship to historical authenticity and place, which in turn shapes their affective memory work. While memorial museums had their roots in the memorials and museums created at the sites of historical atrocity, such as the concentration camps of Europe, increasingly, memorial museums are built in neutral, though often symbolic, locations in new, purpose-built buildings. Not only is this often expedient for collectives working to construct a shared narrative and representation of the past and convey more universal messages about the meaning of past violence, but memorial museums are often also created with an eye to attracting visitors and reaching wide audiences; thus, very often symbolic locations that are either well-established tourist sites or that are in need of revitalization are selected. The three museums here are representative of some of these motivating factors in the creation of memorial museums.

The NMAAHC is on a highly symbolic site—what some call "America's front yard"—surrounded by monuments and museums celebrating American history, culture, and democracy. Yet while Washington has a complex entanglement with the history of slavery, with enslaved people having been bought, sold, worked, and exploited on and around the National Mall, scant reference is made to this specific, local history in the museum; instead, the focus is on telling a sweeping, national story. As with the other museums on the Mall, the NMAAHC is for all Americans (and many international visitors) and everything from the stunning, newly constructed building that references African, Caribbean, and African American culture and architecture to the dense historical narrative that covers centuries and spans the continent is aimed at telling a more universal story of the African American experience that will resonate not only with visitors from the DC area, but those from the deep South, the Midwest and Northeast, the West Coast, and beyond.

Though the NMAAHC is on a symbolic site, meant to convey the universality of its story, the symbolism of its location greatly shapes the story it tells. As Tim Gruenewald argues, the National Mall is the symbolic center of the national imagination—the "conception of the United States as a benevolent force producing continually increasing degrees of freedom, civil rights, and progress" (2021, 4). Thus, museums on the National Mall, by means of their location and—in the case of the NMAAHC, in order to secure such a symbolically rich location—must contribute to this narrative ideal of America. Though the NMAAHC tells the difficult story of slavery and segregation, by ending the historical exhibition with the triumph of Obama's election to the presidency the museum "incorporates the history of slavery, segregation, and subsequent systemic discrimination within the national imagination of the National Mall" and the overarching American tale of progress (Gruenewald 2021, 1). Thus, while the symbolism of the museum's location grants the history that it tells unparalleled recognition and acknowledgment on a national and international scale, this same symbolism means the museum can only go so far to challenge dominant American historical memory; instead, it largely adheres to teleological tales of American racial progress.

The Legacy Museum has more of a historical connection to place that is richly symbolic, but manifests very differently than the NMAAHC. The initial version was in a historic building that had served as a warehouse for enslaved people awaiting sale, and in this first version the museum had a heavy focus on telling the story of how slavery shaped Montgomery. While the museum still tells this story, because of its popularity with visitors from all over the country and world, EJI decided in the second iteration to tell a broader, national, and international story of slavery. The expanded museum is thus in a newly constructed building and begins with the story of the transatlantic slave trade, moves through descriptions of how slavery shaped all of the United States,

particularly cities and states along the Eastern Seaboard, and demonstrates that while slavery, segregation, and lynching were concentrated in the South, their impacts and reach extended far beyond. And while the museum makes note of the weighty historical significance of the new building's location—the site of a cotton warehouse where enslaved people were forced to labor—the museum works to demonstrate how this site and city were a small part of a much larger institution that shaped and continues to shape the entire nation and even the world. Even the museum's name, which departs from so many African American museums that include their location in their names, suggests this sweeping and inclusive narrative.

Thus, although the museum's location in Montgomery is symbolically significant, it tells a larger story than just that of one city, at once capitalizing on the authenticity of its historical location, while aiming for a more universal, national narrative. In writing about the Lynching Memorial, but in words that ring true for the Legacy Museum as well, Brand, Inwood, and Alderman argue that this universal focus may be part of what enables its success in the heart of a deep-red state that has long whitewashed its past: "Because the peace and justice memorial [and museum] takes a broad scale view of the racial violence, it does not focus solely on Montgomery, it leaves space for Montgomery to embrace the memorial [and museum] without having to fully engage in the more difficult process of coming to terms with its own past traumas" (2022, 6). The museum demonstrates that the roots of racial injustice go much deeper and extend far beyond Montgomery and Alabama.

With Greenwood Rising, place and authenticity carry even greater weight. For Greenwood Rising is located in the heart of what had been the thriving Greenwood neighborhood, at a key crossroads of Black Wall Street. Around the museum are the few lasting remnants of the neighborhood. Just down the block stands the Vernon AME Church, one of the few buildings to survive the massacre and burning. Lining the pavement around the museum and surrounding neighborhood are Tulsa's own version of stumbling stones—plaques in the sidewalk giving the name of the business that had been on that site and briefly telling its fate (such as "Carter's Barbershop, 115 N. Greenwood Avenue, Destroyed 1921, Reopened").[2] There are also several murals and historical markers, including one erected by EJI with details about the Tulsa Race Massacre on one side and details on lynchings in Tulsa (including during the massacre) on the other. Across the street from the museum, a storefront has incorporated blackened bricks that were burned during the massacre.

And yet, despite these material reminders of the once-thriving community dubbed Black Wall Street and Greenwood Rising's central place in this effort to remember, mostly what one notices in the neighborhood is the minor league baseball stadium, the highways that bisect the area and create vast sweeps of no-man's-land, and the many cranes busily constructing new buildings as the

neighborhood gentrifies. While the museum wishes to be part of Greenwood's third "rising," it seems that gentrification will take the neighborhood in a very different, white direction (e.g., Grigsby Bates 2021). While luxury condos and new businesses are springing up in Greenwood, it appears that only a handful of the new businesses are Black-owned—nothing like Black Wall Street's heyday (Tulsa Regional Tourism n.d.). Even Greenwood Rising's sleek new concrete building, with its clean lines and subtly dramatic ascendant pattern of voids, is more of a reference to the new construction than it is to the historical neighborhood.

However, inside the buildings and within their exhibitions, the museums' relationship to historical authenticity is almost reversed. In order to tell its sweeping, national story of the African American experience, the NMAAHC uses a vast collection of historical objects, together with documents, archival records, photographs, film, and a great deal of interpretive text. With exhibits designed by RAA, the NMAAHC is reminiscent of RAA's other memorial museum designs, most notably the USHMM. With dense, informative panels and overlapping information interspersed with objects on careful display in glass cases, and the occasional experiential element, the NMAAHC hews closely to traditional museological displays in many memorial museums. With the power of the Smithsonian institution behind it, the NMAAHC has access to a tremendous body of information on slavery and its legacies and the photographs, documents, archival references, and films lend a heavy air of authenticity to the story it tells.

But more than that, it is the impressive collection of objects that brings the past to proverbial life in the NMAAHC. The objects on display range from small—a burnt penny that survived the Tulsa Race Massacre, a tin box used to hold Joseph Trammell's freedom papers—to the massive—a prison watchtower, a segregated railcar, a slave cabin. There are the objects that one might expect to see when learning about the history of slavery—such as shackles and an auction block, or segregation—"Whites Only" signs and Ku Klux Klan hoods. But there are also objects that are unexpected and gain a new meaning on display in this museum, such as Thomas Jefferson's personal effects—which in the museum become not symbols of his brilliance but emblems of the contradictions that he embodied, or a copy of the children's book *The Story of Little Black Sambo* (1899)—which I remember as a story from my childhood but which in the museum is presented as an insidious racist stereotype that has helped to shape popular culture. But many of the objects on display are everyday items that were used by or connected to individuals, such as a bonnet worn by an enslaved woman in the fields, or a carefully carved bowl used to prepare and serve food for enslaved individuals and families, or a cradle in which an enslaved baby slept. Using these kinds of objects, the museum seeks to tell a broad and sweeping national story, but one in which individual lives and

stories help to "humanize" this complicated history. By helping visitors identify with individual experiences, the museum seeks to demonstrate that African American history is U.S. history.

The objects are also part of the museum's affective memory work. Some, like the auction block, though behind a glass display case, cannot help but evoke in an affective way the memory of the countless individuals who were sold from that block, the families that were ripped apart, and the terror of the auction. Others, like the railcar, allow for a more direct experiential encounter, as visitors are, for a moment at least, transported back to the days of segregated transportation. Perhaps no object is more powerful than Emmett Till's casket, the aura of which is unmistakably powerful in compelling visitors to see and understand the depths of the brutality of racial injustice. The sheer scope, importance, and authenticity of the objects collected and displayed in the museum, together with its designation as a Smithsonian institution, reinforce its authority, underlining the fact that the NMAAHC is the national repository for African American history and memory. Thus, while the site is neutral, though highly symbolic and meant to support a universal narrative, the museum is imbued with authenticity and authority, largely through the artifacts that it collects and displays.

The Legacy Museum and Greenwood Rising are very different. Because they are smaller institutions with significantly less funding, and because both were created in a much more compressed time frame than the NMAAHC, the Legacy Museum and Greenwood Rising have very few objects in their collections and, while they draw on the authenticity of the historical sites on which they are located, they rely primarily on narrative and immersive digital media to impact visitors with their stories. And while the museums' exhibits are not unlike the NMAAHC's in that they are contemporary, well-designed, and dense with information conveyed through layers of text, photographs, videos, and documents (most of which are reproductions), they display very few objects. Challenging notions of museums as primarily institutions defined by objects, the Legacy Museum and Greenwood Rising demonstrate the shifting roles and strategies of museums in the twenty-first century with the innovative and creative methods they use to narrate their stories of ongoing racial injustice.

In the Legacy Museum, the key object used to amplify the museum's argument is the soil collections from sites of lynchings. Stevenson and EJI see in soil a connection to the past—to the blood and sweat of those who were enslaved, abused, and killed, and soil has become a metaphor for acknowledgment. It is, in the words of Marita Sturken, "a powerful material means to situate this history [of lynching] within the landscape" (2022, 228). There are no longer bodies that can be respectfully reinterred, so the soil collection serves as a sort of inverse burial, where the ground upon which violence occurred is

uprooted and sacralized in its new place. In the Legacy Museum, the eight hundred jars of soil that are displayed are oddly and eerily beautiful, but they are also haunting in the materiality of the soil they contain and its connection to this violent past. However, while the soil evokes the authenticity of the places in which lynchings occurred, the soil itself is very much from the present, not the past; it is also from all over the country, dispersing responsibility and implication for this past violence far beyond Montgomery.

But perhaps more powerful than this past-made-present in the jars of soil, is the Legacy Museum's use of holographic figures to give visitors an encounter with the past—and present. In a striking departure from traditional museological displays such as those in the NMAAHC, the Legacy Museum presents visitors first with the slave pens and later with the videos of incarcerated individuals who tell their stories. While the first is an encounter with the ghosts of the past, there to haunt the present, the latter is an encounter with our present ghosts. As Sturken writes, these dual encounters "situate the past explicitly within the present and signal that it will demand that visitors engage at the level of complicity with the exhibition content" (2022, 234). The ghosts can't be left behind in this museum.

Greenwood Rising similarly uses holographic figures to tell its story, in this case in the effort to re-create a Black Wall Street barbershop. Like those imprisoned in the slave pens in the Legacy Museum, these are ghosts from the past; but they do not directly address the visitor and in this way are more easily frozen in the past. They chat with each other, turning the visitor into spectator to the past. Greenwood Rising, however, also has a more direct line to the ghosts of the past in the audio testimony of massacre survivors that narrate the immersive, multimedia re-creation of the massacre itself. Through dramatic projections and sound effects, the massacre "experience" gives visitors insight into the terror of those twenty-four hours, but it is the voices and memories of the survivors that give the experience its power.

In *The Witness as Object*, Steffi de Jong argues that "the age-old relationship between museum objects and the stories surrounding them is being turned upside down" as memory itself becomes an object of display in the form of video testimony (2018, 4). In her analysis of how video testimony of Holocaust witnesses became an integral part of memorial museum exhibits, she points toward the theories of Holocaust scholars like Lawrence Langer, Dori Laub, and Giorgio Agamban, who held that the testimonies of Holocaust survivors is unprecedented as a form of memory and utterly unique, "a singular and incomparable speech act whose importance lies in the mere act of uttering them" (2018, 9). Due to this uniqueness, video testimony has acquired a privileged place in memorial museums, in particular Holocaust museums. And as Holocaust survivors pass away, Holocaust museums have turned to holographic representations to keep their memory alive and to convey the memory of the Holocaust

to younger generations. In a similar way, the Legacy Museum and Greenwood Rising seek to harness digital technologies to bring the past into the present and give visitors an "authentic" encounter with historical witnesses. The re-created ghosts of the slave pens and the barbershop do this, but, perhaps more powerfully, it is the stories and memories of the incarcerated individuals in the Legacy Museum and the Tulsa massacre survivors in Greenwood Rising that harness the power of testimony in memorial museums. However, while the incarcerated individuals each tell their own story against a neutral backdrop, the audio testimonies of the Tulsa massacre survivors are layered together and on top of multimedia re-creations, which, while providing a moving and powerful "experience of the massacre," also takes some of the authenticity and importance from the display of testimony in the museum. They lose their individuality as their testimony and memory becomes part of a singular, larger historical narrative.

Despite their uneven use of digital media, the Legacy Museum and Greenwood Rising both work to create an affective experience for visitors that departs from previous "object-based epistemology" (Conn 2010) in museums like the NMAAHC. Because of the political economies of their creation, the Legacy Museum and Greenwood Rising do not have access to the vast material resources available to the NMAAHC and were not able to develop large collections as a foundation for their narratives. Where the NMAAHC relies heavily on its vast collection of objects, which are carefully displayed in vitrines as relics of history that tend to "segregate" past and present (Autry 2017), the Legacy Museum and Greenwood Rising draw upon the authenticity of the historical sites that they are located on, and turn to digital media to create immersive, experiential exhibits that are able to emotionally move visitors. In their departure from more traditional modes of museological display like those found in the NMAAHC, the Legacy Museum and Greenwood Rising thus potentially indicate an evolution in the form of memorial museums, from object-based displays created by museum professionals to interactive, immersive exhibitions that are driven by narratives intended to challenge, provoke, and evoke emotional responses. These smaller, cheaper, more flexible local institutions, though they don't have the symbolic weight and the material resources of larger national institutions, may ultimately have more potential to challenge dominant hegemonic narratives and connect past racial oppression to its ongoing forms.

Moral Messages and Implication

The museums examined in this book, and the future museums they will likely inspire, are working to change the hearts and minds of Americans vis-à-vis race, memory, and the "afterlife" of slavery. As memorial museums, they seek to use

not only historical education but also experiential modes of display in their efforts to morally transform visitors. Jacque Micieli-Voutsinas refers to the mode of implicit, emotional learning in spaces like memorial museums as "affective heritage," which creates for visitors a visceral experience that allows them to not just cognitively process what they are learning but "feel truth" (2021, 6). Through this experience of affective heritage that helps visitors understand the "truth" about the past, visitors are intended to take away moral messages that can contribute to social change. Because memorial museums are focused on telling the story of past violence in a way that educates the present and acknowledges the suffering of victims, their moral messages are typically tied to the ethic of "never again"—they are intended to be institutions that help collectives learn the lessons of the past to prevent future reoccurrences of violence or atrocity.

The museums examined in this book similarly intend to teach the lessons of the past with the hope of ensuring nonrepetition. But rather than the sort of specific atrocity that many memorial museums present—such as the Holocaust or other genocides, periods of dictatorship or totalitarianism, or violent attacks like 9/11—these museums are intended to represent a much longer history with ongoing impacts. In the case of the Legacy Museum, the argument is even stridently made that the past violence continues in the present, though it takes new forms. Thus, the messages of these museums are slightly different. And as we have seen, each museum has a different temporal framework that impacts their moral message. In the case of the NMAAHC, while the historical exhibition makes painfully clear that slavery and its legacies in segregation were horrific and foundational institutions in American society, the overarching narrative of progress dilutes its message of "never again." In the Legacy Museum, a much more robust connection between past and present is made, demonstrating to visitors that there is still much work to be done in the present. Greenwood Rising similarly connects past to present, but in many ways the creation of the museum against a backdrop of gentrifying Greenwood undermines the urgent necessity of present social transformation.

These varied moral messages also reflect the ways in which these museums are intended to operate differently for white and Black visitors. While African American visitors often have all too deep an understanding of the histories and experiences presented in these museums and their ongoing reverberations, white visitors have generally enjoyed the "privilege of unknowing" (Sedgwick 1988). Thus, one of the primary purposes of these three museums is to impart to white visitors the "burden of knowing" (e.g., Waterton 2011) the deep roots of racial injustice in American society—the "consciousness" that is one key aspect of Christina Sharpe's (2016) "wake work." Imparting this burden of knowing or consciousness to white visitors is central to the museums' efforts to demonstrate white implication in past and ongoing racial injustice and thus

spark moral transformation in individuals and collectives in a way that can contribute to social change. As Michael Rothberg writes, "Socially constituted ignorance and denial are essential components of implication; as such, they are also potential starting points for those who want to transform implication and refigure it as the basis of a differentiated, long-distance solidarity" (2019, 200). The effort to overcome denial and ignorance as a starting point for social transformation is at the heart of each of the museum projects examined in this book, and is well summarized by EJI's explanation for creating the National Memorial for Peace and Justice and the Legacy Museum: "A history of racial injustice must be acknowledged, and mass atrocities and abuse must be recognized and remembered, before a society can recover from mass violence" (EJI n.d.-e).

However, while all three museums work to impart the burden of knowing to white visitors, each does so slightly differently. In the NMAAHC, race and slavery are centered in American history as an integral part of the founding of this nation and its complex and contradictory history. The history of race, slavery, and segregation had previously, for the most part, been relegated to "ethnic" or "identity-based" museums and framed as a uniquely African American story separate from mainstream U.S. history. The NMAAHC, however, incorporates African American history into the larger American story and, accordingly, into mainstream historical narratives. The museum makes explicit that the founding of America on ideals of liberty and equality relied upon the institution of slavery as integral and constitutive of the new nation. And in the NMAAHC's long and detailed history of slavery as central to the development of the United States and its examination of its legacies in segregation, the museum demonstrates that this history is not marginal to the American experience, but is, in fact, central to it. In this, it burdens white visitors with the knowledge that slavery was not anomalous to the American story but that "the United States is fundamentally a nation built on the logics and economics of racial difference" (Landsberg 2018, 210).

The Legacy Museum similarly demonstrates the centrality of race to American history, but goes further to show that the "logics and economics of racial difference" that emerged with slavery persist in our institutions today. While the argument that slavery did not end but evolved continues to gain traction today, it remains on the fringes of mainstream historical narratives. The related belief that societal ideas about race have shaped our laws and institutions has been turned into a bogeyman by the right, who are zealously fighting against critical race theory being taught in schools and other institutions. However, while these battles rage, the Legacy Museum quietly and painstakingly lays out the argument—supported by copious evidence and documentation—that slavery did not end but has changed form over the last four hundred years and continues to manifest in today's system of mass incarceration. Along this long journey, visitors are shown the extreme violence of

slavery, belying myths that slavery was a benign institution; they come face-to-face with the inconceivable horrors and sweeping extent of lynching—a past so shameful it has been largely ignored and obscured or framed as exceptional and unusual when the topic arises. And visitors are shown a window into the experiences of some of the 8 million individuals caught up in our criminal justice system. This intense journey shatters any ignorance or denial visitors may have enjoyed before their visit.

Greenwood Rising also seeks to bring to light a long-silenced past; in this case it is the willfully forgotten history of the 1921 Tulsa Race Massacre that is finally told to visitors. But the museum does not just tell of this singular violent act; it situates the massacre within past racial inequality but also makes connections to present. However, while the museum does make the argument that the massacre's roots were in the systems of anti-Blackness that have defined the United States since 1619, and while its narrative extends from this distant past to a confrontation with contemporary racial injustice, its focus is undeniably on the massacre. It not only seeks to help visitors cognitively understand what has been called the worst instance of racial violence in American history, but also to affectively experience the horrors of those twenty-four hours. Local Projects project director L'Rai Arthur-Mensah has argued that exhibitions have the power to "humanize history, to give stories of the past the power to inform our present, and to embolden visitors to make future change" in part through "truth telling" about the past (Architizer 2022). The goal of Greenwood Rising is to impart to visitors the truth of the massacre in a way that will shatter any claims of ignorance and preempt attempts at denial.

Just as in the NMAAHC and the Legacy Museum, this effort to impart to white visitors the burden of knowing helps to place white visitors in the position of implicated subject and show them that they have benefited from the institutions, processes, and structures that have oppressed Black Americans. In the NMAAHC, the historical exhibit demonstrates to visitors that the freedoms that they enjoy as Americans have come at an extremely steep (historical) price. In the Legacy Museum, it becomes clear that the "system" has been rigged from the start, with U.S. institutions shaped in the past and present by white supremacist ideals. And in Greenwood Rising, Greenwood becomes a metaphor for Black disenfranchisement, oppression, and marginalization actively perpetrated by white Americans for their own economic and political gain. Thus, for white visitors to these museums, as the privilege of unknowing falls away, it is difficult not to see their own implication in the structures that have supported (and continue to support) racial injustice.

For Black visitors, the museums operate differently. The commemoration of racial violence and slavery has often been source of trauma for African Americans (e.g., Horton and Horton 2006; Kytle and Roberts 2018), creating tensions evident in the museums analyzed here. And these are issues that not just

museums grapple with; they are related to larger questions of this historiography, representation, and memory of slavery and its legacies. As Christina Sharpe asks, "In the midst of so much death and the fact of Black life as proximate to death, how do we attend to physical, social, and figurative death and also to the largeness that is Black life, Black life insisted from death?" (2016, 20). That is, how can museums truthfully convey the story of past and ongoing racial violence and trauma while also celebrating African American agency, resistance, and resilience, and avoiding narratives that might perpetuate existing or trigger new trauma. These museums have learned from the efforts of previous museums and work to ameliorate this potential for trauma, each in their own way.

The NMAAHC, as we have seen, goes the furthest of the three to balance the beautiful and terrible and to celebrate Black achievement. The balance is present throughout the historical exhibit, where every instance of oppression is matched by an example of resistance and resilience; for every whip or shackle displayed, there is a beautiful work of African art or an artifact that represents African American agency and resistance. But this balance is even more apparent in the building's architecture and overall layout. For the museum has the space and resources to balance the entire subterranean historical exhibit with light and bright upper-level exhibitions on African American culture. The expansive exhibits on music, sports, theater, and other aspects of African American culture can themselves constitute a complete museum visit without even venturing into the underground. But it is especially the experience of ascending from the dark, cramped, and depressing lower-level historical displays into the bright, colorful, and expansive upper-level exhibits that creates an overarching experience of progress, triumph, and celebration. In this, the museum tells a painful history that desperately needs to be incorporated into American historical memory but tempers that pain with a joyous celebration of "Black life insisted from death" (Sharpe 2016, 20).

The Legacy Museum and Greenwood Rising obviously operate on a much smaller scale and so must find other ways to create a balance between truth-telling and hope. The Legacy Museum in many ways does the least to structure this balance into its exhibits. The story of oppression and injustice that it tells is unrelenting; the past is not relegated safely to the past and again and again the museum reminds visitors of the deep foundation of the racial hierarchy that shapes every aspect of our society. In the redesign of the museum, EJI was cognizant of how difficult this experience could be for visitors (in particular Black visitors), and so in the new version they greatly expanded the Reflection Space to make it a space of uplift. Warm lighting, comfortable seats, uplifting music, and inspiring photographs of racial justice warriors give visitors a chance to decompress after their difficult journey through American racism and reflect not only on their experience in the museum but also on what they "can do to make a

difference." But I would argue that the museum's greater impact and source of hope comes from the activist work that EJI is doing to advance social justice. For the Legacy Museum is truly a space of memory activism, where memory of America's darkest past is mobilized in the efforts to change society. And EJI's work at the center of these efforts is evident throughout the museum: it is clear in the extensive research presented on slavery, in particular the domestic slave trade and Montgomery's role in it; it is clear in the utterly unprecedented exhibit on lynching drawn from EJI's research and their Community Remembrance Project, which engages communities across the country in memory activism in the name of social transformation; it is evident in the legal construction of seg-regation that the museum explicates and that points to the role of the criminal legal system in undoing some of the anti-Black structures of U.S. society. And it is perhaps most evident in the section on incarceration, where the museum highlights EJI's own work in the criminal legal system. While it's clear that EJI's work is not enough—for example, there are thousands more incarcerated indi-viduals who appeal to EJI for help than it can take on—it is also clear that the work that EJI is doing is central to efforts to transform American society. And this work includes the creation of the museum and memorial as truth-telling spaces that can extend their other activist work to a much larger audience. Thus, though the exhibits are filled with a multitude of reasons for despair, the fact of the museum's existence and EJI's activist work as the engine that drives it make the museum ultimately a hopeful and deeply meaningful experience for its visitors, helping to explain the numerous buses that unload hundreds of Black visitors to the museum every day, the large African American school groups and family reunions that enthusiastically visit the museum, and the many African American visitors who so clearly value their experience at the museum.

As has been noted, Greenwood Rising was very much inspired by the Leg-acy Museum and I think in many ways wants to emulate the important work that it does and its impact on the local and national community. Greenwood Rising is indeed comparable, as a small institution that was created with a limited budget in a relatively short time frame by a team of people who were mostly not museum professionals. But like the Legacy Museum and the NMAAHC, the museum is intended to be for *all* Americans (and some international visitors) with slightly different messages for white and Black visitors. This is particularly important in the city of Tulsa, which remains highly segregated and is riven with racial inequality. The Tulsa Race Massa-cre, though willfully forgotten for a hundred years, continues to reverberate and shape the contemporary city.

The museum's creators thus wanted it to end the long silence and provide a place for Tulsans, Oklahomans, and all Americans to learn about the massa-cre. It is intended to both "bring to life the horrors of the massacre" in a way that tells a truth that was never publicly told, in particular to white Americans,

and tell the empowering story of "the dignity of a people who turned trials, tribulations, and tragedy into a triumph of the human spirit" (Greenwood Rising n.d.-b). And while the lead curator and director had no prior museum experience, the exhibit design firm Local Projects, was well versed in the complexity of memorializing such a painful event. L'Rai Arthur-Mensah, project director, explained to me that Greenwood Rising is intended to engage in "raw" truth-telling about the past in a way that would lay out the facts for all to see, but do so in a way that would not center trauma and racism (personal communication 2022). For too often, according to Arthur-Mensah, a focus on trauma and racism is ultimately a screen for narratives centering whiteness (personal communication, 2022). To help avoid this trap, Greenwood Rising presents the immersive, traumatic story of the massacre, but situates this particular history within much larger structures and institutions of anti-Blackness and in this way presents to white visitors their implication in the massacre and the systems that enabled it and the neighborhood's subsequent decline.

But the massacre is only part of the museum's focus. It also emphasizes the cultural vibrancy and economic successes of Black Wall Street before 1921 and the innovation and will that drove the neighborhood's rebirth in the decades after the massacre. Arthur-Mensah and the other creative team members were deeply aware of the potential trauma the story of the massacre would have on African American visitors. Thus, they created an "emotional exit" that would allow visitors to avoid the most graphic and difficult parts of the exhibit while still getting a historical overview of the massacre. In this way, care for the experiences of Black visitors and communities learning about this history was at the forefront of the creators' minds as they created Greenwood Rising.

Yet despite this deeply thought-out approach, never once did I see a visitor take the emotional exit, as noted in chapter 4. Rather, it seems that visitors—Black and white—are primarily at Greenwood Rising to learn about the massacre. And despite all of the careful work the museum's creators did Greenwood Rising has alienated many in what arguably is its most important group of stakeholders: Tulsa's African American community. Though the museum powerful shatters the privilege of unknowing for white visitors, it does not have behind it the symbolic weight of the nation that the NMAAHC does or the powerful local and national memory activism of EJI and the Legacy Museum. Rather, the museum is the primary official form of memory of the 1921 Tulsa Race Massacre, the wounds of which remain searingly open as its ongoing impacts continue to harm the African American population of Tulsa. In this way, Greenwood Rising starkly demonstrates the limitations of museums and other symbolic reparations, as well as the limitations of narratives of implication of white Americans, in the face of ongoing racial violence and trauma. The museum's moral message is mixed as it suggests that the museum might serve as a screen for the more difficult work of confronting

and atoning for past racial violence. In fact, there is a real danger that the emphasis on implication and the trauma and violence of slavery and racism in Greenwood Rising—and potentially in the other museums as well—might in a perverse way recenter white experiences, thus bolstering hegemonic historical memory in the United States.

Conclusion

In her recent analysis of "regional" African American museums, Bettina Messias Carbonell writes of the context around the creation of the NMAAHC. There was "a morally urgent and politically insurgent—but slow—awakening to African American history, material culture, individual and collective achievement and their importance to the fabric of the nation." For Carbonell, the NMAAHC "arguably constitutes the dawning of a new 'museum age' in the representation of our national history" (2023, 11). As I have argued, the museums examined here, starting with the NMAAHC, indicate the beginning of a third phase in African American museums and the emergence of a new form of American memorial museum—a new "museum age" for the United States. These museums both move away from triumphalist narratives of racial progress toward efforts to demonstrate, in the words of Alison Landsberg, "*what has remained constant*" (qtd. in Sturken 2022, 232; emphasis in original). In so doing, they also mark a shift from what Aleida Assmann calls the "politics of self-assertion" that has guided U.S. historical memory, particularly in museums, toward a politics of regret and reparation that seeks to confront this painful past and demonstrate the implication of white Americans in past and ongoing racial injustice. It is difficult to understate what a dramatic change this represents for American museology.

However, as I have also demonstrated, the museums are uneven in how (and how successfully) they chart this new museological territory. While I argue that the NMAAHC marks the beginning of this new phase of African American museums (and memorial museums), it is very much a transitional form, paving the way for the others. It is, in many ways, still a history museum (or, as some might say, a "culturally specific" or "identity" museum), attested to by the rigorous historical research in which it is grounded, its massive collection of artifacts, and the plethora of historical evidence that it presents in its chronological narrative—all of which is balanced by the culture galleries that celebrate African American achievement. However, in many ways the NMAAHC also operates as a memorial museum. Memory is incorporated into its exhibits in the testimony of the formerly enslaved that plays at various points in the exhibits, in the experiential elements like the room evoking the transatlantic slave trade or lunch counter, in the wall of names of individuals enslaved by Thomas Jefferson, and in the explicitly memorial components: the display of Emmett

Till's casket and the Contemplative Court. It thus ends up straddling the historical and memorial museum genres in a way that lays the foundation for a new type of American memorial museum that then becomes a source of inspiration for the Legacy Museum and Greenwood Rising.

The NMAAHC also does not go as far as the others to explicitly connect the past to the present in a way meant to radically transform American society. As has been shown, it historicizes racial injustice, not only by ending its historical exhibition with Obama's election, which is followed by a literal ascent into light and celebration, but also in its more traditional exhibits that allow the past to remain safely encased in glass vitrines, unable to fully interrupt our present. However, it has linked past to present in temporary exhibits, like the recent exhibit on Reconstruction, and in some of its public programming, like its response to the murder of George Floyd and the Black Lives Matter protests. But perhaps more importantly, in laying out in meticulous detail that slavery and race are foundational to the United States and the American experience, it's very much implied that the present is shaped by this past—and for anyone paying attention, it's difficult to walk away from the museum not understanding this.

The Legacy Museum and Greenwood Rising are more explicitly memorial museums; they have looked to the commemoration of other atrocities vis-à-vis the global memorial museum movement and have drawn on strategies and practices to imbue their exhibits with experiential elements and affective encounters. In drawing from these global practices, the Legacy Museum and Greenwood Rising build on the work that the NMAAHC does to extend museological representations of race and slavery in the United States and represent a new American iteration of the transnational memorial museum movement. And like memorial museums around the world, the goal of all the museums examined here is transformation. They seek to engage in truth-telling about race, slavery, and its legacies that can contribute to historical understanding, dialogue, and, ultimately, racial reconciliation. They are thus meant to be part of a larger national project of repair and see themselves as important actors in the struggle for social justice. Though the Legacy Museum is the most explicitly activist institution, the others also seek to engage memory activism in the service of present social transformation. However, as I have argued, there are limits to the extent to which these museums can contribute to repair, reconciliation, and social justice, limits that are shaped by their political economies of memory and by the global transfer of memorial museum forms. Nevertheless, these three museums mark one important part—albeit a small one—of larger societal and collective efforts in the United States to reshape narratives, challenge the status quo, and enact social transformation.

Conclusion

• •

Memory's Present and Future

The museums analyzed in this book are both reflections of and contributions to a growing movement to address past and ongoing racial injustice in the United States. In the last couple of decades discursive space has opened for a more critical engagement with the legacies of slavery, and these museums are part of this engagement. Efforts to address past and present racial injustice have taken a range of diverse approaches. Historic sites like southern plantations, Colonial Williamsburg, Mount Vernon, and Monticello have shifted their exhibits and interpretation to include discussions of enslavement. Prominent universities like Brown, Georgetown, and Harvard have dedicated significant resources to researching and atoning for their connections to slavery. Initiatives like the 1619 Project upended the way many Americans understand the racialized foundations of this nation. Small, hyperlocal, and less-endowed institutions and organizations have created online exhibits, such as the University of Arkansas Center for Arkansas History and Culture's (2019) online exhibit on the Elaine Race Massacre or the Cape Fear Museum's (n.d.) online exhibit and interactive map detailing the Wilmington Massacre of 1898 in North Carolina. Although the country is still far from any unified support for reparations, initiatives at the local level, such as those in Evanston, Illinois, and Amherst, Massachusetts, have gained traction.

However, at the same time that momentum seems to be building in the movement to address and come to terms with slavery and its legacies, the backlash is a reminder of how fraught slavery and its memory continue to be in the United States. Across the country, for every step toward acknowledgment and

atonement it seems that there is a step in the other direction: state legislatures and school districts are banning books, forbidding the teaching of slavery and race, and removing Black history courses and curricula; diversity, equity, and inclusion initiatives are being gutted at higher education institutions and other organizations and corporations; states throughout the South continue to celebrate—or have codified by law—Confederate Memorial Day; and racism and white supremacist ideologies have surged. It is a truly volatile and critical moment for the emergence of these museums and the challenging narratives that they convey. It may be too early to fully understand their impact, but there are ways to begin to gauge this.

Visitor Experiences

One way is by thinking about the experiences and impacts these museums have on those who visit them. While it is beyond the scope of this book to conduct rigorous visitor studies, an overview of online visitor reviews of the museums is useful for getting a sense of the kinds of experiences they report having had.[1] Just as scholars have found visitor books to be helpful for better understanding how visitors experience museums (e.g., Macdonald 2005; Simon 2010), they are now also turning to online reviews to understand how visitors experience, process, and write about museum visits (e.g., Buckley-Zistel and Williams 2020; Jaeger 2023; Sodaro 2022). While online reviews are similar to visitor books, they are also a much more public form of sharing and so involve a particularly performative rhetoric that is especially interesting in thinking about museums focused on race and slavery in the United States. Research suggests that individuals post online reviews to help others and for self-enhancement; writing a review is a way of sharing one's individual experience, helping others plan their experiences, and demonstrating one's self-efficacy (e.g., Bronner and de Hoog 2011; Hennig-Thurau et al. 2004; Jamerson 2017; Munar and Ooi 2012). Because social media sites like TripAdvisor are public, international spaces of user-generated content, they can be seen to extend the work and the experience of the museum in significant ways. The reviews also contribute to meaning-making about the past. Buckley-Zistel and Williams describe TripAdvisor as a "transnational moral space" in which "individual moral judgements merge into a collective constitution of one morality about the interpretation of a particular event" (2020, 5). Of course, it is important to keep in mind that online reviews are written by a self-selecting group of individuals who remain largely anonymous; and this is from among the largely self-selecting group who chooses to visit the museum to begin with. Nevertheless, the reviews can offer some insight into how visitors experience and respond to the NMAAHC, the Legacy Museum, and Greenwood Rising.

For the purposes of my admittedly limited analysis of online visitor reviews, I am using only TripAdvisor reviews, which show a wide variation in the number of reviews for each museum, reflecting their location, prominence, and—perhaps most importantly—how long they have been open.[2] The reviews of these three museums are overwhelmingly positive, with the vast majority of visitors giving the museums 5 stars and many reviews stating that they are a "must see," "must visit," or "not to be missed." For example, Pat4eva, who visited the NMAAHC in July 2018, implored readers to "listen when I tell YOU, my people, and the rest of you, that you MUST visit this museum. Not should . . . MUST!" Over seventy reviews of the Legacy Museum use the specific words "must see" to describe the museum, and well over half of the Greenwood Rising reviews include this imperative to visit the museum, including Kemosaab's, who visited in April 2022 and called the museum "a 'must see' for those uninterested in hiding the truth."

While describing tourist sites as "must see" attractions is very common, it seems to be especially so in the context of memorial museums, where doing so takes on a moral dimension (Buckley-Zistel and Williams 2020, 10). Memorial museums are considered especially important as they allow visitors the opportunity to bear witness to past violence; thus, a visit to a memorial museum enacts individuals' (and society's) moral obligation vis-à-vis the past and its memory. As I have written previously about TripAdvisor reviews of the 9/11 Memorial Museum, visitors feel that not only do they have a moral duty to visit the museum, but also that "writing the reviews seems to be an extension of the moral obligation to witness, remember and feel a connection to this past violence" (Sodaro 2022, 435). A number of reviews of the museums analyzed here, in particular of the NMAAHC and the Legacy Museum, compare them to Holocaust museums and/or the USHMM, suggesting that some visitors are accustomed to this particular genre of museum and understand that these new museums focused on racial injustice seek an ethical response in their visitors similar to those expected by Holocaust museums. In conveying to others that a visit is imperative—that the museum is a "must see"—visitors are passing along this moral obligation of memory to future visitors. In light of, and beyond, this imperative to others to visit the museum as a moral obligation to the past, the reviews of these three museums are helpful in further understanding their potential to reshape American historical memory of race, slavery, and injustice, but also some of the limitations of museums in the efforts to transform society.

The NMAAHC, because it has been open the longest and is the most prominent of the three (and because of its location in the heart of a major tourist destination), has the largest number of online reviews. Many of the reviews are aimed at giving practical information to future visitors. A large number mention the need for timed tickets and give tips for navigating the online reservation system (including airing many complaints about the system). Many visitors

write about the museum's café—either recommending it as a tasty stop during the day or complaining that it's too expensive or crowded; and many others comment on how large and dense the museum is and advise visitors on how many hours they should expect to spend (a quick keyword search for "hours" came up with over a thousand reviews including the term). Like the museum critics who reviewed the museum on its opening, many visitors found the museum "overwhelming" in the amount of history presented and its overall scale and scope. A number of visitors also note the cramped, crowded and poorly lit historical exhibits and the confusing layout; in fact, most negative reviews (one or two stars) are based on difficulties getting tickets, how crowded the museum was, or trouble navigating the exhibition layout.

Some visitor reviews are more helpful, though, for understanding how visitors experience the museum. The vast majority of visitors give the museum five stars and laud it for everything from its "outstanding detail" and "extensive history" to its "magnificent" architecture and "powerful and thought-provoking" exhibits. While some visitors appreciate the interactive components, like the lunch counter and railcar, others complain that it is not interactive enough. Corinne B wished the museum had "used technology more and been more interactive," perhaps suggesting that audiences are aware of the shifting practices in museum displays like those discussed in this book. And while some visitors appreciate the museum's efforts to tell the truth ("No sugarcoating and no whitewashing"), others wish it was more graphic, like Face P, who writes, "It should have shown burning bodies hanging from trees while people smiled along with children laughing and playing as if this was an everyday event which [it] probably was."

While TripAdvisor does not require or share demographic information about its reviewers, some reviews reveal the racial identity of their authors, which is also somewhat instructive. Several reviewers who reveal that they identify as African American describe a range of emotion that reflects the goals of the museum's creators to balance the upset with the uplift. For example, Melanie S writes that the NMAAHC "houses the vast beauty, struggles, and legacies of our history and culture in this country both the good and evil"; Valerie H, granddaughter of formerly enslaved people in Tennessee, writes, "My emotions spanned from complete sadness for what my people endured to the rage of how this history is present today," but also describes the museum's story of "triumph." Worktotravel says they visit at least once a year, and it is "always a soul-filling experience with me, both painful and inspirational." Suggested in these reviews is the critical importance of the museum to African Americans. Dana W encapsulates this importance, enthusing, "I've been waiting on an experience that included the contributions of African Americans to the founding and building of this country. Finally, finally finally!! We have a Smithsonian that is truly about truth. No sugarcoating

and no whitewashing. Just tell our story of resilience and while it can be heavy and daunting to grasp, it is a hopeful and wonderful story of our true history in America. I have never been so inspired and so hopeful." Still other Black visitors differentiate their experiences from those of white visitors. Carolyn J writes, "If you are African-American like me, the early history is gut-wrenching. If you are not African-American, then I hope that this history is an eye-opener and for the better."

White visitors, in some cases, display their whiteness and "privilege of unknowing" (Sedgwick 1988) in awkward ways, such as Brayden B, who writes, "much of their history is considered sad" before writing about how "enjoyable" seeing Emmett Till's coffin was, or MJS1944, who writes, "If one is white, one may find it daunting that 90% of the other visitors are black: but everyone behaves respectfully to other visitors."[3] But many more presumably or decidedly white visitors write about how much they learned, such as Ogadoo, who writes, "I am white. I was introduced to facts and accounts that I so wish were not true," or Learning Enlightened, who writes, "As a person not very knowledgeable in black history I learned so much and was able to begin to understand the battle." Still others write about how "uncomfortable," "disturbing," and "humbling" visiting the museum is, such as Griffenrome, who titled their review "Difficult but necessary museum" and writes, "Every American needs to be aware of this history. It is not a fun nor even pleasant experience—but an important one." Some even write about the museum making them feel "sad" or "ashamed" to be white. And while some reviewers laud the museum for showing "how far we have come," other reviewers (presumably white), seem to pick up on the challenge to hegemonic historical narratives that the museum presents, such as ARA49, who writes that the museum "forces the visitor to look at America's social, economic and political history in a new, and rather painful, way, emphasizing the very basic role slavery played in almost every aspect of our history."

Some reviews go even further, perhaps suggesting that their authors are beginning to recognize their implication in this difficult history: Betsy S, for example, writes, "It is hard to reconcile the US and all it's [*sic*] blessings with how white people have treated African-American people. We do not deserve to be blessed given what we have done and [continue] to do to minorities." Ceciletrips writes that everyone, no matter their race, should visit, "especially if you think people should 'get over it,' you must visit and connect the dots between 1400 and now. I think of those whose identity is closely tied to assuming privileges due to accident of birth," alluding to the privilege and benefit that the implicated subject inherits. For Melvin123, the museum opened their eyes to the question of reparations: "For the first time I understood why modern African Americans are due reparations as their ancestors generated well over half of the gross national product of American [*sic*] in the early 1800s. Our

140 • Lifting the Shadow

current wealth, and the wealth of many modern companies are clearly based on the labor of slaves." Carolyn L also connects the painful past in the museum to present racial inequities, writing, "It is unconscionable the treatment the slaves had to endure and I can understand the anger of the black people that still festers to this day. This country would not be the country we are today except for the labors of the slave." Once we get past the practical advice and generic statements of appreciation, it's clear that at least some visitors/reviewers are taking from the museum the messages it is striving to convey. Matt Y sums up the importance of this national institution challenging American historical memory, writing, "This museum fills a void in the national narrative that has for too long glossed over the historical trauma of slavery and its legacy in the form of institutional racism that much of white America is reluctant to contend with to this day. For that alone, it merits every possible accolade."

The Legacy Museum is also extremely positively reviewed, and without the competition of the many other Washington, DC, attractions, it was rated the number-one thing to do in Montgomery on TripAdvisor at the time of writing, followed by the National Memorial for Peace and Justice at number two. Like the NMAAHC, some reviewers offer future visitors advice, letting them know that photography is not allowed in the museum, recommending that visitors take time to read and see as much as possible, lauding the affordable tickets, and letting readers know about the free shuttle bus between the museum and memorial. But on the whole, the reviews of the Legacy Museum are even more effusive and emotional than those of the NMAAHC. Many reviewers call it the "best" or "most powerful" museum they have ever visited.[4] One visitor argues that it should be a Smithsonian museum with federal funding, and several reviewers write that they believe every American or at least every high school student should visit the museum to learn about the "evil," "horrible," "dark" history that it tells. A number of reviewers write that they think it should be replicated in cities across the country so everyone has the chance to visit it, such as CatfriendDavis, who writes, "Every major city in the US should have a museum like this one. I wish they would clone it so the rest of the country could learn about our history." In their belief that the museum should have reach beyond Montgomery, this reviewer and others echo the EJI's Community Remembrance Project's goals of encouraging a diffusion of memory work to the community level across the country (though they also allude to the fact that Montgomery is somewhat off the beaten tourist track and many Americans and others will not be able to visit the museum).

Part of the reason that the museum, described as "stunning, necessary and powerful" by one reviewer, is believed to be so important and impactful that it should be replicated across the country or required to visit by most Americans is because of the powerful emotional response it creates. Visitors write about how the "eye opening" museum is "beyond description," leaving them

"speechless" and "overcome with emotion"; many describe the museum evoking tears in them and in other visitors. Kitty526 put it even more strongly, writing the museum "moved me like having a volcano, tornado, tsunami, mountain inside of me." This powerful, emotional response is the proper one for many reviewers: fkolingen titles their review "If you don't cry you have no soul." Peter Butzin echoes this sentiment, writing "I dare anyone not to be moved by what you will learn about our nation's shameful history of slavery, prejudice and mass incarceration of African Americans."

It is also clear that this powerful emotional response is in part due to the forms of storytelling the museum utilizes. Many reviewers write about the "stunning," "state of the art," interactive exhibits that are "much more than just old photos and written placards of explanations." Shannon Keeley describes them as "some of the most innovative and modern exhibits I've ever experienced," and DocMacD argues that it's "a great example of modern museum design with lots of multimedia experiences." Kat calls it "an experience for the senses," writing, "The interactive holograms and breathtaking sculptures are just amazing," a sentiment echoed by Toyotababy, who argues that the museum is "put so well together that you can 'feel' the exhibit!" These visitor responses show just how powerfully visitors respond to the innovative uses of digital media, art, and interactive elements in the Legacy Museum. I think they also suggest a set of changing expectations, desires, and responses of visitors to memorial museums as museums shift from the display of objects and more traditional modes of historical narration ("old photos and written placards") to more interactive, immersive uses of technology to give visitors an experience or "feeling" of the past.

Some visitors also appear to be cognizant of the fact that the museum is not just focused on the past, but on its ongoing legacies. For example, LKM notes that the "museum highlights the historical through-lines that feed into today's white supremacy movements." The powerful emotional response the museum evokes and the links it makes between past and present appear to be helping it accomplish its goals of changing hearts and minds, with the ultimate goal of societal change. As RCR000 writes, "We made new connections between our history as a nation and current events, and we feel better prepared to create positive change in the world." Many other visitors echo this experience of the museum as transformative. Elizabeth W writes that after visiting the "immersive and frankly breathtaking" museum, "I am a changed person," and others feel compelled to let future visitors know that "this will change your life" or "you can't leave the museum without feeling changed." Kathy 194017 goes even further to qualify this change, writing "My visit there has changed my perspective on life and the history of the US," and Bryan S, whose perspective was also "changed," explains that the visit "almost made me embarrassed to be white."

142 • Lifting the Shadow

Other reviewers also comment on how difficult and uncomfortable the museum can be, but how facing this difficulty is important. Joe, for example, writes, "Painful truth, yet found hope that we have such extraordinary place to deeply think and learn about the horrors of slavery in our history." John K writes, "This isn't a fun museum to visit, but if you come with an open mind and ready to be confronted and challenged, it is worth every minute you spend inside." In these comments you can see reflected some of the discomfort that comes with discovering one's implication in past and ongoing violence. Cherie H echoes this, writing, "The Museum and Memorial didn't set out to make me feel guilty, or woke, or whatever politicians who will be on the wrong side of history want us White folks to believe today. It challenges us to know the truth, know the legacy of suffering and injustice that haunts us still. It challenges us to reflect on how that is different from the collective national narrative, and to reckon with our past." Some reviewers even appear to channel EJI's overarching rationale for creating the museum and the memorial. KSCoral, for example, could practically be quoting EJI when they write, "Until white people in US recognize how slavery, institutionalized racism, terrorism against black citizens, and mass incarceration have kept black Americans from enjoying the same privileges and opportunities as white people, our country will not be able to move forward in harmony." In these reviews we can see some (presumably) white visitors begin to acknowledge white Americans' implication in past and ongoing racism.

There are negative reviews of the museum, some focused on customer service complaints and a few griping about the museum's strict mask requirements. And there are several that argue that the museum is "biased" and has "political overtones." One reviewer, SRB1966, for example, seems to long for a more traditional narrative of uplift, arguing that the museum is "misleading in many ways. It seems to want to hide the successes of our country to overcome inequality." And another, nunya b, titled their review "Historical elements were well done. The political narrative they push underlying current events is inappropriate." These last two examples suggest that some people—clearly in a small minority of the already self-selecting audience of the Legacy Museum—would prefer (or expect) a more traditional museum that tells a story of racial progress and allows history to remain firmly in the past. But the overwhelmingly positive reviews overall suggest that there is a strong public appetite for the challenging, critical counternarrative that the museum provides.

It is this changing public desire for truth-telling about pasts that have been long silenced that inspired the creators of Greenwood Rising to turn to a museum as the key mode of commemorating the 1921 Tulsa Race Massacre, and the Legacy Museum was their direct inspiration. Unfortunately, because the museum is so new and hasn't received the same level of national attention as the NMAAHC and the Legacy Museum, and because Tulsa is not a major

tourist destination, there are not many online reviews of it, limiting what we can glean from them. However, we can draw a few conclusions about how visitors experience the museum. As has been noted, Greenwood Rising also received overwhelmingly positive reviews, with over half of reviewers referring to it as a "must see." It's described as a "masterpiece of a museum" and "first rate" or "first class," a museum that Carol C refers to as "honest, truthful, emotional, brutal, hope, forward-looking" all at once. Several reviewers refer to it as the "best" museum they have ever visited, and a few express surprise that it's not higher ranked on TripAdvisor (at the time of writing it was number eleven on the list of things to do in Tulsa).

As we saw with the Legacy Museum, much of the reason for this effusive praise appears to be the methods of storytelling employed by Greenwood Rising. Reviewers comment on the "unique, immersive format," the exhibits that are "so well conceived and designed," the museum's "interesting artistic displays," and the "care they took to keep in mind emotional responses to the exhibits." Many reviews comment on the museum's use of technology and interactive exhibits, with one visitor specifically mentioning the "brilliant" designer of the museum exhibits, who captured the story "in a very interesting 21st century kind of way." And while the "vivid," "high tech and immersive" exhibits are "masterful" and "engaging," they are also described as "visceral," "intense," and "disturbing." Several visitors comment on how powerful the words of the survivors are in the massacre video simulation, and others enjoyed the holographic barbershop experience. While one reviewer wishes there were more artifacts on display, most visitors seem to greatly appreciate the innovative technology used to tell the story.

Like the other museums discussed here, visitors experience an emotional response to the exhibits; one describes getting "chills," another warns that "it will leave you in tears," and a number describe it as "moving" and "powerful." Many visitors laud the museum for telling this "untold story," a "forgotten chapter" in American history, and of these, a few explain that they came to the museum to learn more after hearing of the massacre as it gained popular attention in recent years. Although the museum's creators were careful to provide visitors with an "emotional exit" to avoid the trauma from the massacre's representation, not a single reviewer appears to have use it; instead, it appears that they come to the museum to learn about the massacre and appreciate the visceral way in which it is told. It is specifically the exhibit on the massacre that most visitors comment on, though some visitors do make the connection between that past and today's ongoing racial injustice. For example, sidkaskey titles their review "To understand the present in light of the past a visit here is mandatory." Terri writes about the Commitment Wall at the end, which "questions each of us to do what we can to avoid the Tulsa massacre from ever happening again," and a couple of others mention continuing discussions

about racial justice that began with their museum visit. A few other visitors talk about "healing" and how the museum gives "hope for a better future," and Tara K expresses the transformative potential of the museum, writing "I had the same experience here as I did while visiting Holocaust museums: horrified by man's cruelty to others, but personally determined to work towards true reconciliation for all." But most of the reviews are expressly focused on learning about the race massacre and that specific part of the museum, suggesting that perhaps the museum is primarily viewed as a container for a painful past—one that is only now being publicly acknowledged and remembered, but still one that resides primarily in the past.

A Growing Trend

Clearly visitors respond powerfully to these new museums, indicating that there is a portion of the public that is open to newly challenging narratives about race, slavery, and its ongoing legacies in the United States, and, especially, the representation of these narratives in immersive, experiential museums. Thus, another way of thinking about the impact of these museums is looking at where this new phase of African American memorial museums is going. As the previous section showed, some visitors longed for these museums to be replicated across the country, suggesting that there is space opening for these kinds of narratives—and a dire need for them, according to some individuals—all over the United States. As I have argued, the three museums discussed in this book are just the beginning of what I believe is a new, third phase of African American museums that are being created to address this difficult past in newly critical and honest ways, using the most contemporary and cutting-edge museum practices and technologies. Though the three museums here began this trend, others are in the process of opening and being developed.

The most fully realized of these new museums to date is the International African American Museum (IAAM), which opened in Charleston, South Carolina, in June 2023. The museum was twenty-three years in the making, delayed by various difficulties with fundraising, a change to its location, the COVID-19 pandemic, and, most recently, its heating, ventilation, and air conditioning system. Despite the obstacles along the way, the museum has opened to excitement and fanfare in an understated yet stunning building, designed by Pei Cobb Freed & Partners and Moody Nolan, the largest Black-owned architecture firm in the United States. The museum hovers on sturdy pillars over Charleston's Gadsden's Wharf, where an estimated 45 percent of all enslaved Africans brought to the United States landed. The heavy historical significance of the site has inspired memorial gardens, designed by Hood Design Studio, that draw from historical reference, like the silhouetted figures carved

into the walkways that evoke the 1781 drawing of the *Brookes* slave ship, as well as contemporary memorial design, such as the reflective black granite wall that lines a boardwalk flanked by kneeling figures commemorating the enslaved and that calls to mind Maya Lin's Vietnam Veterans Memorial.

Inside the 100,000-square-foot, $120 million museum, which was created through a combination of public and private funding, exhibits designed by Ralph Appelbaum Associates (RAA) tell what the museum describes as the "unvarnished stories of the African American experience across generations, the trauma and triumph that gave rise to a resilient people" (IAAM n.d.). Most of the exhibits are arranged thematically and display many artifacts from the museum's growing collection with accompanying explanatory texts in recognizable RAA fashion. But there also appear to be high-tech and interactive components, such as the Transatlantic Experience, which is described as an "immersive media experience"; a re-created Gullah Geechee praise house; exhibits where visitors can listen to testimony from formerly enslaved individuals; and over fifty films, all of which indicate a shift toward twenty-first-century museological practices. And like the NMAAHC, the IAAM strives heavily for a balanced narrative that emphasizes both "grief" and "grace" (Cotter 2023); one that, in the words of the museum director Tonya Matthews at the opening ceremony, "simultaneously hold[s] the sensations of trauma and joy" (IAAM 2023).

But behind this balanced narrative and effort to emphasize joy, the creators of the museum were driven by concerns similar to those who created the museums examined in this book. For example, Wilbur Johnson (2023), the museum chairman, argued in an op-ed in Charleston's *Post & Courier* that the museum stemmed from the "belief that the time had come for a reconciliation"—reconciliation derived from truth-telling about Charleston's role in slavery, which forms the foundation for the museum as "one of the nation's newest platforms, dedicated, ultimately, to the eradication of institutionalized racism." Aki Carpenter, the lead designer from RAA, argues that the museum is both a "site of memory" and "a site of conscience" (Berg 2023). And as with the Legacy Museum and Greenwood Rising, in particular, officials in Charleston hope that the museum will have a big economic impact on the city (Radebaugh 2023). However, and again reminding us of how fraught musealizing this past is—especially with all of the economic benefits expected to come from the practice—as in Tulsa, there are members of Charleston's African American community that are deeply skeptical that the museum represents progress. In the words of Millicent Brown, a historian and activist who founded Citizens Want Excellence at IAAM, "If you're going to use our history as the conduit for money coming into the city, how can you do that where there is not a place for a person to sit in a Black-owned business anywhere within walking distance of this?" (Greenlee 2023).

146 • Lifting the Shadow

Despite these kinds of legitimate concerns, the momentum continues. In Richmond, Virginia, not far from Fredericksburg, where a national slavery museum was proposed in 2001 but never realized (Hanna 2008), ambitious plans have been announced for the ten-acre Shockoe Project. The project, which is intended to be a "multi-faceted space for remembrance, reflection, research, connection, and reclaiming the historic and contemporary narratives of Black experience," is envisioned to include slave auction sites, an interpreted Trail of the Enslaved walkway, an African Burial Ground and memorial, a memorial at the infamous Lumpkin's Slave Jail, the Shockoe Institute, and the National Slavery Museum (The Shockoe Project 2024b). The museum is being described as the "nation's only museum dedicated specifically to slavery in the United States" and "the anchor point to a global site of conscience" (The Shockoe Project 2024a). The city of Richmond is working to raise $265 million for the new memorial complex and its "meticulous curation, interactive displays, and immersive experiences," which will tell Richmond's long silenced history; clearly inspired by EJI's work, the project's master plan even quotes Bryan Stevenson: "We cannot heal the deep wounds inflicted during the era of racial terrorism until we tell the truth about it" (The Shockoe Project Masterplan 2024b).

On a much smaller scale, and also located in Richmond, the artist Paul Rucker has received a $2 million Mellon Foundation grant to open a museum / art space / lending library to display his collection of "artifacts that factually illustrate the systemic racism that lies at the foundations of U.S. society, sustaining racial inequity into the present day" (Cascone 2022). The institution, which will be called Cary Forward, named for Cary Street, which was part of Richmond's own Black Wall Street, will present Rucker's growing collection as "illustrative of so much of why our nation is the way that is, the underlying factors that gave rise to socioeconomic inequalities along racial lines, and the mass incarceration of African Americans." At the same time, it will celebrate African American achievement and serve as a vital space for education about Black history and experience (Cascone 2022). In the words of Rucker, "We need to learn about these things and they have to be part of the conversation if we're going to talk about repair" (Cascone 2022).

It thus seems that momentum is picking up. A new museum focused on the last slave ship to arrive in the United States in 1860, the *Clotilda*, and its survivors opened in Mobile, Alabama, in June 2023. In New York City's Harlem neighborhood, the Urban Civil Rights Museum is slated to open in late 2024 / early 2025 as the first museum to extend the focus on the Civil Rights Movement to the North. It will examine civil rights "from the very roots of the urban north, all the way up through the present day and the Black Lives Matter movement" (National Urban League 2024). In nearby Brooklyn's Prospect Park, a small house museum, Lefferts Historic House, reopened in May 2023

with a focus on slavery. Also in New York City, but intended for a global audience, a new slavery exhibit was brought to the United Nations by Amsterdam's Rijksmuseum. And across the country, established museums are undergoing significant renovation, such as the Charles H. Wright Museum in Detroit (Aimery 2023) and expansion, such as Philadelphia's African American Museum (Moselle 2022).

Overseas, there are parallel initiatives. In Ouidah, Benin, what has been described as a slavery "theme park" has been proposed (and heavily critiqued) as a seaside resort with gardens of remembrance; a "Door of No Return"; a life-size replica of a slave ship; a craft market; hotels, spas, and restaurants; and a space for vodun performances, a West African religion practiced by descendants of the enslaved throughout the Americas. In neighboring Nigeria, there are plans for a World Africa Slave Trade Museum in Badagry (Taiwo 2023). In Amsterdam, plans are underway for a National Slavery Museum (Bunch 2023), and in Glasgow, calls are growing for the city to develop a Museum of Empire and Slavery (Sanderson 2023). In Rio de Janeiro, Valongo Wharf, a UNESCO World Heritage site where approximately 1 million enslaved individuals disembarked during the transatlantic slave trade, recently reopened following a significant renovation (Angeleti 2024). There thus seems to be growing global interest in telling the history and reshaping historical memory of slavery and its ongoing legacies. The three museums examined in this book capture a moment in this growing trend in which public memorial space in the United States is opening up to a confrontation with the history and memory of slavery and its legacies in ways that will no doubt continue to develop and spread.

"A New Era of Truth"

In their 2018 analysis of the long struggle to remember slavery in Charleston, South Carolina, Ethan J. Kytle and Blain Roberts wrote, "If the Holocaust is easily invoked for the purposes of drawing universal moral lessons, the same is not true for American slavery" (2018, 334). This has long been true in the United States—the fact that a national Holocaust museum has existed in Washington, DC, for three decades and that almost every major city in the United States has a Holocaust memorial or museum attests to this use of the Holocaust as the predominant "moral compass" vis-à-vis past violence in American society. However, the museums analyzed in this book, especially taken together with the new and expanding initiatives described above, demonstrate that this is changing. As public discursive space opens in the United States for more honest discussions around slavery, its legacies, and its memories, these new museums are working to convey more universal moral messages about the foundational impact of slavery on U.S. society and its

legacies in ongoing systemic inequality. Just as the Holocaust has so often been used as a warning for us to ensure that "never again" should such violence be allowed to occur, the museums examined here are intended to inspire social transformation in the present and for the future. For example, the goal of the Legacy Museum according to Bryan Stevenson is that "the children of our children will not live under this legacy of slavery." This past, which has long been silenced or only whispered in public institutions of memory, is now being invoked for universal moral messages.

In *Learning from the Germans*, Susan Neiman reminds us that "monuments are not about history; they are values made visible.... When we choose to memorialize a historical moment, we are choosing the values we want to defend, and pass on" (2019, 263). This is at the core of why Confederate monuments have become so controversial, and it is at the heart of why these museums are so important. They are one small intervention into the volatile debates, discussions, and controversies over slavery and its legacies that are embroiling the United States today, but they are an important one. The dominant narrative of racial progress and its concomitant effort to consign past racial violence to history is beginning to crumble as segments of the population seek to confront America's "original sin" and its lasting impacts in the present. As has been noted, this reckoning is occurring in many spheres of society, such as political institutions like the local governments that are enacting reparations, institutions of higher education conducting research on their own ties to slavery, the media, in projects like the 1619 Project and the plethora of books and documentaries centering slavery in American history and memory, and in grassroots mobilization like the Black Lives Matter movement. But museums play an especially important role in these efforts. They have the potential to reach audiences (albeit self-selecting ones) that go beyond those of other initiatives. Museums are also widely considered to be trustworthy institutions that are authoritative when it comes to conveying historical information.[5] From the limited information that we can glean from online reviews, visitors are responding enthusiastically to the history that they are learning in these museums, which reflects an openness among the general public to the values that these museums seek to defend and pass on to future generations.

To grapple with this difficult history in the public space of a museum is critically important today. As Saidiya Hartman writes, "If slavery persists as an issue in the political life of black America, it is not because of an antiquarian obsession with bygone days or the burden of a too-long memory, but because black lives are still imperiled and devalued by a racial calculus and a political arithmetic that were entrenched centuries ago. This is the afterlife of slavery— skewed life chances, limited access to health and education, premature death, incarceration, and impoverishment" (2006, 6). The afterlife of slavery has life-or-death consequences today, and its shadow, as Frederick Douglass (1881)

writes, continues to "poison more or less the moral atmosphere of all sections of the republic." Yet the museums analyzed here represent a reshaping of the narrative and a lifting of the shadow, however tentative. Though they engage in their memory work in ways that are uneven, and though they reveal the limitations of museums as modes of reckoning with past and ongoing racial violence, they are also a step in the direction of meaningful confrontation with America's violent and racist past, and they are not operating in a mnemonic vacuum. As Bryan Stevenson says, "Many of us are calling for a new era of truth and justice, truth and reconciliation, truth and restoration, truth and reparation, around this narrative [of slavery and its legacies] that has never been adequately confronted" (UN News 2023). That confrontation is beginning in museums like the NMAAHC, the Legacy Museum, and Greenwood Rising, which hopefully will help usher in a new era of memory work in the United States and demonstrate that museums can play an important role in advocating for social justice and repair.

Acknowledgments

This book is a product of the tumultuous times we are living in. While writing my first book, *Exhibiting Atrocity: Memorial Museums and the Politics of Past Violence* (Rutgers University Press, 2018), I was acutely aware of the silence surrounding slavery and its legacies in the American commemorative landscape. This began to change as I finished that book in 2017, and I started to conceptualize a book about the new museums that were opening in the context of the frightening shift in U.S. politics spurred by Donald Trump's election to the presidency. As this book began to take shape in my mind, COVID-19 erupted into our lives, followed by the murder of George Floyd and the Black Lives Matter protests of 2020, the 2020 presidential election, and the events of January 6, 2021, giving a greater urgency to the book I was hoping to write, even while my time, focus, and resources for research and writing screeched to a halt.

However, I have had tremendous support, despite this turbulent context, which has enabled me to complete this project, one that has become so important to me. Much of this support was institutional, for which I am extremely grateful. The City University of New York's Borough of Manhattan Community College (BMCC) granted me a sabbatical in 2021–2022, which afforded me the time and focus to seriously set to work researching and writing. During my sabbatical, I was hosted as a visiting scholar at New York University (NYU) through their Faculty Resource Network and at the New School for Social Research (NSSR)'s Transregional Center for Democratic Studies, which gave me access to the substantial resources of these two institutions, including their libraries and their incredible faculty, in particular Joyce Apsel (NYU) and Elzbieta Matynia (NSSR). The Professional Staff Congress/Research Foundation of the City University of New York generously provided me with two grants (2021 and 2022) that made it possible to travel to Washington, Montgomery, and Tulsa to conduct fieldwork at the museums. Finally, I was

151

the extremely fortunate recipient of a Mellon/ACLS Community College Faculty Fellowship (2022–2023), which enabled me to take additional time off from teaching and allowed me to finish the book that I had begun while on sabbatical. I am so very grateful for the significant support these institutions and individuals provided.

I am also indebted to many individuals who have helped to move the project forward. At Equal Justice Initiative (EJI), senior attorney Sia Sanneh and communications manager Tania Cordes have been invaluable in their help. Local Projects project director L'Rai Arthur-Mensah was an incredible resource for learning about Greenwood Rising, as were the many tour guides, staff, and others that I spoke to on my many visits to the museums. I am grateful for the generous comments of the anonymous reviewers of my proposal and manuscript, as well as for the editors to whose volumes I contributed parts of this research: Thomas DeGloma and Janet Jacobs, coeditors of *Interpreting Contentious Memory: Countermemories and Conflicts over the Past* (Bristol University Press, 2023), Stephan Jaeger and Kerstin Barndt, coeditors of *Museums, Narratives, and Critical Histories: Narrating the Past for Present and Future* (De Gruyter, 2024), and Magdalena Saryusz-Wolska, Joanna Wawrzyniak, and Zofia Wóycicka, editors of the special issue "Mnemonic Wars: New Constellations" of *Memory Studies* (vol. 15, no. 6 [2022]). I presented parts of this research at various conferences and other gatherings in the last few years and am grateful to the many individuals who gave me valuable feedback, as well as to my wonderful colleagues in the Memory Studies Association's Museums and Memory Working Group.

In addition to the many individuals who assisted me in my research, I am grateful to my colleagues at the BMCC for their support, as well as to my incredible students, who have helped me understand the continuing impacts of slavery and racial injustice in our society. I would also like to thank Rutgers University Press and, in particular, my editor, Peggy Solic, who has been wonderful to work with. And of course, I am eternally grateful to my husband, Jonah, and daughter, Stella, who are always up to be dragged to memorial museums and to talk about the many injustices and problems in our society. I can't thank them enough for their unending support!

At many times while writing this book, I have felt utter despair at the state of the world around us and the ongoing inequalities and injustices that mark our society. As we enter another presidential election that feels even more dangerous than the last two, it's difficult not to despair. Yet the important work that the museums analyzed here—together with many other individuals, organizations, and institutions—are doing to confront past racial injustice with the goal of creating a better present and future, gives me great hope, which I wish to share with readers of this book. As EJI founder Bryan Stevenson says, "Hope is our superpower," and I hope a bit of that power is imparted here.

Notes

Introduction

1 The Flatbush African Burial Ground was supposed to be the site of a new "affordable housing" development under Mayor Bill de Blasio's administration (2014–2021). However, significant advocacy halted those plans, and the site has been taken over by the New York City Department of Parks and Recreation for development (Flatbush African Burial Ground Coalition n.d.).

2 Many were quick to note how gently and respectfully the police arrested Roof—even buying him food from Burger King when he complained that he was hungry—in comparison to the many Black and brown people who have been and continue to be brutalized and killed by the police, often for no cause at all (Pearl 2015).

3 Just moments into the speech that launched his campaign, Trump infamously claimed that most Mexicans who come to the United States are criminals and rapists.

4 For example, in November 2022 Trump had a high-profile dinner with Ye (formerly Kanye West), who has been under fire for racist and anti-Semitic comments including tweeting "I love Hitler," and known white nationalist Nick Fuentes. That same week, Brooklyn Nets basketball star Kyrie Irving was suspended for five games (and lost his Nike sponsorship) after tweeting about an anti-Semitic film.

5 Critical race theory (CRT) emerged in the 1980s as an academic concept and legal framework that argues that racism is structured into U.S. institutions, practices, and procedures. Like broader misconceptions about racism as an individual phenomenon, those seeking to ban CRT fundamentally misunderstand that racism can exist without prejudice and argue that any discussion of race, racism, and slavery (gender and sexism is increasingly included as well) will make (white) students uncomfortable (Ray and Gibbons 2021). Considering that CRT is a theoretical perspective that one would most likely not encounter until graduate school, it is patently ridiculous that politicians are claiming it is being taught in elementary schools across the country.

154 • Notes to Pages 8–25

6 However, most scholarly work on the Legacy Museum is in fact focused on its sister institution, the National Memorial for Peace and Justice. Further, the Legacy Museum reopened in 2021 with significantly expanded exhibitions, while most scholarship on the museum focuses on its first iteration.

Chapter 1 Race and Memory in the United States

1 The word for "work off the past" in German is *Vergangenheitsbewältigung*, which refers to public debates and efforts around confronting and coming to terms with the past, in particular the Holocaust.

2 This narrative takes its name from *The Lost Cause: A New Southern History of the War of the Confederates*, a book published in 1866 by Virginian Edward A. Pollard, who coined the term and provided what Karen Cox calls a "rhetorical balm to soothe [former Confederates'] psychological wounds" by laying out what would become the Lost Cause narrative's key pillars (2021, 16–17).

3 Reconstruction was the short period that began after the end of the Civil War, when slavery had been abolished and the Thirteenth, Fourteenth, and Fifteenth Amendments had been added to the Constitution to fully integrate the newly emancipated population. Great strides were made toward equality during Reconstruction, despite ongoing violence and terror committed by the newly formed Ku Klux Klan and other recalcitrant white populations. Progress was abruptly halted and reversed with the Compromise of 1877, when Ulysses S. Grant withdrew federal troops from the South in exchange for southern support for Grant's Republican successor Rutherford B. Hayes, ushering in the period known as Jim Crow.

4 One such example is June 19, Juneteenth, which was made a federal holiday celebrating the end of slavery in the United States in 2021. On that date in 1865, word (and enforcement) of Lincoln's Emancipation Proclamation finally made it to East Texas, the last of the Confederate states to receive the news. Throughout the last 150 years, African Americans have celebrated a number of different dates as Freedom Day or Emancipation Day.

5 There is a thriving subfield focused on dark tourism that examines this interest in visiting sites of death, trauma, and atrocity (e.g., Lennon and Foley 2000; Stone and Sharpley 2008).

6 The Anacostia Neighborhood Museum was created as an arm of the Smithsonian in 1967. Described as "an experimental store-front museum," it was intended to attract more African American visitors to the Smithsonian museums on the National Mall (Smithsonian Institution Archives n.d.).

7 In 1996, the newly opened King National Historic Site was widely advertised in the international terminal of Atlanta's Hartsfield Airport in the weeks leading up to the Olympics. No such advertisements were placed in the domestic terminals, suggesting that this push for rehabilitation might be primarily externally oriented (Dwyer and Alderman 2008, 61).

8 The museum was built on land donated by the Coca-Cola Company.

9 This is how the museum narrative was described by Calinda Lee, former head of interpretation at the NCCHR, at a conference held at the University of Dayton in December 2021 (Morrow et al. 2021). In her talk she discussed the problems with the museum's depiction of U.S. human rights violations and plans for changes to the museum's narrative. The museum is indeed expanding, though what this

means for the exhibitions and narratives is not year clear (NCCHR 2022). Lee has since left the museum.

10 Another recent museum straddling the second and third phases of African American museums is the Mississippi Civil Rights Museum (MCRM), which opened in 2017, in Jackson, Mississippi, together with the Mississippi History Museum as the first state-funded civil rights museum. The MCRM, while focused specifically on the Civil Rights Movement in Mississippi, takes a more expansive view of history, framing the movement in the context of slavery and its legacies. It also suggests, though in a much less explicit way than we shall see in some of the museums analyzed here, that the struggle continues even today. As King and Gatchet argue, the MCRM "effectively connects the past to the present and future" (2023, 164) and, in the words of *New York Times* critic Holland Cotter (2017), "refuses to sugarcoat history." The museum presents the violence of Jim Crow, lynching, and segregation in a way that departs from many other civil rights museums, but, ultimately, as a state institution it "promotes a rhetoric of gradual and consistent progress that concludes with the dismantling of some of the most egregious elements of white supremacy and a celebration of the state having the highest number of African American elected politicians in the nation" (King and Gatchet 2023, 181), a celebration that ignores the persistent racial inequalities in the state.

11 Though it should be noted that this museum occupies a floor within the larger Merseyside Maritime Museum and is not its own, freestanding museum.

12 In fact, audience research by Alderman, Butler, and Hanna (2016, 213) found that a number of tourists' ideas and expectations about plantations were informed by the 1939 film *Gone with the Wind*. The fact that many plantations promote themselves as venues for weddings and other romantic and romanticized events underlines this public perception.

13 While I agree that the Whitney is a groundbreaking institution of enormous importance in the emerging public historical discourse around slavery, I have limited my focus in this book to museums, specifically new, purpose-built museums, and the additional layers of mediation that differentiate them from historic sites like the Whitney.

14 Formosa had purchased the site in the 1990s in order to build a rayon factory. The company commissioned a detailed study of the site in response to pushback by environmental and historic preservation groups, but ultimately the decline in popularity of rayon led Formosa to sell the site in 2000.

15 *Born in Slavery: Slave Narratives from the Federal Writers' Project, 1936–1938* is a collection of over 2,300 firsthand accounts of formerly enslaved individuals collected by the Works Progress Administration. The collection consists of over 10,000 pages of text and over 500 black-and-white photographs and is the country's most comprehensive collection of the stories of those who were enslaved. The collection is digitized and available in the public domain through the Library of Congress and, as shall become clear in the coming chapters, is widely used in museum exhibitions on slavery as a key form of testimony to this history.

16 This is very similar to the identity cards distributed at the U.S. Holocaust Memorial Museum.

17 This move immediately invited controversy as both the interpreters and audiences—white and Black—struggled with the living history depiction of American slavery (Horton 1999, 30). The controversy came to a head in 1994,

156 • Notes to Pages 30–45

when Colonial Williamsburg's African American Department decided to reenact a slave auction and everyone from the actors, audiences, and curators to academics and other members of the public weighed in on how and whether such violent and fraught aspects of American history can be presented to the public without devolving into entertainment and spectacle.

18 For detailed critiques of the MAAH, see Apel (2001) and Wood (2009).

19 The exhibit did go on to be a successful traveling exhibit (Vlach 2006).

20 There is currently a bill before Congress to make the African Burial Ground in New York a national museum, with an expanded building and a partnership with the NMAAHC.

Chapter 2 Telling "America's Story"

Excerpts from this chapter appeared in "'Feeling Truth': Objects, Embodiment and Temporality in the National Museum of African American History and Culture and the Legacy Museum," in *Museums, Narratives, and Critical Histories: Narrating the Past for Present and Future*, ed. Stephan Jaeger and Kerstin Barndt (Berlin: De Gruyter, 2024), 25–44.

1 "Making a way out of no way" is a popular African American expression and the title of one of the museum's exhibits. It is also sprinkled throughout many others in the museum and is often used as a metaphor for its very creation.

2 *A Fool's Errand* is the title of Lonnie Bunch's (2019) book about the creation of the museum.

3 These arguments appear to no longer have much influence—plans are currently underway for the Smithsonian's National Museum of the American Latino and American Women's History Museum.

4 Adjaye, whom the *New York Times* called "arguably the world's first Black 'starchitect'" and who was knighted by Queen Elizabeth in 2017, was forced to withdraw from a number of prominent projects in summer of 2023, including a redevelopment of the International Slavery Museum in Liverpool, the redesign of the Studio Museum Harlem, and a British Holocaust memorial, among others, when allegations of misconduct, including sexual harassment, sexual assault, and a toxic work environment were brought by former female employees (Pogrebin and Marshall 2023). It's not clear yet what these allegations will mean for buildings that are intimately connected with Adjaye, like the NMAAHC.

5 Scholar Marcus Wood, however, strongly critiques the building, arguing that its reference to Yoruba design, which had been considered superior by colonial powers, "parrot[s] the arrogant but politically poisonous generalizing vision of African art laid out by British, and indeed Central European colonial powers" (2022, 427).

6 Till's body was exhumed in 2005 for an investigation by the Justice Department into whether anyone was involved in Till's murder other than Roy Bryant and J. W. Milam, who were tried and acquitted and subsequently confessed to the crime, knowing they could not be tried again. The Justice Department found no one else implicated and Till was reburied, while the original casket was placed in storage until the NMAAHC acquired it in 2009.

7 The Scholarly Advisory Committee included Bernice Johnson Reagon, Taylor Branch, Clement Price, Richard Powell, Deborah Willis, Alvia Wardlaw,

Johnnetta Betsch Cole, Michael Blakey, Drew Days, Alfred Moss, and Leslie Fenwick.

8 Around 3,500 are on display.

9 Jefferson famously wrote this in *Notes on the State of Virginia* in 1785.

10 This topic is largely avoided in museums focused on racial inequity, with the exception being Liverpool's International Museum of Slavery (e.g., Araujo 2020, 119).

11 There is no sustained discussion in the museum of the Thirteenth Amendment's loophole that abolished slavery except for prisoners, however. Many scholars and activists have argued that this loophole helped to pave the way for the United States' contemporary system of mass incarceration, which many view as a new form of slavery (see chapter 3).

12 Colvin, who was a teenager at the time and was not viewed by the NAACP leadership as a galvanizing symbol for the boycott, is only cursorily mentioned in the exhibit. Even in 2021, Ms. Colvin was fighting to have the record of her arrest expunged.

13 The railcar and guard tower were so large they had to be installed before the roof was put on the building (Bunch 2019, 204–205).

14 In addition to the three subterranean levels of the historical exhibit and the top two floors of exhibits, there is a concourse level featuring the museum café and temporary exhibit space, the entry-level "Heritage Hall," and a library, classrooms, and interactive educational rooms on the second floor.

Chapter 3 "Shine the Light of Truth"

Excerpts from this chapter appeared in "Contentious Pasts, Contentious Futures: Race, Memory and Politics in Montgomery's Legacy Museum," in *Interpreting Contentious Memory: Countermemories and Conflicts over the Past*, ed. Thomas DeGloma and Janet Jacobs (Bristol, UK: Bristol University Press, 2023), 154–174, and are being used with permission from Bristol University Press. Additional excerpts appeared in "'Feeling Truth': Objects, Embodiment and Temporality in the National Museum of African American History and Culture and the Legacy Museum," in *Museums, Narratives, and Critical Histories: Narrating the Past for Present and Future*, ed. Stephan Jaeger and Kerstin Barndt (Berlin: De Gruyter, 2024), 25–44.

1 MASS Design, which stands for Model of Architecture Serving Society, is a Boston-based firm with an eclectic portfolio, including memorial and other sites across the United States and many projects in Rwanda and other parts of Africa. Their mission is to "research, build, and advocate for architecture that promotes justice and human dignity" with the belief that architecture can help "shape new narratives [and help societies] collectively heal" (MASS Design Group n.d.).

2 However, while Local Projects and Greenwood Rising are eager to emphasize their collaboration, in conversations with EJI and Local Projects, I noticed that both sought to distance themselves from each other and minimize any work that they had done together.

3 Interestingly, Stevenson has never acknowledged how political and problematic genocide memory in Rwanda is (e.g., Kelley 2017; Sodaro 2011, 2018). And while Germany has been a model for other nations in its commemoration of the Holocaust through a self-indicting lens, scholars have noted how absent Germany's role in colonialism has been in public memory (e.g., Bach 2019; Cronin 2022).

158 • Notes to Pages 71–86

Similarly, while South Africa has created impressive and world-renowned memorials to Apartheid, many would agree that the nation's reckoning with its past is nowhere near complete, particularly when it comes to persistent economic inequality.

4 The title of the installation, *Nkyinkyim*, comes from an Adinkra symbol (from the West African region including Ghana) and means "twisting" or "versatility."

5 EJI has partnered on several videos with Sharp as Knives (n.d.) and artist and journalist Molly Crabapple, as well as with Google and HBO for other parts of their projects).

6 I recently had the opportunity to interact with a digital representation of a Holocaust survivor, Oskar Knoblach, at the Arizona Jewish Historical Society. The docents provided lists of the fifty or one hundred most popular questions that visitors could ask of him, and there were pages and pages listing hundreds of other questions that he could answer. We even went "off script," and he was able to answer some simple questions. The technology is extremely impressive.

7 I was horrified to see that a lynching had occurred in the small county in Wyoming, Goshen County, where I had been born and raised and never once learned of this history.

8 The map is also available online; see EJI (n.d.-d).

9 The museum opened before the first anti-lynching law, the Emmett Till Anti-lynching Act, was signed into law by President Biden in 2022, over a hundred years after the first bill was introduced.

10 Poll or literacy tests were one of many mechanisms used under Jim Crow to ensure that African Americans were not able to vote. Poll tests usually consisted of a long list of questions, many difficult or impossible to answer, that were given to potential voters at the discretion of the poll workers to determine their "eligibility." So, while a white voter might be asked, "Who is the president of the United States," a Black voter might be asked, "If it were proposed to join Alabama and Mississippi to form one state, what groups would have to vote approval in order for this to be done?" (Jim Crow Museum 2023).

11 The young man is Ian Manuel. His story has a "happy" ending as EJI was able to get him released.

12 Westcott, with the two other young women tortured and experimented on by Sims, Lucy, and Betsey, is powerfully commemorated at a nearby memorial site, "The Mothers of Gynecology," developed by artist Michelle L. Browder and her More Up Campus project. The organization plans to renovate the house in downtown Montgomery where Sims conducted his experiments to be a museum and working clinic for low-income and uninsured women, as well as build a "changemakers" museum and travel accommodations for visitors and activists. The memorial and Browder's ambitious plans further evidence a sea change in efforts to confront the past in Montgomery and no doubt have gained momentum from EJI's memorialization work. They are also likely contributing to further change.

13 During one visit to Montgomery I visited the First White House of the Confederacy, where the curator was excited to introduce me to a group of older women nicely dressed in pastels, who were members of the White House Association. They were eager to recommend historic sites for me to visit—both Confederate and civil rights–era, and to chat about the importance of preserving the house and its memory. When I asked them about the EJI sites, they complained that the EJI sites had taken visitors from the Civil War and civil rights sites and disdainfully

Notes to Pages 89–97 • 159

remarked on the "boutique hotels" going up all over downtown, while admitting that revitalization was a good thing.

Chapter 4 "After a Century of Silence"

An earlier version of this chapter appeared as "Race, Memory and Implication in Tulsa's Greenwood Rising," *Memory Studies* 15, no. 6 (2022): 1378–1392, and is being used with permission from Sage.

1 "After a century of silence" is taken from the homepage of the museum's website (https://www.greenwoodrising.org/).
2 The Five Civilized Tribes of Oklahoma—Cherokees, Chickasaws, Choctaws, Creeks, and Seminoles—were formalized by the Dawes Act of 1887, which created "Final Rolls" of citizenship for each tribe and allotted land in Indian Territory to tribal members (National Archives 2022). Members of the tribes enslaved many African Americans who were brought to Oklahoma on the Trail of Tears in the 1830s and were later freed; in many cases freedmen received full citizenship and membership in the tribe, including land allotments.
3 The Oklahoma Commission to Study the Tulsa Race Riot of 1921 estimated the deaths at between 150 and 300.
4 John Hope Franklin was also the chair of the NMAAHC Scholarly Advisory Committee until his death in 2009.
5 The International Coalition of Sites of Conscience describes itself on its home page as "the only global network of historic sites, museums and memory initiatives that connects past struggles to today's movements for human rights. We turn memory into action" (https://www.sitesofconscience.org/).
6 When I visited, the only other people there were homeless.
7 However, many Black Tulsans argue that this kind of redevelopment of Greenwood, including the construction of Greenwood Rising, is primarily benefitting white business owners as Black owners and entrepreneurs are priced out of the neighborhood (e.g., Jan 2021).
8 Though the Centennial Commission argued that a historical center was needed in order to tell the full story, the Greenwood Cultural Center's focus is in fact telling the story of the race massacre using photographs, text panels, and some video. The exhibits are extremely outdated and very low-budget, with far too much text and no indication of where the material on display comes from. A rather poor-quality film, *The Tulsa Lynching of 1921*, was playing when I visited, and an employee/volunteer put out a few folding chairs for the two or three other visitors there. The tired, low-tech exhibits and lack of visitors are a sharp contrast with Greenwood Rising.
9 Holocaust museums are frequently evoked by Greenwood Rising leaders as models for museological reckoning with past atrocity, but Local Projects project director L'Rai Arthur-Mensah also compared Tulsa to South Africa when describing for me the necessity of this effort to come to terms with Tulsa's past violence (personal communication, 2022).
10 A $1.5-million state appropriation was requested by the Greenwood Cultural Center, but it ultimately went to Greenwood Rising (Human Rights Watch 2021).
11 Unlike the NMAAHC, the Greenwood Rising team did not appear to make an effort to find a Black architect. A quick look at the firm's "Who We Are" page suggests that it is an almost entirely white firm; see Narrate Design (n.d.-b).

160 • Notes to Pages 97–107

12 While the Jewish Museum Berlin is not technically a memorial museum, Daniel Libeskind's architecture has been deeply influential in other memorial and memorial museum projects, such as the National September 11 Memorial & Museum, where architecture that incorporates voids and "negative form" is increasingly common (e.g., Young 2016).

13 Greenwood Rising brought in a new executive director in January 2023 to replace Armstrong. The new executive director, Raymond Doswell, is a museum professional who served as vice-president for curatorial services at the Negro League Baseball Museum in Kansas City, Missouri, from 1995 to 2022.

14 This is very similar to the 9/11 Memorial Museum, which was also designed by Local Projects; though it was intended to emphasize individual memories and experiences of the day, the museum creates from those memories one overarching, hegemonic national memory of 9/11 (e.g., Sodaro 2018).

15 A pair of letters that displays this spirit is reproduced on the wall and is also part of the prologue to Johnson's 1998 book *Black Wall Street: From Riot to Renaissance in Tulsa's Historic Greenwood District*. In them Curtis sends money to Oliver after the massacre so he can flee Tulsa and come to Chicago. Oliver politely declines the offer, writing: "True it is, we are facing a terrible situation. . . . They have destroyed our homes; they have wrecked our schools; they have reduced our churches to ashes and they have murdered our people, Curtis; but they have not touched our spirit. And while I speak only for myself, let it be said that I came here and built my fortune with the SPIRIT, I shall reconstruct it here with that SPIRIT, and I expect to live on and die here with it" (Johnson 1998, viii–ix).

16 In urban centers all over the country, throughout the 1960s and 1970s and under the purview of the Federal-Aid Highway Act, interstate highways were constructed to provide access to the (mostly white) suburbs, many of which carved up mostly Black and minority neighborhoods. The government used eminent domain to remove people from these neighborhoods to make space for the highways.

17 The Commitment Wall calls to mind similar displays at other memorial museums and sites, such as Montgomery's Civil Rights Memorial Center's Wall of Justice, which projects the names of visitors who commit to working for justice, or the USHMM's "From Memory to Action" exhibit, which invited visitors to write a pledge to take action against injustice on a card, which was then projected on a wall. Lower-tech examples of this also abound, such as the NMAAHC's "Reconstruction" exhibit, which offered visitors cards on which to write and pin up their ideas about how to reconstruct America, or New York's African Burial Ground, which gives visitors Post-it notes on which to respond to the memorial and exhibits. Many respond with their own commitments to never forget and work toward racial justice.

18 In 2001, the Tulsa Reparations Coalition sued the city of Tulsa for "restitution and repair," but the case was dismissed based on Oklahoma's two-year statute of limitations for civil actions (Human Rights Watch 2020). A second lawsuit was filed in fall 2021, this time under the public nuisance statute and the three remaining survivors, together with descendants and advocates in the fight, testified before Congress in 2021. The lawsuit was dismissed in 2023, though the dismissal has been appealed and the case will go before the Oklahoma Supreme Court.

19 There are but a handful of examples of reparations paid in the United States, including those paid to Japanese Americans interred during World War II; payments for property damage for survivors of the Rosewood, Florida, race

Notes to Pages 107–140 • 161

massacre; and local initiatives like that in Evanston, Illinois, which offers housing grants to families discriminated against in the housing market.

20 A recent poll found two-thirds of Americans and almost 90 percent of Republicans oppose reparations (J. Sharpe 2021).

21 According to the museum's website, the "frivolous litigation" is based on "the false assertion that Greenwood Rising and the City of Tulsa are one and the same" (Greenwood Rising n.d.-e).

Chapter 5 America's New Memorial Museums

Excerpts from this chapter appeared in "'Feeling Truth': Objects, Embodiment and Temporality in the National Museum of African American History and Culture and the Legacy Museum," in *Museums, Narratives, and Critical Histories: Narrating the Past for Present and Future*, ed. Stephan Jaeger and Kerstin Barndt (Berlin: De Gruyter, 2024), 25–44.

1 Unfortunately, this control extends to academics like me trying to get information from EJI about the creation of the museum.

2 The plaques are highly reminiscent of the *Stolpersteine* (stumbling stones) that are scattered throughout Germany and Europe as constant reminders of the Holocaust's heavy toll.

Conclusion

1 Conducting research on visitor experiences is notoriously difficult. Many museums don't allow outside researchers to do such work (such as the Legacy Museum); others conduct their own research, but don't share it with academic researchers (Greenwood Rising has an optional visitor survey but did not respond to me when I asked if they would share the results). Rigorous visitor research, which would include lengthy interviews and even longitudinal follow up, is very resource intensive and so prohibitive for many museums scholars, including myself.

2 TripAdvisor (2023) touts itself as "the world's largest travel guidance platform" that has over 1 billion reviews and is viewed by hundreds of millions of people each month. As of mid-2024, the NMAAHC has over 3,700 TripAdvisor reviews, the Legacy Museum has just over 500, and Greenwood Rising has a mere 49. For the purpose of this brief and not overly systematic review, I have read approximately 200 reviews each for the NMAAHC and Legacy Museum (about a third pre-pandemic and the rest more recent reviews after the museums reopened, and I focused on visitors who list a U.S. location) and all of those of Greenwood Rising. I also conducted some specific keyword searches to get at particular issues raised in reviews and read all of the (relatively few) reviews giving the museums under 3 stars.

3 This is clearly this particular reviewer's perspective; while the museum does not make public any demographic information about visitors, from my own experience the racial make-up of visitors was much more balanced and perhaps skewing more toward white visitors.

4 Though some qualify it as the best historical or civil rights museums they have visited.

5 Several widely cited surveys of U.S. museum visitors found that for the majority of those surveyed, museums were considered to be one of the most trustworthy sources of historical information (IMPACTS Experience 2017; Merritt 2021). More recently, even as trust has diminished among the U.S. public in many spheres of society, like politics and media, a recent survey by the American Alliance of Museums found that museums ranked 6.4 on a scale of 1 to 10 for trustworthiness, above the U.S. government (4.5), national news organizations like NPR and the *New York Times* (4.8), nonprofits and nongovernmental organizations (5.3), and researchers or scientists (6.1) (Merritt 2021).

References

Adams, Char. 2021. "Evanston Is the First U.S. City to Issue Slavery Reparations. Experts Say It's a Noble Start." NBC News, March 26, 2021. https://www.nbcnews.com/news/nbcblk/evanston-s-reparations-plan-noble-start-complicated-process-experts-say-n1262096.

Adams, Tim. 2015. "Bryan Stevenson: America's Nelson Mandela." *Guardian*, February 1, 2015. https://www.theguardian.com/us-news/2015/feb/01/bryan-stevenson-americas-mandela.

Aimery, Jakkar. 2023. "Charles H. Wright Museum of African American History Nets $1.8M for Renovations." *Detroit News*, September 27, 2023. https://www.detroitnews.com/story/news/local/detroit-city/2023/09/27/detroits-wright-museum-african-american-history-renovations/70978795007/.

Albeck-Ripka, Livia. 2021. "3 Tulsa Massacre Survivors Receive $1 Million Donation." *New York Times*, May 19, 2021. https://www.nytimes.com/2022/05/19/us/tulsa-massacre-survivors-donation.html.

Alderman, Derek H., David L. Butler, and Stephen P. Hanna. 2016. "Memory, Slavery, and Plantation Museums: The River Road Project." *Journal of Heritage Tourism* 11, no. 3: 209–218.

American Alliance of Museums. 2022. "Museum Field Experiencing Compounding Financial Losses, New Survey Reveals." Press release, February 8, 2022. https://www.aam-us.org/2022/02/08/museum-field-experiencing-compounding-financial-losses-new-survey-reveals/.

Amsden, David. 2015. "Building the First Slavery Museum in America." *New York Times*, February 26, 2015. https://www.nytimes.com/2015/03/01/magazine/building-the-first-slave-museum-in-america.html.

Andermann, Jens, and Silke Arnold-de Simine. 2012. "Introduction: Memory, Community and the New Museum." *Theory, Culture & Society* 29, no. 1: 3–13.

Anderson, Benedict. 1991. *Imagined Communities: Reflections on the Origin and Spread of Nationalism*. New York: Verso.

Angeleti, Gabriela. 2024. "Valongo Wharf—Historic Hub of Brazil's Slave Trade—Opens Following Overdue $400,000 Renovation." *The Art Newspaper*, January 2, 2024. https://www.theartnewspaper.com/2024/01/02/valongo-wharfhistoric-hub-of-brazils-slave-tradeopens-to-the-public-following-overdue-400000-renovation.

164 • References

Apel, Dora. 2001. "Images of Black History." *Dissent*, Summer 2001. https://www.dissentmagazine.org/article/images-of-black-history/.

Apsel, Joyce. 2019. "'Inspiration Lives Here': Struggle, Martyrdom and Redemption in Atlanta's National Center for Civil and Human Rights." In *Museums and Sites of Persuasion: Politics, Memory and Human Rights*, edited by Joyce Apsel and Amy Sodaro, 91–115. Abingdon, UK: Routledge.

Araujo, Ana Lucia. 2018. "Tourism and Heritage Sites of the Atlantic Slave Trade and Slavery." In *A Companion to Public History*, edited by David Dean, 277–288. Hoboken, NJ: John Wiley and Sons.

Araujo, Ana Lucia. 2020. *Slavery in the Age of Memory: Engaging the Past*. New York: Bloomsbury.

Araujo, Ana Lucia. 2021. *Museums and Atlantic Slavery*. New York: Routledge.

Araujo, Ana Lucia. 2023. "Slavery." In *The Handbook of Memory Activism*, edited by Yifat Gutman and Jenny Wüstenberg, 196–201. New York: Routledge.

Architizer. 2022. "Local Projects Construct Immersive Remembrance Journey: Greenwood Rising." *Architizer Blog*, 2022. https://architizer.com/blog/practice/details/greenwood-rising/.

Armstrong, Philip. 2021. "Museum Confidential" (podcast interview). Tulsa Public Radio, June 25, 2021. https://museumconfidential.libsyn.com/greenwood-rising.

Arnold-de Simine, Silke. 2012. "The 'Moving' Image: Empathy and Projection in the International Slavery Museum, Liverpool." *Journal of Educational Media, Memory, and Society* 4, no. 2: 23–40.

Arnold-de-Simine, Silke. 2013. *Mediating Memory in the Museum: Trauma, Empathy, Nostalgia*. Cham, Switzerland: Palgrave Macmillan.

Arthur-Mensah, L'Rai, and Philip Armstrong. 2021. "Humanizing History: Greenwood Rising Case Study." Keynote presented at SEGD Exhibition + Experience Design, Washington, DC, August 5, 2021.

Assmann, Aleida. 2020. *Is Time Out of Joint? On the Rise and Fall of the Modern Time Regime*. Translated by S. Clift. Ithaca, NY: Cornell University Press.

Atlanta Downtown. 2009. "Award-Winning Director George C. Wolfe Named Chief Creative Officer for Atlanta's Center for Civil & Human Rights." Pressroom, June 9, 2009. https://www.atlantadowntown.com/article/award-winning-director-george-c-wolfe-named-chief-creative-officer-for-atlantas-center-for-civil-and-human-rights.

Autry, Robyn. 2013. "The Political Economy of Memory: The Challenges of Representing National Conflict at 'Identity-Driven' Museums." *Theory and Society* 42, no. 1: 57–80.

Autry, Robyn. 2017. *Desegregating the Past: The Public Life of Memory in the United States and South Africa*. New York: Columbia University Press.

Bach, Jonathan. 2019. "Colonial Pasts in Germany's Present." *German Politics and Society* 37, no. 4: 58–73.

Bailey, Dina. 2019. "The Activist Spectrum in United States Museums." In *Museum Activism*, edited by Robert R. Janes and Richard Sandell, 293–303. New York: Routledge.

Bennett, Tony. 1999. "The Exhibitionary Complex." In *Representing the Nation: A Reader*, edited by David Boswell and Jessica Evans, 332–361. New York: Routledge.

Berg, Nate. 2023. "A New Museum about America's History of Slavery Reclaims One of the Nation's Most Sacred Grounds." *Fast Company*, June 27, 2023. https://www.fastcompany.com/90915092/international-african-american-museum-history-slavery.

Berlin, Ira. 2004. "American Slavery in History and Memory and the Search for Social Justice." *Journal of American History* 90, no. 4: 1251–1268.

"Best New Attraction of 2021? SkyFly: Soar America." 2022. *USA Today 10Best*, January 1, 2022. https://10best.usatoday.com/awards/travel/best-new-attraction-2022/.

Bevernage, Berber. 2015. "The Past Is Evil/Evil Is Past: On Retrospective Politics, Philosophy of History, and Temporal Manichaeism." *History and Theory* 54, no 3: 333–352.

Blight, David. 2002. *Race and Reunion: The Civil War in American Memory*. Cambridge, MA: Harvard University Press.

Blustein, Jeffrey. 2008. *The Moral Demands of Memory*. New York: Cambridge University Press.

Bonilla-Silva, Eduardo. 2015. "Getting Over the Obama Hope Hangover: The New Racism in 'Post-Racial' America." In *Theories of Race and Ethnicity: Contemporary Debates and Perspectives*, edited by Karim Murji and John Solomos, 57–73. Cambridge: Cambridge University Press.

Brand, Anna Livia, Joshua F. Inwood, and Derek Alderman. 2022. "Truth-Telling and Memory-Work in Montgomery's Co-Constituted Landscapes." *ACME: An International Journal for Critical Geographies* 21, no. 5: 468–483.

Bronin, Sara. 2020. "How to Fix a National Register of Historic Places That Reflects Mostly White History." *Los Angeles Times*, December 15, 2020. https://www.latimes.com/opinion/story/2020-12-15/historic-preservation-chicano-moratorium-national-register.

Bronner, Fred, and Robert de Hoog. 2011. "Vacationers and eWOM: Who Posts, and Why, Where, and What?" *Journal of Travel Research* 50, no. 1: 15–26.

Brooks, Robert, and Alan H. Witten. 2001. "The Investigation of Potential Mass Grave Locations for the Tulsa Race Riot." In *Tulsa Race Riot: A Report by the Oklahoma Commission to Study the Tulsa Race Riot of 1921*, 123. https://www.okhistory.org/research/forms/freport.pdf.

Brooms, Derrick R. 2012. "Lest We Forget: Exhibiting (and Remembering) Slavery in African-American Museums." *Journal of African American Studies* 15, no. 4: 508–523.

Brown, Vincent. 2009. "Social Death and Political Life in the Study of Slavery." *American Historical Review* 114, no. 5: 1231–1249.

Buckley-Zistel, Susanne, and Timothy Williams. 2020. "A 5* Destination: The Creation of New Transnational Moral Spaces of Remembrance on TripAdvisor." *International Journal of Politics, Culture, and Society* 30: 221–238.

Bunch, Lonnie. 2019. *A Fool's Errand: Creating the National Museum of African American History and Culture in the Age of Bush, Obama, and Trump*. Washington, DC: Smithsonian Books.

Bunch, Lonnie. 2023. "Reflections from a Dutch National Reckoning." *Smithsonian Magazine*, November 17, 2023. https://www.smithsonianmag.com/blogs/office-of-the-secretary-of-the-smithsonian/2023/11/17/reflections-from-a-dutch-national-reckoning/.

Burch, Audra D. S., and Luke Vander Ploeg. 2022. "Buffalo Shooting Highlights Rise of Hate Crimes against Black Americans." *New York Times*, May 16, 2022. https://www.nytimes.com/2022/05/16/us/hate-crimes-black-african-americans.html.

Burns, Andrea. 2013. *From Storefront to Monument: Tracing the Public History of the Black Museum Movement*. Amherst: University of Massachusetts Press.

166 • References

Butler, David L. 2001. "Whitewashing Plantations: The Commodification of a Slave-Free Antebellum South." *International Journal of Hospitality & Tourism Administration* 2, nos. 3–4: 163–175.

Butler, Tyler. 2023. "Greenwood Rising, City, 1921 Commission Facing Lawsuit from Descendent of Massacre Victim." Tulsa News Channel 8, January 25, 2023. https://ktul.com/news/local/greenwood-rising-city-1921-commission-facing -lawsuit-from-descendent-of-massacre-victim.

Cape Fear Museum. n.d. "Wilmington Massacre and Coup d'état of 1898—Timeline of Events." https://nhcgov.maps.arcgis.com/apps/MapJournal/index.html?appid =5a4f5757e4904fb8bef6db842c1ff7c3.

Carbonell, Bettina Messias. 2023. *Consequential Museum Spaces: Representing African American History and Culture*. Lanham, MD: Lexington Books.

Cascone, Sarah. 2022. "Artist Paul Rucker Has Received $2 Million in Grants to Open a Permanent Museum about the History of Racism in the U.S." *ArtNet News*, November 15, 2022. https://news.artnet.com/art-world/paul-rucker-cary -forward-mellon-grant-2138982,

Casey, Valerie. 2005. "Staging Meaning: Performance in the Modern Museum." *TDR/ The Drama Review* 49, no. 3: 78–95.

Catlin, Roger. 2015. "Smithsonian to Receive Artifacts from Sunken 18th-Century Slave Ship." *Smithsonian Magazine*, March 31, 2015. https://www.smithsonianmag .com/smithsonian-institution/sunken-18th-century-slave-ship-found-south-africa -180955458/.

CCS Fundraising. n.d. "National Museum of African American History and Culture." Accessed July 13, 2023. https://www.ccsfundraising.com/case-studies/national -museum-of-african-american-history-and-culture/.

Center for Arkansas History and Culture. 2019. "Elaine Race Massacre." University of Arkansas. https://ualrexhibits.org/elaine/.

Churchwell, T. D. "Pete." 2001. "Preface: Skeleton out of the Closet." In *Tulsa Race Riot: A Report by the Oklahoma Commission to Study the Tulsa Race Riot of 1921*, v–vi. https://www.okhistory.org/research/forms/freport.pdf.

City of Montgomery. n.d. "Downtown Revitalization." Accessed May 4, 2024. https://www.montgomeryal.gov/government/city-government/city-departments /community-development/development-division/downtown-revitalization.

Conn, Steve. 2010. *Do Museums Still Need Objects?* Philadelphia: University of Pennsylvania Press.

Cotter, Holland. 2016. "The Smithsonian African American Museum Is Here at Last. And It Uplifts and Upsets." *New York Times*, September 15, 2016. https://www .nytimes.com/2016/09/22/arts/design/smithsonian-african-american-museum -review.html.

Cotter, Holland. 2017. "The New Mississippi Civil Rights Museum Refuses to Sugarcoat History." *New York Times*, December 18, 2017. https://www.nytimes .com/2017/12/18/arts/design/jackson-mississippi-civil-rights-museum-medgar -evers.html.

Cotter, Holland. 2021. "Greenwood Rising Links Tulsa's Tragic History to Today's Struggles." *New York Times*, June 3, 2021. https://www.nytimes.com/2021/06/03/arts /design/greenwood-rising-museum-tulsa-history-.html?searchResultPosition=2.

Cotter, Holland. 2023. "In Charleston, a Museum Honors a Journey of Grief and Grace." *New York Times*, June 12, 2023. https://www.nytimes.com/2023/06/23/arts /design/charleston-african-american-museum.html.

Cox, Karen. 2021. *No Common Ground: Confederate Monuments and the Ongoing Fight for Racial Justice*. Durham, NC: University of North Carolina Press.

Cronin, Joseph. 2022. "Germany's Holocaust Memory Problems." *SFS: Georgetown Journal of International Affairs*, April 20, 2022. https://gjia.georgetown.edu/2022/04/20/germanys-holocaust-memory-problems%EF%BF%BC/.

Crowe, Kweku Larry, and Tabathi Lewis. 2021. "The 1921 Tulsa Massacre: What Happened to Black Wall Street." *Humanities* 42, no. 1 (Winter 2021). https://www.neh.gov/preview-link/node/29441/20e3c6b7-ad28-49d6-9207-ee810e3c2357.

Crowley, Michael, and Jennifer Schuessler. 2021. "Trump's 1776 Commission Critiques Liberalism in Report Derided by Historians." *New York Times*, January 18, 2021. https://www.nytimes.com/2021/01/18/us/politics/trump-1776-commission-report.html.

Cummings, John Jay III. 2015. "The U.S. Has 35,000 Museums. Why Is Only One about Slavery?" *Washington Post*, August 14, 2015. https://www.washingtonpost.com/opinions/the-us-has-35000-museums-why-is-only-one-about-slavery/2015/08/14/91d75f54-4138-11e5-846d-02792f854297_story.html.

Dafoe, Taylor. 2018. "A First Look inside the New Alabama Museum Boldly Confronting Slavery and Its Brutal Legacy." *Artnet*, April 25, 2018. https://news.artnet.com/art-world/legacy-museum-memorial-peace-justice-1272686.

David, Lea. 2020. *The Past Can't Heal Us: The Dangers of Mandating Memory in the Name of Human Rights*. Cambridge: Cambridge University Press.

de Almeida, Juniele Rabêlo, and Larissa Moreira Viana. 2018. "Public History in Movement. Present Pasts: The Memory of Slavery in Brazil." *International Public History* 1, no. 1. https://www.degruyter.com/document/doi/10.1515/iph-2018-0008/html.

de Certeau, Michel. 1988. *The Practice of Everyday Life*. Los Angeles: University of California Press.

de Jong, Steffi. 2018. *The Witness as Object: Video Testimony in Memorial Museums*. New York: Berghahn Books.

Domby, Adam. 2020. *The False Cause: Fraud, Fabrication, and White Supremacy in Confederate Memory*. Charlottesville: University of Virginia Press.

Doss, Erica. 2010. *Memorial Mania: Public Feeling in America*. Chicago: University of Chicago Press.

Douglass, Frederick. 1881. "The Color Line." *The North American Review* 132, no. 295: 567–577.

Duke University. 2021. "Oil and Blood: The Color of Wealth in Tulsa, Oklahoma." Samuel DuBois Cook Center on Social Equity. https://socialequity.duke.edu/portfolio-item/oil-and-blood-the-color-of-wealth-in-tulsa-oklahoma/.

Duncan, Carol. 1991. "The Art Museum as a Ritual of Citizenship." In *Exhibiting Cultures: The Poetics and Politics of Museum Display*, edited by Ivan Karp and Steven D. Lavine, 88–103. Washington, DC: Smithsonian Institution Press.

Dwyer, Owen J., and Derek H. Alderman. 2008. *Civil Rights Memorials and the Geography of Memory*. Chicago: Center for American Places at Columbia College.

Eichsted, Jennifer L., and Stephen Small. 2002. *Representations of Slavery: Race and Ideology in Southern Plantation Museums*. Washington, DC: Smithsonian University Press.

Ellsworth, Scott. 1992. *Death in a Promised Land: The Tulsa Race Riot of 1921*. Baton Rouge: Louisiana State University Press.

168 • References

Ellsworth, Scott. 2021. *The Ground Breaking: The Tulsa Race Massacre and an American City's Search for Justice.* New York: Dutton.

Enck-Wanzer, Darrel. 2011. "Barack Obama, the Tea Party, and the Threat of Race: On Racial Neoliberalism and Born Again Racism." *Communication, Culture and Critique* 4, no. 1: 23–30.

Equal Justice Initiative (EJI). 2018. *Slavery in America: The Montgomery Slave Trade.* https://eji.org/wp-content/uploads/2020/08/slavery_report-08-20-20-web.pdf.

Equal Justice Initiative (EJI). 2021. *Annual Report.* https://eji.org/wp-content/uploads/2005/11/eji-audited-financials-2021.pdf.

Equal Justice Initiative (EJI). 2022. "Alabama Tourism's 2022 Attraction of the Year." December 1, 2022. https://eji.org/news/ejis-new-legacy-museum-named-alabama-tourisms-2022-attraction-of-the-year/.

Equal Justice Initiative (EJI). n.d.-a. "About EJI." Accessed May 5, 2024. https://eji.org/about/.

Equal Justice Initiative (EJI). n.d.-b. "Freedom Monument Sculpture Park." Accessed January 10, 2024. https://legacysites.eji.org/about/monument/.

Equal Justice Initiative (EJI). n.d.-c. "The Legacy Museum: From Enslavement to Mass Incarceration." Accessed September 20, 2022. https://web.archive.org/web/20220920104516/https://museumandmemorial.eji.org/museum.

Equality Justice Initiative (EJI). n.d.-d. "Lynching in America." Accessed November 3, 2022. https://lynchinginamerica.eji.org/explore.

Equal Justice Initiative (EJI). n.d.-e. "The National Memorial for Peace and Justice." Accessed December 31, 2022. https://web.archive.org/web/20221231175549/https://museumandmemorial.eji.org/memorial.

Erll, Astrid. 2011. "Travelling Memory." *Parallax* 17, no. 4: 4–18.

Fabre, Geneviève, and Robert O'Meally, eds. 1994. *History and Memory in African-American Culture.* New York: Oxford University Press.

Felman, Shoshana. 1992. "The Return of the Voice: Claude Lanzmann's Shoah." In *Testimony: Crises of Witnessing in Literature, Psychoanalysis and History*, edited by Shoshana Felman and Dori Laub, 204–283. New York: Routledge.

Fischer, Marc. 1995. "Library of Congress Scraps Plantation Life Exhibit." *Washington Post*, December 20, 1995. https://www.washingtonpost.com/archive/politics/1995/12/20/library-of-congress-scraps-plantation-life-exhibit/997eb8ef-cc91-4aa9-b056-2505c92aa763/.

Flatbush African Burial Ground Coalition. n.d. "What's to Come." Accessed January 9, 2024. https://www.flatbushafricanburialground.org/future.

Foundation for the Remembrance of Slavery. n.d. "Our History." Accessed January 18, 2023. https://memoire-esclavage.org/en/our-history.

Frohne, Andrea E. 2015. *The African Burial Ground in New York City: Memory, Spirituality, and Space.* Syracuse, NY: Syracuse University Press.

Frosh, Paul. 2018. "The Mouse, the Screen and the Holocaust Witness: Interface Aesthetics and Moral Response." *New Media & Society* 20, no. 1: 351–368.

Gardullo, Paul, and Lonnie G. Bunch. 2017. "Making a Way Out of No Way: The National Museum of African American History and Culture." *History Workshop Journal* 84, no. 1: 248–256.

Gayle, Caleb. 2021. "100 Years after the Tulsa Massacre, What Does Justice Look Like?" *New York Times*, May 25, 2021. https://www.nytimes.com/2021/05/25/magazine/tulsa-race-massacre-1921-greenwood.html.

Glymph, Thavolia. 2003. "'Liberty Dearly Bought': The Making of Civil War Memory in African American Communities in the South." In *Time Longer Than Rope: A Century of African American Activism*, edited by Charles M. Payne and Adam Green, 111–140. New York: New York University Press.

Greenlee, Cynthia R. 2023. "'I'm Here to See the Truth Is Being Told': Inside Charleston's Museum of Black History." *Guardian*, July 9. 2023. https://www.theguardian.com/us-news/2023/jul/09/charleston-museum-black-history.

Greenwood Rising. n.d.-a. "About." Accessed May 5, 2024. https://www.greenwoodrising.org/about.

Greenwood Rising. n.d.-b. "Experience Greenwood." Accessed May 5, 2024. https://www.greenwoodrising.org/experience.

Greenwood Rising. n.d.-c. "Frequently Asked Questions." Accessed May 5, 2024. https://www.greenwoodrising.org/faqs.

Greenwood Rising. n.d.-d. "Pathway to Hope." Accessed May 5, 2024. https://www.greenwoodrising.org/pathway-to-hope.

Greenwood Rising. n.d.-e. "Why Has Greenwood Rising Been Repeatedly Sued by SolomonSimmonsLaw, Led by Damario Solomon-Simmons ('DSS')?" Accessed November 12, 2023. https://web.archive.org/web/20231112082907/https://www.greenwoodrising.org/faqs/#faqs-question-4.

Grigsby Bates, Karen, presenter. 2021. "The Neighborhood of the Tulsa Race Massacre Faces Increasing Gentrification." *All Things Considered*. Aired June 1, 2021, on NPR. https://www.npr.org/2021/06/01/1002219096/the-neighborhood-of-the-tulsa-race-massacre-faces-increasing-gentrification.

Gruenewald, Tim. 2021. "Progress versus Social Justice: Memory at the National Museum of African American History and Culture." *Journal of American Culture* 44, no. 2: 116–129.

Halbwachs, Maurice. 1992. *On Collective Memory*. Translated, edited, and with an introduction by Lewis A. Coser. Chicago: University of Chicago Press.

Hampton, Deon J. 2021. "Tulsa 'Remember and Rise' Event Canceled Days before Centennial of Race Massacre after Dispute over Payment to Survivors." NBC News, May 28, 2021. https://www.nbcnews.com/news/us-news/tulsa-remember-rise-event-canceled-days-centennial-race-massacre-n1269028.

Hanna, Stephen P. 2008. "A Slavery Museum? Race, Memory, and Landscape in Fredericksburg, Virginia." *Southeastern Geographer* 48, no. 3: 316–337.

Harris, Leslie M. 2020. "Higher Education's Reckoning with Slavery." *American Association of University Professors Academe* (Winter 2020). https://www.aaup.org/article/higher-education%E2%80%99s-reckoning-slavery#.Y72fpoTMKUl.

Hartman, Saidiya. 2006. *Lose Your Mother: A Journey along the Atlantic Slave Route*. New York: Farrar, Strauss and Giroux.

Harvard Radcliffe Institute. 2022. "Ruth J. Simmons | Morning Keynote || Harvard & the Legacy of Slavery." YouTube video, 1:09: 43. May 12, 2022. https://www.youtube.com/watch?v=OGXDQ2_3OBM&t=6s.

Hawthorne, Christopher. 2016. "D.C.'s New African American Museum Is a Bold Challenge to Traditional Washington Architecture." *Los Angeles Times*, September 16, 2016. https://www.latimes.com/entertainment/arts/la-et-cm-nmaahc-architecture-review-20160913-snap-htmlstory.html.

Hayward, Jeff, and Christine Larouche. 2018. "The Emergence of the Field of African American Museums." *The Public Historian* 40, no. 3: 163–172.

Hemeon, Jacinda. 2021. "'This Issue Isn't Dead': Tulsa Race Massacre Lawsuit Seeks Reparations for Emotional, Physical Damages." *OU Daily*, April 9, 2021. https://www.oudaily.com/crimson_quarterly/this-issue-isn-t-dead-tulsa-race-massacre-lawsuit-seeks-reparations-for-emotional-physical-damages/article_59407342-93df-11eb-b5ff-7f04f2eb8bb5.html.

Hennig-Thurau, Thorsten, Kevin P. Gwinner, Gianfranco Walsh, and Dwayne D. Gremler. 2004. "Electronic Word-of-Mouth via Consumer-Opinion Platforms: What Motivates Consumers to Articulate Themselves on the Internet?" *Journal of Interactive Marketing* 18, no. 1: 38–52.

Hill, Karlos K. 2021. "Community-Engaged History: A Reflection on the 100th Anniversary of the 1921 Tulsa Race Massacre." *American Historical Review* 126, no. 2 (June 2021): 670–684.

Horton, James Oliver. 1999. "Presenting Slavery: The Perils of Telling America's Racial Story." *The Public Historian* 21, no. 4: 19–38.

Horton, James Oliver. 2006. "Slavery in American History: An Uncomfortable National Dialogue." In *Slavery and Public History: The Tough Stuff of American Memory*, edited by James Oliver Horton and Lois E. Horton, 35–56. New York: New Press.

Horton, James Oliver, and Lois E. Horton, eds. 2006. *Slavery and Public History: The Tough Stuff of American Memory*. New York: New Press.

Hudson, Michael. 2017. *Ghosts, Landscapes and Social Memory*. London: Routledge.

Hulser, Kathleen. 2012. "Exhibiting Slavery at the New-York Historical Society." In *Politics of Memory: Making Slavery Visible in the Public Space*, edited by Ana Lucia Araujo, 232–251. New York: Routledge.

Human Rights Watch. 2020. "The Case for Reparations in Tulsa, Oklahoma." https://www.hrw.org/news/2020/05/29/case-reparations-tulsa-oklahoma.

Human Rights Watch. 2021. "Failed Justice 100 Years after Tulsa Race Massacre: Commission Alienates Survivors; State, City Should Urgently Ensure Reparations." May 21, 2021. https://www.hrw.org/news/2021/05/21/us-failed-justice-100-years-after-tulsa-race-massacre.

Huyssen, Andreas. 2003. *Present Pasts: Urban Palimpsests and the Politics of Memory*. Stanford, CA: Stanford University Press.

Huyssen, Andreas. 2011. "International Human Rights and the Politics of Memory: Limits and Challenges." *Criticism* 53, no. 4: 607–624.

Ifill, Sherrilyn A. 2018. *On the Courthouse Lawn: Confronting the Legacy of Lynching in the Twenty-First Century*. Rev. ed. Boston: Beacon Press.

IMPACTS Experience. 2017. "People Trust Museums More Than Newspapers: Here Is Why That Matters Right Now (DATA)." KYOB+. https://www.colleendilen.com/2017/04/26/people-trust-museums-more-than-newspapers-here-is-why-that-matters-right-now-data/.

International African American Museum (IAAM). 2023. "International African American Museum Opens to the Public," June 28, 2023. https://iaamuseum.org/news/international-african-american-museum-opens-to-the-public/.

International African American Museum (IAAM). n.d. "About IAAM." Accessed May 5, 2024. https://iaamuseum.org/about/.

Ionescu, Arleen. 2017. *The Memorial Ethics of Libeskind's Berlin Jewish Museum*. London: Palgrave Macmillan.

Jaeger, Stephan. 2023. "Visitor Emotions, Experientiality, Holocaust, and Human Rights: TripAdvisor Responses to the Topography of Terror (Berlin) and the

Kazerne Dossin (Mechelen)." In *Visitor Experience at Holocaust Memorials and Museums*, edited by Diana Popescu, 31–45. Abingdon, UK: Routledge.

Jamerson, Trevor. 2017. "Digital Orientalism: TripAdvisor and Online Travelers' Tales." In *Digital Sociologies*, edited by Jessie Daniels, Karen Gregory, and Tressie McMillan Cottom, 119–136. Chicago: Policy Press.

Jan, Tracy. 2021. "The 'Whitewashing' of Black Wall Street." *Washington Post*, January 21, 2021. https://www.washingtonpost.com/business/2021/01/17/tulsa -massacre-greenwood-black-wall-street-gentrification/.

Janes, Robert R., and Richard Sandell. 2019. *Museum Activism*. New York: Routledge.

Jim Crow Museum. 2023. "1965 Alabama Literacy Test." Accessed May 4, 2024. https://jimcrowmuseum.ferris.edu/pdfs-docs/origins/al_literacy.pdf.

Jinks, Rebecca. 2014. "Thinking Comparatively about Genocide Memorialization." *Journal of Genocide Research* 16, no. 4: 423–440.

John Hope Franklin Center for Reconciliation. n.d. "About the Center." Accessed May 5, 2024. https://www.jhfcenter.org/about-us.

Johnson, Hannibal. 1998. *Black Wall Street: From Riot to Renaissance in Tulsa's Historic Greenwood District*. Austin, TX: Eakin Press.

Johnson, Hannibal B. 2020. "Tulsa, Then and Now: Reflections on the Legacy of the 1921 Tulsa Race Massacre." *Great Plains Quarterly* 40, no. 3: 181–185.

Johnson, Wilbur. 2023. "Commentary: Why We Had to Build Charleston's Interna- tional African American Museum." *Post & Courier*, June 26, 2023. https://www .postandcourier.com/opinion/commentary/commentary-why-we-had-to-build -charlestons-international-african-american-museum/article_e94def36-143f-11ee -aa7d-1b102e1f462c.html.

Joseph, Peniel E. 2022. *The Third Reconstruction: America's Struggle for Racial Justice in the Twenty-first Century*. New York: Basic Books.

Justice for Greenwood (@Just4Greenwood). 2021. "Dear @GreenwoodRising: We don't want your Tulsa Race Massacre-themed Disneyland. Shiny buildings, museums and coffee shops won't make us forget how you and the City of Tulsa refuse to acknowledge the inherent anti-blackness Tulsa is built upon." Twitter, March 12, 2021. https://twitter.com/Just4Greenwood/status/137019090789140 4806.

Kelley, Thomas. 2017. "Maintaining Power by Manipulating Memory in Rwanda." *Fordham International Law Journal* 41, no. 1: 79–134.

Kendi, Ibram X. 2017. *Stamped from the Beginning: The Definitive History of Racist Ideas in America*. New York: Nation Books.

Kennicott, Philip. 2016. "The African American Museum Tells Powerful Stories—But Not as Powerfully as It Could." *Washington Post*, September 14, 2016. https://www .washingtonpost.com/entertainment/museums/the-african-american-museum -tells-powerful-stories--but-in-a-disjointed-way/2016/09/14/b7ba7e4c-7849-11e6 -bd86-b7bbd53d2b5d_story.html.

King, Steven A., and Roger Avis Gatchet. 2023. *Terror and Truth: Civil Rights Tourism and the Mississippi Movement*. Jackson: University of Mississippi Press.

Kompanek, Christopher. 2014. "George C. Wolfe: From 'The Colored Museum' to an Actual Museum." *American Theater*, November 2014. https://www.americantheatre .org/2014/10/21/george-c-wolfe-from-the-colored-museum-to-an-actual-museum/.

Krehbiel, Randy. 2019. "$9 Million Renovation snd Expansion of Greenwood Cultural Center Announced, Coincides with Tulsa Race Massacre Centennial." *Tulsa World*, May 10, 2019. https://tulsaworld.com/news/9-million-renovation-and

172 • References

-expansion-of-greenwood-cultural-center-announced-coincides-with-tulsa-race
-massacre/article_d41c8f41-a821-5ab7-a1b2-d64eca170292.html.

Kytle, Ethan J., and Blain Roberts. 2018. *Denmark Vesey's Garden: Slavery and Memory in the Cradle of the Confederacy*. New York: New Press.

Landsberg, Alison. 2004. *Prosthetic Memory: The Transformation of American Remembrance in the Age of Mass Culture*. New York: Columbia University Press.

Landsberg, Alison. 2007. "Response." *Rethinking History* 11, no. 4: 627–629.

Landsberg, Alison. 2018. "Post-Postracial America: On Westworld and the Smithsonian National Museum of African American History and Culture." *Cultural Politics* 14, no. 2: 198–215.

Landsberg, Alison. 2023. "Memory vs. History: The Politics of Temporality." In *The Handbook of Memory Activism*, edited by Yifat Gutman and Jenny Wüstenberg, 42–47. New York: Routledge.

Lawrence, Jeffrey. 2018. "Memorializing the Present: Montgomery's New Legacy Museum." *Los Angeles Review of Books*, November 18, 2018. https://lareviewofbooks .org/article/memorializing-the-present-montgomerys-new-legacy-museum/.

Lennon, John, and Malcolm Foley. 2000. *Dark Tourism: The Attraction of Death and Disaster*. London: Thompson Learning.

Levin, Samuel. 2018. "Lynching Memorial Leaves Some Quietly Seething: 'Let Sleeping Dogs Lie.'" *Guardian*, April 28, 2028. https://www.theguardian.com/us-news/2018 /apr/28/lynching-memorial-backlash-montgomery-alabama.

Levy, Daniel, and Natan Sznaider. 2010. *Human Rights and Memory*. University Park, PA: Pennsylvania State University Press.

Linenthal, Edward. 1995. *Preserving Memory: The Struggle to Create America's Holocaust Museum*. New York: Viking.

Linenthal, Edward. 2006. "Epilogue: Reflections." In *Slavery and Public History: The Tough Stuff of American Memory*, edited by James Oliver Horton and Lois E. Horton, 213–224. New York: New Press.

Linn-Tynen, Erin. 2020. "Reclaiming the Past as a Matter of Social Justice: African American Heritage, Representation and Identity in the United States." In *Critical Perspectives on Cultural Memory and Heritage: Construction, Transformation and Destruction*, edited by V. Apaydin, 255–268. London: UCL Press.

Local Projects. n.d. "Work." Accessed May 6, 2024. https://localprojects.com /work/.

Macdonald, Sharon. 2005. "Accessing Audiences: Visiting Visitor Books." *Museum and Society* 3, no. 3: 119–136.

Margalit, Avashai. 2004. *The Ethics of Memory*. Cambridge, MA: Harvard University Press.

Martin, Michel, presenter. 2021. "Museum Tracing Legacy of Slavery in America Marks Moment for 'Truth-Telling.'" *All Things Considered*. Aired October 3, 2021, on NPR. https://www.npr.org/2021/10/03/1042883036/museum-tracing-legacy-of -slavery-in-america-marks-moment-for-truth-telling.

MASS Design Group. n.d. "About." Accessed May 4, 2024. https://massdesigngroup .org/index.php/about.

Meister, Robert. 2012. *After Evil: A Politics of Human Rights*. New York: Columbia University Press.

Merritt, Elizabeth. 2021. "Exploring Museums and Trust 2021." American Alliance of Museums, October 5, 2021. https://www.aam-us.org/2021/10/05/exploring -museums-and-trust-2021/.

Messer, Chris M. 2021. *The 1921 Tulsa Race Massacre: Crafting a Legacy.* Cham, Switzerland: Palgrave Macmillan.

Micieli-Voutsinas, Jacque. 2021. *Affective Heritage and the Politics of Memory after 9/11: Curating Trauma at the Memorial Museum.* New York: Routledge.

Modlin, E. Arnold, Jr. 2008. "Tales Told on the Tour: Mythic Representations of Slavery by Docents at North Carolina Plantation Museums." *Southeastern Geographer* 48, no. 3: 265–287.

Morrison, Toni. 1989 (2008). "A Bench by the Road." *The World*, January–February 1989 (reprinted in 2008). https://www.uuworld.org/articles/bench-road.

Morrow, Paul, Leora Kahn, Joel R. Pruce, Calinda Lee, and Migiwa Orimo. 2021. "The Potential for Visualizing Advocacy." Panel discussion at the Social Practice of Human Rights Conference, Human Rights Center at the University of Dayton, Dayton, OH, December 2, 2021.

Moselle, Aaron. 2022. "Philly's African American Museum Moving to the Ben Franklin Parkway." *WHYY*, August 11, 2022. https://whyy.org/articles/philadelphia-african-american-museum-ben-franklin-parkway-family-court-building/.

Munar, Ana María, and Can-Seng Ooi. 2012. "The Truth of the Crowds." In *The Cultural Moment in Tourism*, edited by Laurajane Smith, Emma Waterton, and Steve Watson, 255–273. New York: Routledge.

Narrate Design. n.d.-a. "Greenwood Rising Project Update." Accessed May 6, 2024. https://narratedesign.com/greenwood-rising-project-update-details/.

Narrate Design. n.d.-b. "Who We Are." Accessed May 6, 2024. https://narratedesign.com/who-we-are/.

National Archives. 2022. "Dawes Records of the Five Civilized Tribes: Cherokee, Chickasaw, Choctaw, Creek, and Seminole Tribes in Oklahoma." Accessed August 23, 2022. https://www.archives.gov/research/native-americans/dawes/background.html.

National Center for Civil and Human Rights (NCCHR). 2022. "NCCHR Groundbreaking: Center Breaks Ground on Multi-Wing Expansion, Announces Team Leading Design and Construction." October 20, 2022. https://www.civilandhumanrights.org/ncchr-groundbreaking/.

National Center for Civil and Human Rights (NCCHR). n.d. "About the Center." Accessed May 6, 2024. https://www.civilandhumanrights.org/about-the-center/.

National Museum of African American History and Culture (NMAAHC). n.d.-a. "About the Museum." Accessed May 6, 2024. https://nmaahc.si.edu/about/about-museum.

National Museum of African American History and Culture (NMAAHC). n.d.-b. "The Building." Accessed May 6, 2024. https://nmaahc.si.edu/explore/building.

National Museum of African American History and Culture (NMAAHC). n.d.-c. "Sweet Home Café." Accessed May 6, 2024. https://nmaahc.si.edu/visit/sweet-home-cafe.

National Urban League. 2024. "National Urban League's Innovative Urban Civil Rights Museum Will Bring Little-Examined Corners of History to Light." January 3, 2024. https://nul.org/news/national-urban-leagues-innovative-urban-civil-rights-museum-will-bring-little-examined-corners.

Neiman, Susan. 2019. *Learning from the Germans: Race and the Memory of Evil.* New York: Farrar, Strauss and Giroux.

Newkirk, Vann R. 2016. "How a Museum Reckons with Black Pain." *The Atlantic*, September 23, 2016. https://www.theatlantic.com/entertainment/archive/2016/09/national-museum-of-african-american-history-and-culture-smithsonian/501356/.

New York Times. 2019. "The 1619 Project." *New York Times Magazine*, August 14, 2019. https://www.nytimes.com/interactive/2019/08/14/magazine/1619-america-slavery.html.

Nora, Pierre. 1989. "Between Memory and History: Les Lieux de Mémoire." *Representations*, no. 26: 7–24.

Oklahoma Commission to Study the Tulsa Race Riot of 1921. 2001. *Tulsa Race Riot.* https://www.okhistory.org/research/forms/freport.pdf.

Olick, Jeffrey. 2007. *The Politics of Regret: On Collective Memory and Historical Responsibility.* New York: Routledge.

Ostow, Robin. 2019. "Negritude, Americanization and Human Rights in Gorée, Senegal: The Maison de Esclaves 1966–2019." *International Journal of Francophone Studies* 22, nos. 3–4: 271–297.

Ostow, Robin. 2020. "The Museum as a Model for a Human Rights-Based Future: The International Slavery Museum, Liverpool, UK." *Journal of Human Rights Practice* 12, no. 3: 620–641.

Ostow, Robin. 2024. *Curating Human Rights.* Abingdon, UK: Routledge.

Pape, Robert. 2021. "What an Analysis of 377 Americans Arrested or Charged in the Capitol Insurrection Tells Us." *Washington Post*, April 6, 2021. https://www.washingtonpost.com/opinions/2021/04/06/capitol-insurrection-arrests-cpost-analysis/.

Patterson, Orlando. 2018. *Slavery and Social Death: A Comparative Study.* Cambridge, MA: Harvard University Press.

Pearl, Mike. 2015. "Why Are Some People Saying Dylan Roof Was Given Special Treatment When He Was Arrested?" *Vice*, June 23, 2015. https://www.vice.com/en/article/4wbnzd/why-are-some-people-saying-dylann-roof-was-given-special-treatment-when-he-was-arrested-623.

Perry, Andre M., Anthony Barr, and Carl Romer. 2021. "The True Costs of the Tulsa Race Massacre, 100 Years Later" Brookings, May 28, 2021. https://www.brookings.edu/research/the-true-costs-of-the-tulsa-race-massacre-100-years-later/.

Phillips, Maya. 2019. "The Smithsonian's Black-History Museum Will Always Be a Failure and a Success." *New Yorker*, October 24, 2019. https://www.newyorker.com/culture/cultural-comment/the-smithsonians-black-history-museum-will-always-be-a-failure-and-a-success.

Pierce, Lori, and Kaily Heitz. 2020. "Say Their Names." *American Quarterly* 72, no. 4: 961–977.

Pogrebin, Robin, and Alex Marshall. 2023. "Studio Museum in Harlem and Other Clients Cut Ties to David Adjaye." *New York Times*, July 6, 2023. https://www.nytimes.com/2023/07/06/arts/design/david-adjaye-architect-allegation.html.

Potter, Amy E., Stephen P. Hanna, Derek H. Alderman, Perry L. Carter, Candace Forbes Bright, and David L. Butler, eds. 2022. *Remembering Enslavement: Reassembling the Southern Plantation Museum.* Athens: University of Georgia Press.

Radebaugh, Sophia. 2023. "International African American Museum Expected to Make Big Impact on Tourism." WCBD News 2, June 26, 2023. https://www.counton2.com/news/local-news/officials-preparing-for-international-african-american-museum-to-make-big-economic-impact/.

Ray, Rashawn, and Alexandra Gibbons. 2021. "Why Are States Banning Critical Race Theory?" Brookings, November 2021. https://www.brookings.edu/blog/fixgov/2021/07/02/why-are-states-banning-critical-race-theory/.

Renan, Ernst. 2018. *What Is a Nation? and Other Political Writings*. Translated and edited by M.F.N. Giglioli. New York: Columbia University Press. First published 1882.

Robertson, Gary. 2022. "A New Vision: Richmond Revives the Slavery Museum Proposal, but It Won't Come Cheap." *Richmond Magazine*, January 17, 2022. https://richmondmagazine.com/news/features/a-new-vision/.

ross, kihana miraya. 2020. "Call It What It Is: Anti-Blackness." *New York Times*, June 4, 2020. https://www.nytimes.com/2020/06/04/opinion/george-floyd-anti -blackness.html.

Rothberg, Michael. 2019. *The Implicated Subject: Beyond Victims and Perpetrators*. Stanford, CA: Stanford University Press.

Rothstein, Edward. 2016. "National Museum of African American History and Culture Review: A Moving but Flawed Accounting of History." *Wall Street Journal*, September 14, 2016. https://www.wsj.com/articles/national-museum-of -african-american-history-and-culture-review-a-moving-but-flawed-accounting-of -history-1473893066.

Ruffins, Fath Davis. 1992. "Mythos, Memory, and History: African American Preservation Efforts, 1820–1990." In *Museums and Communities: The Politics of Public Culture*, edited by Ivan Karp, Christine Mullen Kreamer, and Steven Lavine, 506–611. Washington, DC: Smithsonian Books.

Sanderson, Ginny. 2023. "Glasgow Museum of Slavery Calls to Recognise City's Past." *The Herald*, September 25, 2023. https://www.heraldscotland.com/news/23812131 .glasgow-museum-slavery-calls-recognise-citys-past/.

Schneider, Keith. 2019. "Revitalizing Montgomery as It Embraces Its Past." *New York Times*, May 21, 2019. https://www.nytimes.com/2019/05/21/business/montgomery -museums-civil-rights.html.

Schult, Tanja. 2020. "Reshaping American Identity: The National Memorial for Peace and Justice and Its Take-Away Twin." *Liminalities* 16, no. 5: 1–45.

Schultz, Corey Kai Nelson. 2021. "Creating the 'Virtual' Witness: The Limits of Empathy." *Museum Management and Curatorship* 38, no. 1: 2–17.

Schwartz, Sarah. 2021. "Lawmakers Push to Ban '1619 Project' from Schools." *Education Week*, February 3, 2021. https://www.edweek.org/teaching-learning/lawmakers -push-to-ban-1619-project-from-schools/2021/02.

Scott, Chadd. 2021. "Greenwood Rising Shares Two Stories of Tragedy in Tulsa, Oklahoma's Greenwood District." *Forbes*, June 15, 2021. https://www.forbes.com /sites/chaddscott/2021/06/15/greenwood-rising-shares-two-stories-of-tragedy-in -tulsa-oklahomas-greenwood-district/?sh=498078912af1.

Sedgwick, Eve. 1988. "Privilege of Unknowing." *Genders* 1: 102–124.

SEGD. 2017. "The Segregated Lunch Counter and Panorama of the Civil Rights Movement." https://segd.org/projects/segregated-lunch-counter-and-panorama -civil-rights-movement/.

Severson, Kim. 2012. "New Museums to Shine a Spotlight on Civil Rights Era." *New York Times*, February 19, 2012. https://www.nytimes.com/2012/02/20/us/african -american-museums-rising-to-recognize-civil-rights.html.

Sharp as Knives. n.d. "Animations with Molly Crabapple." Accessed May 6, 2024. https://www.sharpasknives.com/#/withmolly/.

Sharpe, Christina. 2016. *In the Wake: On Blackness and Being*. Durham, NC: Duke University Press.

Sharpe, Jared. 2021. "UMass Amherst/WCVB Poll Finds Nearly Half of Americans Say the Federal Government Definitely Should Not Pay Reparations to the Descendants of Slaves." University of Massachusetts, Amherst, April 29, 2021. https://www.umass.edu/news/article/umass-amherstwcvb-poll-finds-nearly -half.

The Shockoe Project. 2024a. "Frequently Asked Questions." Accessed May 6, 2024. https://theshockoeproject.com/#ShockoeTimeline.

The Shockoe Project. 2024b. "Master Plan for the 10 Acres in Shockoe Valley—v2.0." Accessed May 6, 2024. https://rva.gov/sites/default/files/2024-02/Shockoe%20 Project_Masterplan%20for%20The%2010%20Acres_v2.0_8.5x11.pdf.

Shoenberger, Elisa. 2023. "What Does It Mean to Decolonize a Museum?" Museum-Next, January 2, 2023. https://www.museumnext.com/article/what-does-it-mean -to-decolonize-a-museum/.

Simko, Christina. 2020. "Marking Time in Memorials and Museums of Terror: Temporality and Cultural Trauma." *Sociological Theory* 38, no. 1: 51–77.

Simko, Christina. 2021. "From Legacy to Memory: Reckoning with Racial Violence at the National Memorial for Peace and Justice." *Annals of the American Academy of Political and Social Science* 694, no. 1: 157–171.

Simon, Nina. 2010. *The Participatory Museum*. Santa Cruz, CA: Museum 2.0.

Sloan, Karen. 2022. "UCLA Law Project Catalogs Hundreds of Anti-Critical Race Theory Measures." Reuters, August 3, 2022. https://www.reuters.com/legal/legal industry/ucla-law-project-catalogs-hundreds-anti-critical-race-theory-measures -2022-08-03/.

Smith, Jamil. 2021. "Bryan Stevenson on Tracing the Legacy of American Enslavement to Modern-Day Mass Incarceration." *Vox*, October 13, 2021. https://www.vox.com /22722941/bryan-stevenson-equal-justice-legacy-museum-american-enslavement -mass-incarceration.

Smith, Roger. 2014. *A Pedagogy of Witnessing: Curatorial Practice and the Pursuit of Social Justice*. Albany: State University of New York Press.

Smithson, Aaron. 2021. "Tulsa's Greenwood Rising Museum Strikes a Nerve in a Community Still Seeking Justice." *Architect's Newspaper*, July 15, 2021. https:// www.archpaper.com/2021/07/tulsa-greenwood-rising-museum-strikes-a-nerve/.

Smithsonian. 2023. "Facts about the Smithsonian Institution." April 1, 2023. https:// www.si.edu/newsdesk/factsheets/facts-about-smithsonian-institution-short.

Smithsonian. n.d. "Visitor Stats." Accessed May 6, 2024. https://www.si.edu/newsdesk /about/stats.

Smithsonian Institution Archives. n.d. "Anacostia Community Museum." Accessed May 6, 2024. https://www.google.com/search?q=Anacostia+Community +Museum&rlz=1C1GEWG_enNZ1086NZ1086&sourceid=chrome&ie=UTF-8.

Sodaro, Amy. 2011. "Politics of the Past: Remembering the Rwandan Genocide at the Kigali Memorial Center." In *Curating Difficult Knowledge: Violent Pasts in Public Places*, edited by Erica Lehrer, Cynthia Milton, and Monica Patterson, 72–88. Basingstoke, UK: Palgrave Macmillan.

Sodaro, Amy. 2018. *Exhibiting Atrocity: Memorial Museums and the Politics of Past Violence*. New Brunswick, NJ: Rutgers University Press.

Sodaro, Amy. 2019. "Selective Memory: Memorial Museums, Human Rights and the Politics of Victimhood." In *Museums and Sites of Persuasion: Politics, Memory and Human Rights*, edited by Joyce Apsel and Amy Sodaro, 19–35. Abingdon, UK: Routledge.

Sodaro, Amy. 2022. "'Bring Your Kleenex and Plan Something Fun for Later . . .' Social Media Reviews of the 9/11 Museum." In *The Memorial Museum in the Digital Age*, edited by Victoria Walden, 415–505. Brighton, UK: REFRAME.

Southern Poverty Law Center. 2019. *The Year in Hate and Extremism: 2019. A Report from the Southern Poverty Law Center*. https://www.splcenter.org/sites/default /files/yih_2020_final.pdf.

Stevenson, Bryan. 2014. *Just Mercy*. New York: Spiegel and Grau.

Stone, Philip, and Richard Sharpley. 2008. "Consuming Dark Tourism: A Thanatological Perspective." *Annals of Tourism Research* 35, no. 2: 574–595.

Sturken, Marita. 2016. "The Objects That Lived: The 9/11 Museum and Material Transformation." *Memory Studies* 9, no. 1: 13–26.

Sturken, Marita. 2022. *Terrorism in American Memory: Memorials, Museums, and Architecture in the Post-9/11 Era*. New York: New York University Press.

Taiwo, Bankole. 2023. "Obasanjo, Group Meet over African Slave Trade Museum." *Punch*, September 23, 2023. https://punchng.com/obasanjo-group-meet-over -african-slave-trade-museum/.

Teeger, Chana, and Vered Vinitzky-Seroussi. 2007. "Controlling for Consensus: Commemorating Apartheid in South Africa,'" *Symbolic Interaction* 30, no. 1: 57–78.

Theoharis, Jeanne. 2018. *A More Beautiful and Terrible History: The Uses and Misuses of Civil Rights History*. Boston: Beacon Press.

Torpey, John. 2006. *Making Whole What Has Been Smashed: On Reparations Politics*. Cambridge, MA: Harvard University Press.

TripAdvisor. 2023. "About Us." https://tripadvisor.mediaroom.com/us-about-us.

TripAdvisor. n.d. "Museums in Washington DC." Accessed May 4, 2024. https:// www.tripadvisor.com/Attractions-g28970-Activities-c49-a_allAttractions.true -Washington_DC_District_of_Columbia.html.

Trotter, Matt, presenter. 2021. "1921 Tulsa Race Massacre Centennial Commission Told to Stop Using Survivor's Name, Likeness." Aired April 16, 2021, on Public Radio Tulsa. https://www.publicradiotulsa.org/local-regional/2021-04-16/1921 -tulsa-race-massacre-centennial-commission-told-to-stop-using-survivors-name -likeness.

Tulsa Regional Tourism. n.d. "Explore Black-Owned Restaurants and Businesses in Tulsa." Accessed May 6, 2024. https://www.visittulsa.com/black-history/black -owned-businesses/.

UNESCO. n.d. "Routes of Enslaved Peoples." https://www.unesco.org/en/routes -enslaved-peoples.

UN News. 2023. "Interview: Cultural Spaces Help Counter Harmful Legacy of Slavery, Argues Bryan Stevenson." April 2, 2023. https://news.un.org/en/interview/2023 /04/1135232.

U.S. Congress. 1928. *Public Buildings and Grounds. Hearings before the Committee on Public Buildings and Grounds, House of Representatives, US Congress. Seventieth Congress, First Session, on H.J. Res. 60 . . .* Vol. 1. Washington, DC: U.S. Government Printing Office.

Vlach, John Michael. 2006. "The Last Great Taboo Subject: Exhibiting Slavery at the Library of Congress." In *Slavery and Public History: The Tough Stuff of American Memory*, edited by James Oliver Horton and Lois E. Horton, 57–74. New York: New Press.

von Daacke, Kirt. n.d. "Universities Studying Slavery (USS)—The Birth of a Movement." University of Virginia, President's Commission on Slavery and the

University. Accessed May 6, 2024. https://slavery.virginia.edu/universities-study
ing-slavery-uss-the-birth-of-a-movement/.

Wainwright, Oliver. 2016. "'A Welcome Rebuke to Dead White Men': The Smithson-
ian's African American Museum Finally Arrives." *Guardian*, September 16, 2016.
https://www.theguardian.com/artanddesign/2016/sep/15/smithsonian-national
-museum-african-american-history-washington-architecture-review.

Walden, Victoria Grace. 2022. "What Is 'Virtual Holocaust Memory'?" *Memory
Studies* 15, no. 4: 621–633.

Waterton, Emma. 2011. "The Burden of Knowing versus the Privilege of Unknowing."
In *Representing Enslavement and Abolition in Museums: Ambiguous Engagements*,
edited by Laurajane Smith, Geoff Cubitt, Kalliopi Fouseki, and Ross Wilson,
23–43. Abingdon, UK: Routledge.

Wegman, Jesse. 2018. "At This Memorial, the Monuments Bleed." *New York Times*,
April 25, 2018. https://www.nytimes.com/2018/04/25/opinion/alabama-lynching
-memorial.html.

The White House. 2016. "Remarks by the President at the Dedication of the National
Museum of African American History and Culture." Press release, September 24,
2016. https://obamawhitehouse.archives.gov/the-press-office/2016/09/24/remarks
-president-dedication-national-museum-african-american-history.

Wilentz, Sean. 2020. "A Matter of Facts." *The Atlantic*, January 22, 2020. https://www
.theatlantic.com/ideas/archive/2020/01/1619-project-new-york-times-wilentz/605152/.

Wilkens, Robert L. 2016. *Long Road to Hard Truth: The 100 Year Mission to Create the
National Museum of African American History and Culture*. Washington, DC:
Proud Legacy Publishing.

Wilkerson, Isabel. 2020. *Caste: The Origin of Our Discontents*. New York: Random
House.

Williams, Paul. 2007. *Memorial Museums: The Global Rush to Commemorate Atrocities*.
New York: Berg.

Wilson, Mabel O. 2016. *Begin with the Past: Building the National Museum of African
American History and Culture*. Washington, DC: Smithsonian Books.

Winter, Jay. 2001. "The Memory Boom in Contemporary Historical Studies." *Raritan
Quarterly* 21, no. 1: 52–66.

Wood, Marcus. 2009. "Slavery, Memory, and Museum Display in Baltimore: The
Great Blacks in Wax and the Reginald F. Lewis," *Curator: The Museum Journal* 52,
no. 2: 147–167.

Wood, Marcus. 2022. "Re-tooling Memory and Memory Tools: America's Ongoing
Re-Memory of Slavery." In *Writing the History of Slavery*, edited by David Stefan
Doddington and Enrico Dal Lago, 417–430. New York: Bloomsbury.

Woodley, Jenny. 2023a. "The Meaning of Emancipation: African American Memory
as a Challenge to *The Birth of a Nation*." In *In the Shadow of The Birth of a Nation:
Racism, Reception and Resistance*, edited by Melvyn Stokes and Paul McEwan,
191–206. New York: Springer.

Woodley, Jenny. 2023b. "'Nothing Is Lost': Mourning and Memory at the National
Memorial for Peace and Justice." *Memory Studies* 16, no. 5: 1054–1070.

Woodley, Jenny. 2024. "Loss, Grief, and Death at US Civil Rights Museums." In *The
Routledge Handbook of Museums, Heritage, and Death*, edited by Trish Biers and
Katie Stringer Clary, 120–129. Abingdon, UK: Routledge.

Wüstenberg, Jenny. 2017. *Civil Society and Memory in Postwar Germany*. Cambridge:
Cambridge University Press.

Wüstenberg, Jenny, and Yifat Gutman, eds. 2023. *Routledge Handbook of Memory Activism*. Abingdon, UK: Routledge.

Yahr, Emily. 2016a. "'We Did It': Read John Lewis's Emotional Speech at the African American Museum Opening," *Washington Post*, September 24, 2016. https://www.washingtonpost.com/news/arts-and-entertainment/wp/2016/09/24/we-did-it-read-john-lewiss-emotional-speech-at-the-african-american-museum-opening/.

Yahr, Emily. 2016b. "Read George W. Bush's Speech at the African American Museum, 13 Years after Signing the Bill to Build It." *Washington Post*, September 24, 2016. https://www.washingtonpost.com/news/arts-and-entertainment/wp/2016/09/24/read-george-w-bushs-speech-at-the-african-american-museum-13-years-after-signing-the-bill-to-build-it/.

Yiin, Wesley. 2016. "Timeline: It Took over 100 Years for the African American Museum to Become a Reality." *Washington Post*, September 21, 2016. https://www.washingtonpost.com/entertainment/museums/timeline-it-took-over-100-years-for-the-african-american-museum-to-become-a-reality/2016/09/20/dc080c54-5a8c-11e6-831d-0324760ca856_story.html.

Young, James. 1993. *The Texture of Memory: Holocaust Memorials and Meaning*. New Haven, CT: Yale University Press.

Young, James. 2016. *The Stages of Memory: Reflections on Memorial Art, Loss, and the Spaces Between*. Amherst: University of Massachusetts Press.

Zeskind, Leonard. 2012. "A Nation Dispossessed: The Tea Party Movement and Race." *Critical Sociology* 38, no. 4: 495–509.

Index

abolitionist movement, 6, 26, 50

activism, 6, 23–24, 51; African American, 6, 15, 79, 81, 106, 109, 145; memory, 6, 11, 85–86, 131–132, 134; by museums, 10–11, 18–20, 27, 61, 63–64, 110, 117–118, 131–134

Adjaye, David, 43, 45, 156n4

African American: achievement, 22, 24, 39, 46, 50, 53–55, 57–58, 82, 130, 133, 146; agency, 10, 34, 38, 49–50, 56, 58, 62, 79, 82, 115, 130; heritage sites, 6, 19–20, 26; history and culture, 10–11, 19–25, 32–33, 38–41, 43–44, 47–48, 57–58, 63–64, 115, 124, 130; memory work, 14–15, 19–21, 38–39, 44, 68–69, 77, 85–86, 114, 117–120; resistance, 10, 23, 26, 38–39, 46, 48–50, 57–58, 81–82, 85–86, 130

African American museums, 8, 14, 26–27, 30, 33, 39, 44, 58, 82, 113–114; first phase, 19–20, 22–23, 40, 128; national, 10–12, 31, 34, 40, 44–45, 60, 86, 112, 121–124, 131–132, 146; regional, 19–20, 133; second phase, 20–23, 40–42, 57, 155n10; as sites of empowerment, 10, 18, 20, 22–23, 51, 57, 115, 131–132; third phase, 8, 10, 23–25, 31, 90, 112–113, 133–134, 144, 149, 155n10

African Burial Grounds: Flatbush, Brooklyn, New York City, 1–2, 6, 9, 153n1; Lower Manhattan, New York City, 2, 30–31, 156n20, 160n17; Richmond, Virginia, 146

afterlife of slavery, 10, 21, 27, 126, 148

Akoto-Bamfo, Kwame, 66, 71

Alderman, Derek, 117, 122

Amherst, Massachusetts, 7, 135

Amusan, Egunwale, 109

Anacostia Community Museum, 20, 30, 154n6

Anacostia Neighborhood Museum. *See* Anacostia Community Museum

Andrew W. Mellon Foundation, 114, 116, 146

Angola prison, 53, 55

anniversary commemorations, 7, 26–27, 39, 56, 93, 97, 108

anti-Blackness, 5, 39; as depicted in museums, 2, 27, 32, 34, 89, 100, 105–106, 129, 131–132

apartheid, 65, 78–79

Apartheid Museum, 24, 69, 98

Araujo, Ana Lucia, 27, 29, 31, 44, 48, 55–56, 59–60

archival documentation, 17, 24, 72, 123

archives, 44, 77, 92

Armstrong, Philip, 96–98, 104, 108, 119, 160n13

Arthur-Mensah, L'Rai, 96, 100, 129, 132, 159n9

artworks, 28–29, 56, 71, 75, 82, 85, 96–97, 130, 146; sculptures, 29, 48, 66, 68, 71, 81, 85, 94, 141

Assmann, Aleida, 16–17, 133

Atlanta, Georgia, 21, 23–25, 42, 154n7

182 • Index

authenticity: of location, 69–71, 75, 97, 120–123, 124–126, 144; of museum experiences, 11, 68, 72, 85, 113, 120, 123–124, 126
Autry, Robyn, 11, 19–23, 30, 33, 113–114, 120

backlash against racial equality, 8, 13–14, 30, 36, 63, 78, 87, 100, 135–136
balancing upset and uplift, 22–23, 41, 46, 49–51, 57–58, 62, 81, 130–131, 138, 145
Baldwin, James, 40
Baptist churches, 21, 28, 51
barbershops, 90, 98–99, 119, 122, 125–126, 143
bearing witness, 17, 73, 76, 101–102, 137
Benin, 26, 147
Berlin, 17, 68–69, 97, 160n12
Birmingham Civil Rights Institute, 20–21, 42
Birmingham, Alabama, 19–21, 24, 42
Black. See African American
Black Codes, 50, 100
Black Lives Matter (BLM), 6, 7–8, 35, 54, 56, 61, 81, 85, 134, 146, 148
Black Panthers, 51, 53–54
Black Power movement, 19–20, 51, 53–54
Black Wall Street, 11, 90, 95, 97–99, 102–103, 109, 122–123, 125, 132, 146
Bonilla-Silva, Eduardo, 3
Brand, Anna Livia, 117, 122
Brooklyn, New York, 1–2, 6, 56, 77, 117, 146–147
Brown University, 6, 135
Buchenwald, 13
Bunch, Lonnie, 32, 38, 41–45, 57–61, 114–115, 156n2
Burns, Andrea, 19, 22
Bush, George W., 37–38, 41

Cambodia, 16, 26
Capitol, U.S., 4–5, 45
Carbonell, Bettina Messias, 133
caste system, 76, 80, 84
Charles H. Wright Museum of African American History (MAAH), 20, 30, 147
Charleston, South Carolina, 3–4, 13–15, 25, 29–30, 144–145, 147
Charlottesville, Virginia, 4, 13–14
Chile, 16, 101

chronological exhibitions, 47, 54, 133
Civil Rights Act, 24, 51
Civil Rights Movement, 8, 38, 65, 68, 74, 103; as depicted in museums, 11, 23–25, 40, 50–51, 53, 68, 78–79, 81–82, 146, 155n10
Civil War, 4, 15–16, 19, 39, 44, 50
Coca-Cola, 23, 116, 154n8
colonialism, 19, 26, 47, 90, 156n5, 157n3
Colonial Williamsburg, 29, 135, 155n17
commemorative practices, global, 5–6, 9–12, 14–18, 24, 28–32, 35, 70, 110–111, 134, 146–147
Community Remembrance Project, 76–78, 85–86, 131, 140
complicity of white Americans, 59, 66–67, 76, 125. See also implicated subject
Compromise of 1877, 50, 154n3
Confederate: flag, 4–5; heritage, 15, 64–65, 117, 136, 158n13; monuments, 4–5, 8, 85, 148; symbols, 4, 35
Cotter, Holland, 61–62, 109, 155n10
COVID-19 pandemic, 14, 50, 56, 87, 116, 144
criminal legal system, 64, 79–80, 83, 131
critical race theory, 5, 35, 85, 128, 153n5
Cummings, John, 28

David, Lea, 16, 41
Davis, Jefferson, 65
Davis Brody Bond, 42–43
decolonization, 6, 19, 26
de Jong, Steffi, 72–73, 125
diversity, equity, and inclusion (DEI), 1–20, 136
Douglass, Frederick, 35, 81, 148–149
drugs, war on, 54, 79

Elaine, Arkansas, 51, 135
elections, presidential, 3–5, 38, 54, 57, 60, 63, 82, 115, 134
emancipation, 6, 15, 19, 30, 39, 50, 154nn3–4
emotional exit, 51, 100, 132, 143
empowerment, 10, 18, 20, 22–23, 51, 57, 115, 131–132
Equal Justice Initiative (EJI), 10, 32; Community Remembrance Project, 76–78, 85–86, 131, 140; legal advocacy, 63–64, 68–69, 80–83, 85, 116, 131; research,

65, 77, 82–83, 85, 131. *See also* Legacy
Museum; National Memorial for Peace
and Justice
ethics, memorial, 11, 16–17, 33, 45, 73, 90,
99, 106–107, 111, 127, 137
Evanston, Illinois, 7, 135, 160n19
exhibitions: experiential, 9, 17–18, 33, 51–53,
89–90, 102, 113, 123–127, 133–134, 144;
immersive, 11, 24, 32, 47, 60–61, 89–90,
97–102, 113, 124–126, 143–146; interac-
tive, 18, 24, 33, 51–56, 74, 77–78, 135, 138,
141, 145–146; traditional, 9, 12, 33, 54,
60–61, 71, 100, 113, 123, 134, 141–142

Fabre, Geneviève, 14–15, 64
family separation, 48, 71–72, 75
films (in museums), 24, 53, 55–56, 75, 79, 98,
101–102, 117, 123, 145
First White House of the Confederacy, 65,
158n13
Floyd, George, 7–8, 14, 56, 61, 81, 85, 100,
134
Formosa Corporation, 28, 155n14
France, 26
Franklin, B. C., 92
Franklin, John Hope, 45, 92–96, 159n4
Freedom Rides, 24, 51
Freelon, Philip, 23, 42–43, 45
Freelon Group Associates, 42–43, 45
funding for museums: private, 10, 28,
63–64, 86, 96, 114, 116, 118, 120, 145;
public, 20, 114, 116–117, 120, 140; public-
private partnership, 20–21, 23, 90, 93, 96,
114, 118–120, 145
fundraising, 43, 58, 70, 96, 114, 116, 120,
144

gentrification, 103–104, 109, 119, 122–123,
127
Germany, 13–14, 16, 65, 101, 118, 157n3,
161n2
Ghana, 26, 43, 66, 71
Gone with the Wind (film), 28, 155n12
Google, 61, 69, 77, 116–117, 158n5
Gordon, Private, 75, 105
grassroots activism, 2, 6, 20, 45, 120, 148
Great Migration, 39, 51
Greenwood Cultural Center, 94–97, 159n8,
159n10

Greenwood Rising, 11, 33, 89–111; build-
ing, 97, 123; challenge to racial progress
narrative, 11, 33–34, 119; collections, 33,
97–98, 124; Commitment Wall, 104,
110, 143, 160n17; community engage-
ment, 95–97, 108, 110–111; controversies,
11, 89–90, 106–111, 118–119, 132; design,
69, 95–96, 117, 119; economic impact
of, 94, 109, 118; emotional exit, 51, 100,
132, 143; exhibitions, 98–104, 124–125;
history, 90–95; as immersive journey,
11, 33, 89, 98–99, 101–102, 113, 132, 143;
and implication, 105–106, 110, 129, 132;
linking past and present injustice, 12,
33–34, 89, 104–106, 109, 119, 127, 129;
opening, 8, 89, 97, 112; staff and adminis-
tration, 45, 95–96, 98, 101–103, 108, 119,
132; use of innovative technology, 33, 61,
89, 97, 99, 124–126, 143. *See also* Tulsa
Race Massacre
Gruenewald, Tim, 48, 58, 121
guilt, 35, 59–60, 84, 142

Hall-Harper, Vanessa, 106, 110
Hannah-Jones, Nikole, 7
Hartman, Saidiya, 10, 148
Harvard University, 64, 116–117, 135
HBO, 94, 116–117, 158n5
hierarchies, racial, 3, 27, 31, 70, 75–76,
83–84, 103, 130
higher education, 3, 5–6, 136, 148
historical markers, 64–65, 68, 86, 97,
122
historically Black colleges and universities
(HCBUs), 5, 40, 50
historic sites, 2, 4, 8–10, 19–21, 26–30, 40,
97, 112, 155n13
history museums, 10, 17–18, 22–23, 33, 40,
60, 73–74, 83, 133
Holocaust, 5, 26, 40–41, 99, 127, 147–148;
museums, 2, 16–18, 22–23, 32, 48, 68,
72–73, 95, 109, 137, 144; survivor testi-
mony, 72–73, 101, 125–126. *See also*
U.S. Holocaust Memorial Museum
(USHMM)
holographic images, 72–73, 76, 98, 119,
125–126, 141, 143
human rights discourse, 16, 24–27, 56, 64,
78, 107, 159n5

184 • Index

implicated subject, 9, 35, 59, 64, 66–67, 83–84, 110, 129, 139, 141
inclusion, 6, 18–19, 29, 32, 34, 39, 43, 122, 136
Indigenous peoples, 2, 18
International African American Museum (IAAM), 144–146
International Afro-American Museum. *See* Charles H. Wright Museum of African American History (MAAH)
International Slavery Museum, 27, 156n4, 157n10
Inwood, Joshua F., 117, 122

Jefferson, Thomas, 29, 48, 123, 133–134, 157n9
Jewish Museum Berlin, 17, 97, 160n12
John Hope Franklin Center for Reconciliation, 93–96; Reconciliation Park, 93–95
Johnson, Hannibal B., 95, 97, 119
Juneteenth, 56, 154n4
Just Mercy (Stevenson), 64, 81, 116

King, Martin Luther, Jr., 21, 24, 40, 53, 79
King National Historic Site, 21, 154n7
Knigge, Volkhard, 13
Ku Klux Klan (KKK), 39, 50–51, 81, 100, 105, 123, 154n3
Kytle, Ethan J., 15, 147

Landsberg, Alison, 4, 17, 31, 59, 83, 85–86, 102, 133
Legacy Museum: From Enslavement to Mass Incarceration, 2, 8–12, 31–35, 45, 60–61, 63–90, 95, 97–100; affective experience at, 70–73, 76–78, 80, 140–141; buildings, 68, 70; collections, 33, 115–116, 124–125; community engagement, 76–77, 85; design, 68–70; exhibitions, 70–82, 124–125; expansion, 64, 70, 80, 85, 87, 116, 121–122, 130, 154n6; history, 64–65; linking past and present injustice, 33–34, 63–64, 73–74, 77–78, 82–86; opening, 8, 63; Reflection Space, 81–82, 130; research, 65, 77, 82, 85, 131; slave pens, 71–74, 76, 80, 83, 125–126; staff and administration, 45, 64, 87; use of digital technology, 33, 73, 126, 141. *See also* Equal Justice Initiative (EJI); National Memorial for Peace and Justice

legal advocacy, 63–64, 68–69, 80–82, 85, 116, 131
Lewis, John, 38, 41
Library of Congress (LOC), 30
lieux de mémoire, 15, 44
Linenthal, Edward, 18, 37
Local Projects, 61, 69, 95–96, 98, 117, 119, 129, 132
Lost Cause narrative, 9–10, 15–16, 21, 23, 29, 56, 64, 86, 119, 154n2
lunch counter sit-ins, 24, 51, 53, 61, 133, 138
lynching: as depicted in museums, 25, 34, 50–51, 63, 65–68, 74–87, 101, 117, 122–125, 128–129, 131, 155n10; history of, 10, 39, 91
Lynching Memorial. See National Memorial for Peace and Justice

Madeo Studio, 69, 117
"Make America Great Again," 3, 85
"making a way out of no way," 38–41, 46, 48–50, 55, 58, 156n1
maps, 48, 71, 77–79, 117, 135
March on Washington, 24, 51, 79
marginalized groups, 5–6, 20, 26, 40, 44
Martin, Trayvon, 54, 56, 77
MASS Design Group, 66, 157n1
mass incarceration, 34, 157n11; as depicted in Legacy Museum, 2, 10–11, 34, 63–64, 70, 74, 79–81, 83–85, 116, 129–130, 141–142; as depicted in NMAAHC, 53, 55–56
mass violence, 17, 19, 73, 101, 128
Matthews, Kevin, 94, 108
memorial museums: affective experience in, 9, 17–18, 27–29, 47–48, 51–52, 71–73, 79–80, 85, 89, 97–102, 126–127; confronting past injustice, 14, 16, 73–74, 82–84, 105–106, 112–113, 126–134; as educators, 16, 32–33, 39, 82, 89–90, 100, 113, 126–127, 131–132, 139, 146; global trends in, 9–11, 17–18, 22, 32, 110–111, 134, 147; limitations of, 11–12, 34, 90, 110, 113, 120, 132, 134, 138, 149; and moral transformation, 11–12, 16–17, 31, 34, 41–42, 53, 73, 84–86, 126–128
memory: activism, 6, 11, 85–86, 131–132, 134; boom, 2, 9, 16, 20; scholars, 2, 59, 82–83, 99

memory work: African American, 14–15, 19–21, 38–39, 44, 68–69, 77, 85–86, 114, 117–120; American, 19, 38, 68, 85–86, 124, 140, 149; global, 14, 65, 69

Middle Passage, 47, 60–61, 70, 74

Mississippi, 24–25, 52, 74, 155n10

Mobley, Mamie Till, 45, 52

Montgomery, Alabama, 2, 10, 24, 31, 53, 63–88, 95, 109, 117–122, 131, 140

Montgomery Bus Boycott, 24, 53, 79

Monticello, 29, 48, 135

moral obligations of museums, 12, 17, 41, 47, 73, 137

moral remembrance, 16, 41

Morrison, Toni, 25

Mount Vernon, 29, 135

mourning Black lives, 48, 64, 67

Museum of the African Diaspora, 20, 42

museum staff: nonprofessional, 45, 61, 68–69, 95–98, 115, 117, 119, 130–132; professional, 41, 44, 68–69, 114–115, 126, 160n13

National Afro-American Museum, 20, 40

National Center for Civil and Human Rights (NCCHR), 23–25, 42, 53, 154n9

National Mall, 34, 38, 41–43, 45–46, 50, 58, 62, 114–115, 119, 121

National Memorial for Peace and Justice, 63, 65–68, 86–87, 116, 122, 128, 140, 154n6

National Museum of African American History and Culture (NMAAHC): building, 4, 42–43, 45–46, 58, 97, 115, 138; cafe, 55, 137–138; collections, 43–45, 115, 123–124, 126; community outreach, 43–44; Contemplative Court, 55, 133–134; events, 44, 56–57, 61; experiential elements, 47–53, 133, 138; history, 37–41; opening, 8, 37–38, 138; permanent exhibitions, 43–55, 58–61, 115, 129–130, 133–134, 138; Scholarly Advisory Committee, 45, 156n7; as symbol of national unity, 10, 37; temporary exhibitions, 56–57, 61, 134; as transitional form, 10, 38, 60–62, 133–134

National Museum of American History, 30, 41, 43–44, 114–115

National Museum of the American Indian (NMAI), 40, 42

Native Americans, 89–90, 97, 159n2

Neiman, Susan, 13–14, 148

"never again," 16–17, 32–33, 127, 148

New York Times, 7, 61–62, 74, 109, 155n10, 162n5

Nigeria, 26, 147

9/11 Memorial Museum, 2, 18, 31, 42, 82, 95, 113, 137

NPR (National Public Radio), 43, 70, 162n5

O'Meally, Robert, 14–15, 64

Obama, Barack, 4, 13, 47, 60, 69; election of, 3, 8, 54–55, 61, 82, 115, 121, 134; and opening of NMAAHC, 37–38

Oklahoma, 32, 41, 51, 89–111, 118, 132, 159nn2–3, 160nn18–19

Oklahoma Commission to Study the Tulsa Race Riot of 1921, 93, 101, 107

online exhibits, 135, 158n8

oral histories, 29, 43, 48

paradox of slavery and freedom, 10, 37–38, 47–48, 58–61, 115

Parks, Rosa, 45, 51, 65, 79

plantations, 4, 9, 27–30, 53, 135, 155n12

political economies of museums, 11, 64, 113–120, 126, 134

politics: of regret, 14–21, 25–26, 31, 35, 106, 109, 111, 133; of self-assertion, 17, 27, 133

post-postracial America, 1–10, 14, 31, 36, 60–61, 64

prisons, 74, 80–81, 87–88, 123, 157n11. See also Angola prison

Providence, Rhode Island, 7, 25

racial inequality, 9, 35, 59–60, 82, 85, 105, 129, 131

racial oppression, 8–10, 14, 23, 59, 63, 126

racial progress narrative: challenges to, 2–3, 8–12, 31, 64, 69, 83, 86, 112–113, 117, 133, 142; in museums, 14, 23–25, 48, 58, 60–61, 73–74, 121; in U.S. historical memory, 3, 8, 13, 63, 148

racial terror, 5, 11, 21, 63, 65–66, 69, 76–80, 82–85, 146

186 • Index

racism, structural, 3–8, 19, 35–36, 59–60, 85, 105–106, 129–132, 140–149, 153n5; depicted at Greenwood Rising, 11, 34, 90, 99–100, 104–106, 109, 119; depicted at Legacy Museum, 34, 63, 70–81, 88, 117, 130–131, 142; depicted at NMAAHC, 45, 56–61, 140; depicted in other museums, 21–22, 130, 144–146

Ralph Appelbaum Associates (RAA), 46, 61, 115, 117, 123, 145

Randle, Lessie, 107–109

reconciliation, racial, 11, 41–42, 63, 86, 89–90, 93–95, 103–104, 107, 134, 144–145, 149

Reconstruction, 15–16, 50, 56, 75, 134, 154n3

reparations, 6–7, 11, 16, 35, 85, 90, 93, 106–110, 135, 148; addressed in museums, 50, 56, 95, 103–104, 139

Republicans, 3, 7, 15, 41, 107, 161n20

resistance to racial equality, 8, 13–14, 30, 36, 63, 78, 85, 87, 100, 135–136

retrospective politics, 14, 16, 22

revitalization, economic, 20–21, 23, 42, 87, 93, 97, 117–120, 145, 158n13

Revolutionary War, 47–48

riots, 4–5, 40, 51, 53; mischaracterization of race massacres as, 34, 51, 55, 89, 92, 103, 106

Roberts, Blain, 15, 147

Rothberg, Michael, 9, 35, 59–60, 84, 106, 110, 128

Rowland, Dick, 91

Rucker, Paul, 146

Rwanda, 16, 26, 65, 69, 101, 157n1, 158n3

sacrifices for a cause, 14–15, 24, 39

San Francisco, California, 7, 20, 42

Sanneh, Sia, 68–69

Seck, Ibrahima, 28

Selma-to-Montgomery March, 24, 51, 53, 65

Sharpe, Christina, 21, 127, 130

Shockoe Project, 146

Simko, Christina, 83, 86–87

Simmons, Ruth, 6

sit-ins, 24, 51; at Woolworth's in Greensboro, North Carolina, 51, 53

1619 (year), 100, 129: 1619 Project, 7, 85, 135, 148

slave: auctions, 65, 71–72, 75, 123–124, 146, 155n17; cabins, 28, 49–50, 85, 123; jails, 28, 146; pens, 71–74, 76, 80, 83, 125–126

Slavers of New York, 2, 6

slave trade, 29, 64–65; domestic, 30, 48, 69, 71, 75, 131; transatlantic, 26–27, 47–48, 59, 70–71, 83, 121–122, 133, 147

slavery: abolition of, 6, 26–27, 74; central role in U.S. history, 7–9, 23, 32, 55, 71, 84, 105, 115, 121–122, 147–148; and educational institutions, 5–6, 135–136, 148; evolution into mass incarceration, 2, 34, 68, 73–74, 79–80, 83, 116, 128; and implication, 59; legacies of, 5–8, 10–11, 21, 27, 31–35, 84–86, 106, 135, 144, 147–148; memory of, 2, 6, 14–15, 25–27, 30, 35–36, 63, 112, 129–130, 140; as represented in Greenwood Rising, 90, 100; as represented in Legacy Museum, 10–11, 34, 63–66, 68–71, 73–88, 115–117, 119, 121, 128–129; as represented in NMAAHC, 10, 33–34, 44, 46–50, 53, 55–60, 115, 121, 123, 127–128, 134; as represented in other museums, 10, 14, 23, 25, 27–31, 135, 145–147

Smithsonian Institution museums. See individual museums

social change, 12, 34, 40, 64, 86, 113, 127–128, 134, 141

social justice, 11, 28, 39, 41–42, 117–118, 131, 134, 149

South Africa, 16, 65, 157n3, 159n9

Stevenson, Bryan, 10, 63–65, 68–70, 74, 82, 84, 88, 116–117, 124, 146, 148–149, 157n3

StoryCorps, 43

storytelling in museums, 10–11, 18, 27, 33–34, 47–48, 55, 68–69, 75, 85–86

Sturken, Marita, 8, 68, 124–125

Supreme Court: Oklahoma, 107, 160n18; U.S., 3, 64, 74, 80, 107

survivor testimony. See witness testimony

Tea Party, 3

Theoharis, Jeanne, 23

Till, Emmett, 45, 52, 60–61, 124, 133–134, 139, 156n6, 158n9

timelines, 48, 74–75, 100

touchscreens, 53, 74–75, 77, 79, 82

tour guides, 1, 29, 98–103

Index • 187

tourism, 17, 20–21, 23, 26–28, 87, 90, 109–110, 117, 137, 140, 142–143
transformation, moral, 16–17, 31–34, 57, 73, 84–86, 98–99, 102, 127–128, 131, 141
TripAdvisor, 12, 62, 136–138, 140, 143, 161n2
Trump, Donald J., 3–5, 7, 38, 57, 63, 153nn3–4
truth-telling, 43, 57, 87–89, 100, 109, 113, 117, 131–132, 134, 138, 145–146
Tubman, Harriet, 45, 56, 81
Tulsa, Oklahoma, 2, 11, 51, 55, 89–111, 118–120, 122–123, 126, 131–132, 142–145
Tulsa Race Massacre, 2, 11, 34, 51, 56, 89–111, 118, 122–123, 129, 131–132, 142; history, 90–94. *See also* Greenwood Rising
Tulsa Race Massacre Centennial Commission, 11, 89, 94–96, 107–108, 110, 118–120, 159n8
Tulsa Tribune, 91–93

Underground Railroad, 20, 40
UNESCO, 26, 147
unevenness: of African American history, 47, 57; of museums' success, 28, 34, 36, 84, 126, 133, 149
Universities Studying Slavery, 6, 85
urban renewal, 20, 92, 103
U.S. Congress, 4, 39–42, 77–78, 81, 107, 114–115, 117
U.S. Holocaust Memorial Museum (USHMM), 17–18, 31, 40–43, 46–48, 52–53, 55, 69, 82, 123, 137
use of color in museum exhibitions, 51, 75–77, 83, 130
use of language in museum exhibitions, 76, 100

Vernon AME Church, 103, 122
victim-perpetrator binaries, 9, 35, 105–106
vindicationist narrative of African American history, 22–23, 39, 63–64, 84

visitor research, 12, 136–144, 148, 161n1. *See also* TripAdvisor
visitors to museums: Black, 57, 59, 64, 81, 87–88, 127, 129–132, 138–139; white, 28, 32, 59–60, 66–67, 86–88, 127–129, 132, 139, 142, 161n3
voter suppression, 3, 56
Voting Rights Act, 3, 24, 51

Walden, Victoria, 99, 102
Watchmen (HBO series), 94
Wells, Ida B., 77, 81
West Africa, 26–27, 147
Westcott, Anarcha, 81, 158n12
White House, 39, 45
white nationalism, 4–5, 14, 38, 153n4
white privilege, 35, 59–60, 84, 110, 127, 129, 132, 139, 142
white supremacy, 4, 10, 15, 19, 27; as depicted at Greenwood Rising, 100–101; as depicted at Legacy Museum, 74, 79, 81, 83, 129, 141; as depicted at NMAAHC, 38, 48, 55–56, 59–60, 62
whitewashing history, 15, 27–28, 92, 119, 122, 138–139
Whitney Plantation, 9, 28–29, 155n13
Wilberforce, Ohio, 20, 40
witness testimony, 34, 72–73, 75–76, 83, 91, 101–102, 105–106, 108–109, 125–126
"wokeism," 5, 142
Woodley, Jenny, 66–67
working off the past, 13–14, 154n1
World War II, 39–40, 92, 160n19
WPA Slave Narrative collection, 29, 48, 73, 155n15
Wüstenberg, Jenny, 118

Yale University, 6, 116–117

About the Author

AMY SODARO is professor of sociology at the Borough of Manhattan Community College/City University of New York. Her research focuses on memorialization of past violence in memorial museums. She is the author of *Exhibiting Atrocity: Memorial Museums and the Politics of Past Violence* and coeditor of *Museums and Sites of Persuasion: Politics, Memory and Human Rights* and *Museums and Mass Violence: Perils and Potential*. She is an editor of the journal *Memory Studies* and cochair of the Memory Studies Association Museums and Memory working group.

Available titles in the Genocide,
Political Violence, Human Rights series:

Nanci Adler, ed., *Understanding the Age of Transitional Justice: Crimes, Courts, Commissions, and Chronicling*

Bree Akesson and Andrew R. Basso, *From Bureaucracy to Bullets: Extreme Domicide and the Right to Home*

Jeffrey S. Bachman, *Genocide Studies: Pathways Ahead*

Jeffrey S. Bachman, *The Politics of Genocide: From the Genocide Convention to the Responsibility to Protect*

Andrew R. Basso, *Destroy Them Gradually: Displacement as Atrocity*

Alan W. Clarke, *Rendition to Torture*

Alison Crosby and M. Brinton Lykes, *Beyond Repair? Mayan Women's Protagonism in the Aftermath of Genocidal Harm*

Lawrence Davidson, *Cultural Genocide*

Myriam Denov, Claudia Mitchell, and Marjorie Rabiau, eds., *Global Child: Children and Families Affected by War, Displacement, and Migration*

Daniel Feierstein, *Genocide as Social Practice: Reorganizing Society under the Nazis and Argentina's Military Juntas*

Joseph P. Feldman, *Memories before the State: Postwar Peru and the Place of Memory, Tolerance, and Social Inclusion*

Alexander Laban Hinton, ed., *Transitional Justice: Global Mechanisms and Local Realities after Genocide and Mass Violence*

Alexander Laban Hinton, Thomas La Pointe, and Douglas Irvin-Erickson, eds., *Hidden Genocides: Power, Knowledge, Memory*

Douglas A. Kammen, *Three Centuries of Conflict in East Timor*

Eyal Mayroz, *Reluctant Interveners: America's Failed Responses to Genocide from Bosnia to Darfur*

Pyong Gap Min, *Korean "Comfort Women": Military Brothels, Brutality, and the Redress Movement*

Fazil Moradi, *Being Human: Political Modernity and Hospitality in Kurdistan-Iraq*

Walter Richmond, *The Circassian Genocide*

S. Garnett Russell, *Becoming Rwandan: Education, Reconciliation, and the Making of a Post-Genocide Citizen*

Tatiana Sanchez Parra, *Born of War in Colombia: Reproductive Violence and Memories of Absence*

Victoria Sanford, Katerina Stefatos, and Cecilia M. Salvi, eds., *Gender Violence in Peace and War: States of Complicity*

Irina Silber, *Everyday Revolutionaries: Gender, Violence, and Disillusionment in Postwar El Salvador*

Amy Sodaro, *Lifting the Shadow: Reshaping Memory, Race, and Slavery in U.S. Museums*

Samuel Totten and Rafiki Ubaldo, eds., *We Cannot Forget: Interviews with Survivors of the 1994 Genocide in Rwanda*

Eva van Roekel, *Phenomenal Justice: Violence and Morality in Argentina*

Anton Weiss-Wendt, *A Rhetorical Crime: Genocide in the Geopolitical Discourse of the Cold War*

Kerry Whigham, *Resonant Violence: Affect, Memory, and Activism in Post-Genocide Societies*

Timothy Williams, *The Complexity of Evil: Perpetration and Genocide*

Ronnie Yimsut, *Facing the Khmer Rouge: A Cambodian Journey*

Natasha Zaretsky, *Acts of Repair: Justice, Truth, and the Politics of Memory in Argentina*

Julien Zarifian, *The United States and the Armenian Genocide: History, Memory, Politics*